D0099928

DEC 1 9 1997

PROPERTY OF:
RANCHO MIRAGE PUBLIC LIBRARY
42-520 BOB HOPE DRIVE
RANCHO MIRAGE, CA 92270
(760) 341-READ (7323)

CALIFORNIA
POTTERIES
The Complete Book

Mike Schneider

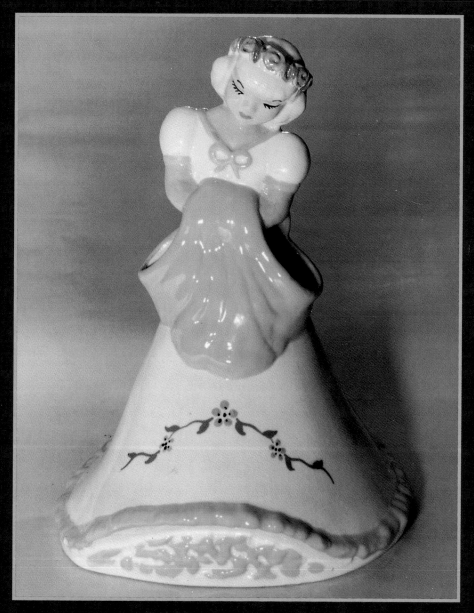

Schiffer Publishing Ltd

77 Lower Valley Road, Atglen, PA 19310

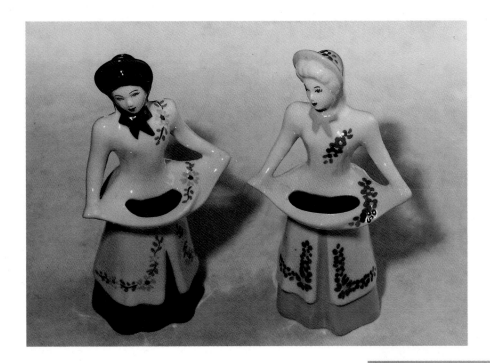

A pair of identical planters, each 9-1/2 inches high. One has a Weil Ware inkstamp and paper label, the other is unmarked, a circumstance seen quite often with California pottery. Estimated value: $22 each. *Oravitz Collection*

Published by Schiffer Publishing Ltd.
77 Lower Valley Road
Atglen, PA 19310
Please write for a free catalog.
This book may be purchased from the publisher.
Please include $2.95 for shipping.
Try your bookstore first.

We are interested in hearing from authors
with book ideas on related subjects.

Copyright 1995 by Mike Schneider

All rights reserved. No part of this work may be reproduced or used in any form or by any means--graphic, electronic, or mechanical, including photocopying or information storage and retrieval systems--without written permission from the copyright holder.

Printed in Hong Kong
ISBN: 0-88740-877-X

Page 2 CIP

Library of Congress Cataloging-in-Publication Data

Schneider, Mike.
 California potteries : the complete book : with price guide
/ Mike Schneider.
 p. cm.
 ISBN 0-88740-877-X
 1. Pottery figures--California--Catalogs. 2. Pottery, Ameri-
can--California--Catalogs. 3. Pottery--20th century--Califor-
nia--Catalogs. I. Title.
NK4660.S354 1995
738.8'2'09794075--dc20 95-24288
 CIP

Gay ninety bar figure, 9-1/2 inches high and unmarked, was made by Brayton-Laguna, currently one of the more popular of California's numerous potteries. Estimated value: $100. *Oravitz Collection.*

Title page

The *Nancy* planter, marketed by Walter Wilson, typifies California figural pottery from the 1930s to the 1960s. The piece is 9 inches high, marked "Nancy / by / Walter Wilson" in black glaze on three lines (see page 224). Estimated value: $20. *Private Collection.*

Dedication

This book is dedicated, posthumously, to Ted Royce, one of the few people I have met who made my life richer just by the fact that he lived, and I was lucky enough to have known him.

DeLee Art was a prolific California pottery that made quality figurines and planters. Here the outside planters stand 7-1/2 inches high, while the piece in the middle, also a planter, is 8 inches. In addition to the *Ranchita* paper label, the girl on the right carries a DeLee Art paper label (see page 85), and an impressed mark, "DeLee Art / © LA / Hollywood" on three lines. Originally, the boy probably had a name, too. Currently, however, he has only a DeLee paper label and two impressed marks, "DeLee / Art" on two lines, and "© / 12 / LA" on three lines. The girl on the left is not marked, a common occurrence with DeLee. Estimated value: left and right $16 each, middle $22. *Oravitz Collection.*

Acknowledgments

Richard and Susan Oravitz provided the majority of the pieces that appear in the book. As you might imagine after leafing through its pages, their house is a virtual fantasyland of California pottery, a wonderous place that most of us will duplicate only in our dreams. The Oravitzs also have the knowledge to go with the collection, and that made my job much easier than it ever would have been without them. Besides the pictures, and the information, they always give me something that is much more important, an infectious enthusiasm about collecting pottery, about its beauty, significance, and charm. That makes me want to continue writing books about it forever. I doubt if any writer could look at pottery with Richard and Susan very long before starting to think, "Yes, there probably should be a book on that."

Betty and Floyd Carson have that same kind of enthusiasm and knowledge. As always, they opened their home and their computer-like memories to us, allowed us to photograph anything we wanted, and answered all of the questions we asked.

Both Louise Lovick and Barbara Graettinger brought pieces to the Medina Antique Show for us to photograph, each of them helping to make the book a bit better.

Others who contributed either pictures or information include Danny Borgis, Shirley and Leonard Graff, Allen and Michelle Naylor, Rick and Jan Pleska, and Katherine Finch Webb.

Cindy, my wife, accompanied me on all of the photo shoots, gathered information, ran errands and so many other things they are too numerous to list. I mention her last because she always helps me see each project through to the finish.

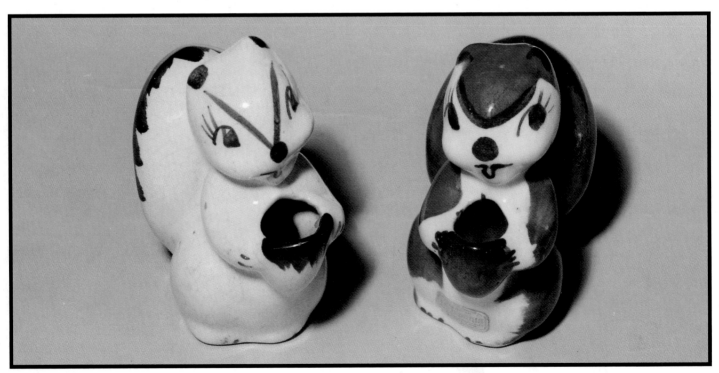

While some California potteries made fancy, delicate things, others, such as Rio Hondo of El Monte, opted for the plain and simple approach to ceramics. These Rio Hondo squirrel planter/bud vase/toothpicks are 3-3/4 inches high. A close-up of a Rio Hondo paper label, as seen on the green squirrel here, appears on page 183. Estimated value: $5 each. *Oravitz Collection.*

Author's Note

Some of the names of pieces shown in this book appear in *italics*, while others are set in standard type. A name written in *italics* signifies that the company that made the piece used that name to identify it. This information was gleaned from marks, paper labels, catalogs, or other references. In a few cases *italics* have been used for the blatantly obvious without consulting any of the above references. For example, the Brad Keeler *Little Red Riding Hood*, on page 36.

I would encourage collectors to use the *italicized* names as much as possible when talking about their collections, and especially when buying or selling sight unseen, as when doing business via telephone, FAX, computer, or mail.

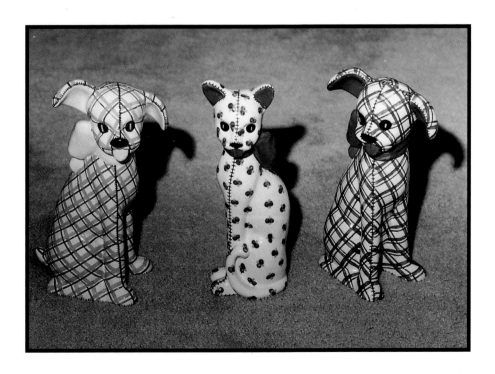

Two *Fireside Gingham Dogs* and a *Fireside Calico Cat*. When the names are in *italics* it means the names were used by the company. In this case they were used in Brayton's 1948 wholesale catalog. Other places in the book the names may have come from sales sheets, or from marks on the pieces themselves. All three pieces are 14-1/2 inches high. All are unmarked. Estimated value: $175 each. *Carson Collection*.

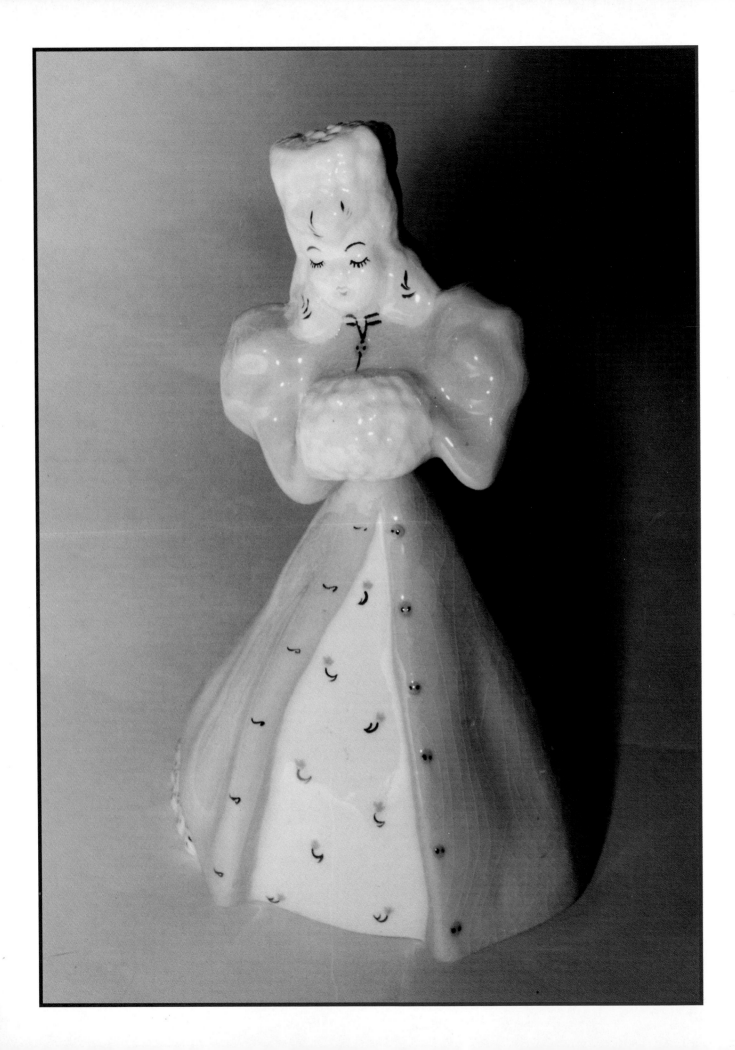

Contents

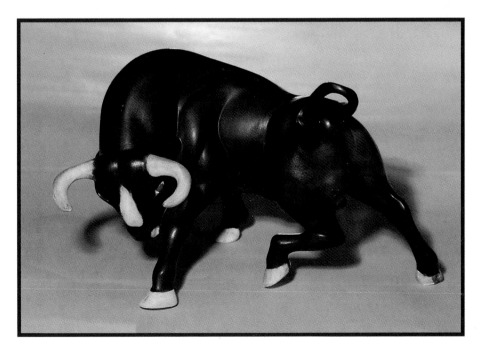

Opposite page:
Modglin's, a company about which little is known, made some of California's best pottery. This 9-1/2 inch high figurine is inkstamped "Modglin's / Original / Los Angeles" on three lines. Estimated value: $40. *Oravitz Collection.*

Above:
See page 61 for information about this Brayton-Laguna bull.

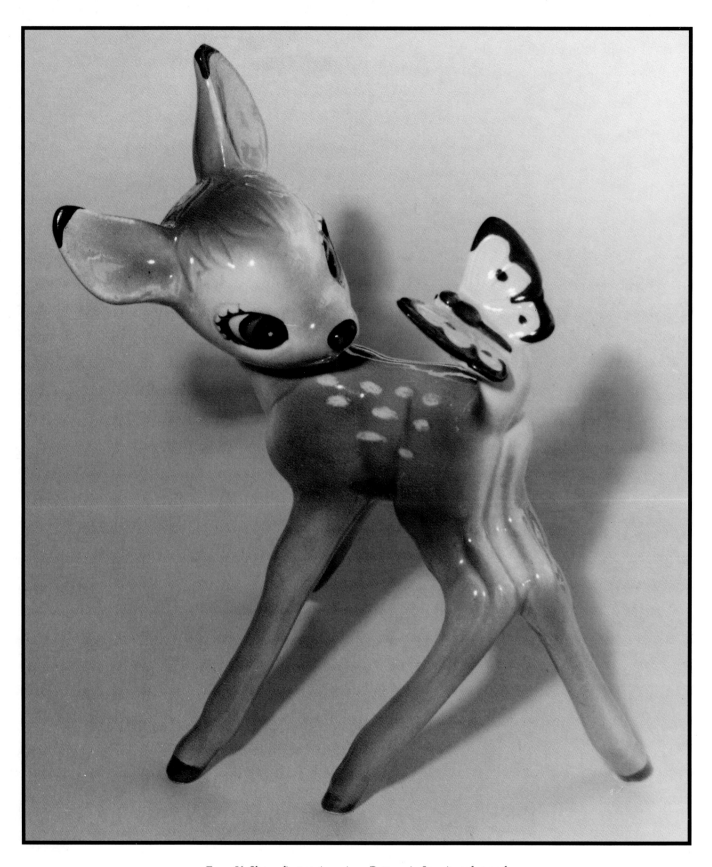

Evan K. Shaw, first at American Pottery in Los Angeles and
later at Metlox in Manhattan Beach, made some of the best
Disney figures ever produced anywhere. Marked only by a
long-gone paper label, *Bambi* stands 8-1/2 inches high. (*Faline*,
with blue eyes instead of brown, is shown on page 22.)
Estimated value: $150. *Private Collection.*

Introduction

Long overlooked, undervalued and unappreciated, California figural pottery might aptly be called the last frontier of mid-twentieth century American ceramics. The manufacturers of our country's other pottery hotbeds of the 1930s through the 1960s, basically the East and Midwest, have been fairly well covered by authors and actively sought by collectors. But California's potteries, for the most part, have received little attention from either.

That's unfortunate.

The Golden State's kilns, most of which were centered in and around Los Angeles, fired some wonderful creations during the middle years of the century, a period extending roughly from the early part of the Depression to the beginning of the Vietnam War. Considered merely collectibles today, there seems little doubt that given a bit more longevity their original designs and attractive, often meticulous, decoration will eventually elevate them to the status of true art pottery.

Consider the 1940s. During that decade legendary potteries such as Rookwood and Weller, their earlier creative fires all but extinguished, appeared content to hang on by turning out tired Deco designs in boring solid colors. Upstarts such as Royal Copley and Shawnee found commercial success by airbrushing their wares into every five-and-dime in the nation. But California's potteries relied on a different tactic. In the trend setting manner for which the state is known, they blazed a new trail across the pottery frontier, and it took them straight to Macy's, Bullock's and other upscale department stores. Collectively they had a fresh approach to style, glazes and decoration, the likes of which had never been seen before.

A good example might be the pair of Hedi Schoop oriental planters. Typical of Schoop's style, their faces exhibit only minimal detail, their hands none. But their clothing is exquisite. From the very natural billowing of their silk shirts to the graphically perfect stencilled dragons on their chests, the figures basically look like a pair of fashion store mannequins whose only purpose is to serve as a

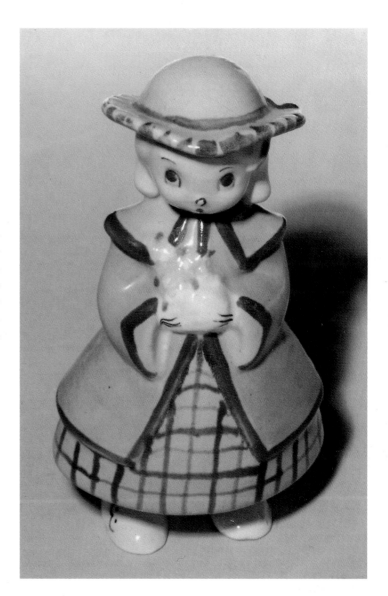

One of Brayton Laguna's most popular lines was the children series. This is *Miranda,* 7 inches high, unmarked, and made of flesh color bisque. Although none of the kids could be considered common, *Miranda* is the one seen most often. Estimated value: $45. *Oravitz Collection.*

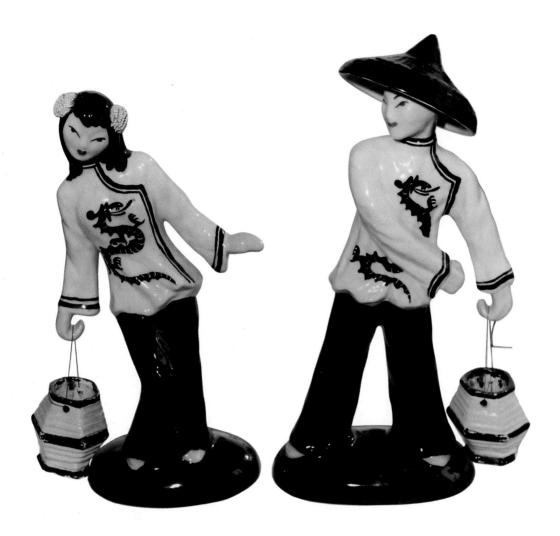

With examples such as these mannequin-like oriental people, European-born Hedi Schoop introduced a new style of design that was quickly copied by other California ceramists. The figure on the left is 11-3/4 inches high, the one on the right 12-3/4. They are marked, "Hedi Schoop / Hollywood Cal." in brown glaze on two lines. Estimated value: $90 per pair. *Oravitz Collection.*

frame on which to drape their beautiful clothing. The same is true of nearly all Hedi Schoop figural pieces. Why? Because before Schoop escaped from Germany early in the Nazi era she had already studied fashion design, along with sculpture, at several European art institutes, and career-wise was pursuing threatical ambitions. Later, when she went into the pottery business in North Hollywood, her creativity evolved from that background. Schoop's mannequin type figurines were as fresh an approach to mass produced ceramics in the 1940s as Picasso's cubism had been to fine art approximately 30 years earlier. Her's was a pioneering, trend-setting change that caught the eye of an appreciative public.

But Hedi Schoop was just one of numerous Cali-

fornia ceramists who raced to prosperity by offering consumers a change of pace from the eastern potteries' wares. Evan K. Shaw, Durlin and Webb Brayton, Kay Finch and a host of others defiantly cast off the self-imposed restraints of the pottery establishment that had long choked creativity. Unencumbered, they poured new life into their vocation and revived a dying industry.

Another reason California's potteries deserve more attention is the sheer number of them that existed. During the period this book covers, which is roughly from the early 1930s through the mid-1960s, there were probably more potteries in California alone than in Ohio, Pennsylvania and New Jersey combined. According to Jack Chipman in *The*

In the California of the 1930s and 1940s Walt Disney brought fantasy to the silver screen while Kay Finch brought it to ceramics. These fanciful pigs, *Grumpy* on the left and *Smiley* on the right, stand 6 and 6-3/4 inches high, respectively. Both have inkstamp marks, "Kay Finch / California." Estimated value: $95 each. *Oravitz Collection.*

Collector's Encyclopedia of California Pottery (Collector Books, 1992), in 1948 there were in excess of 800 potteries up and running in that one state. That's a staggering number. Perhaps even more staggering (and shameful) is that today most collectors of American art pottery would be hard pressed to name even ten of them.

But, while the general lack of knowledge about this potential ceramic smorgasbord may seem appalling at first, it is not altogether bad. The plus side is that the work of many of the better but lesser known California potteries can be had for what, relatively speaking, would have to be called pocket change when compared to the prices paid for examples made by more readily recognized firms. For instance, many of the rather plain 1940s Rookwood pieces referred to earlier sell in the $200 to $500 price range. But the pair of Hedi Schoop oriental planters shown would probably run only $80 to $100. And that's from a knowledgeable dealer. I have seen comparable sets at antique shows recently that were tagged as little as $25.

So the good news is that the great majority of California pottery is right where most collectors would like the object of their pursuit to be: unique in style and high in quality, though still affordable. But you better get out and start searching for it now because as more and more people begin to appreciate California pottery the law of supply and demand will not allow prices to remain low forever.

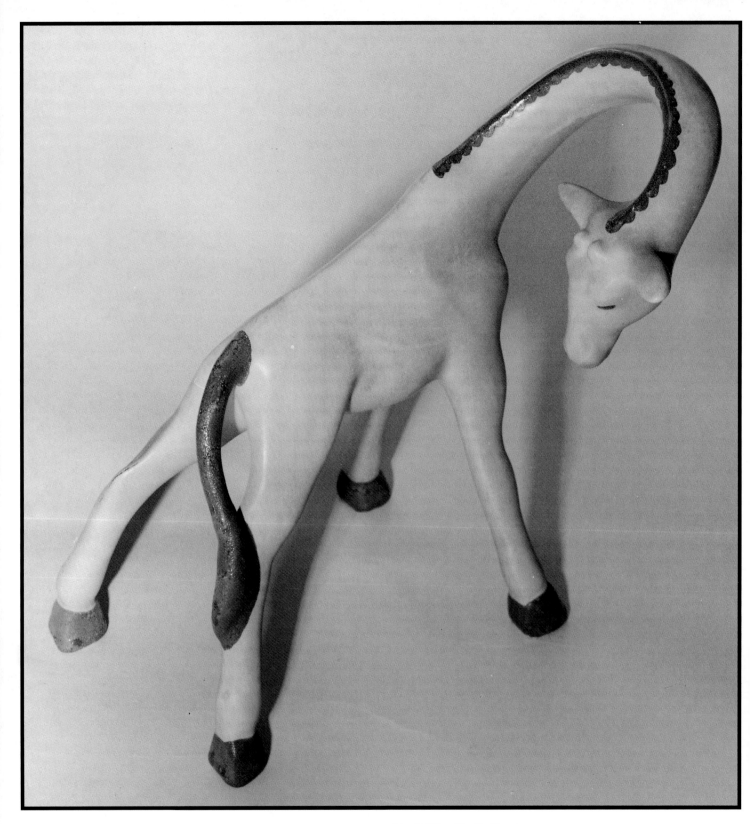

While Brayton Laguna was started in 1927 by Durlin Brayton, it wasn't until 1936, when Brayton married Ellen Webster Grieve, that the pottery made the switch from mainly dinner and utility wares to mainly figural ware. Then it made some strange looking but artistically pleasing animals such as this giraffe, which is 9-1/2 inches high and unmarked. The mate for this animal stands straight up. In Brayton's 1957 catalog, where the pair sold for $17.50, this one is shown with its neck around the neck of the other. Estimated value: single $60, pair $120. *Oravitz Collection.*

Chapter 1
The California Pottery Movement

Pinpointing the beginning of the California pottery movement is a subject capable of generating endless debate. Some would say it began in 1909 when former Kentuckian, J.A. Bauer, opened his new pottery in Los Angeles. Others might peg the beginning to 1875, as that was the year Charles Gladding, Peter McBean and George Chambers cranked up a plant in Lincoln to manufacture brick, roofing tile and other building materials, that eventually transformed itself into the now famous dinnerware concern that produced the perennially popular Franciscan Ware. And still others would go back to historic or prehistoric native Americans who found California's clays to their liking, even if they did not use them as extensively as Indians in other parts of the the country used their local clays.

For the purposes of this book on California *figural* pottery, however, 1934 seems like a good starting point. It was that year that two young men, brothers Will and George Climes, began a rudimentary ceramics operation in the former's garage in Los Angeles. While other potteries covered may have begun several years earlier—Brayton Laguna, for example, in 1927, and Metlox in 1922—their operations remained largely non-figural until the late 1930s. The Climes, on the other hand, delved into figural pottery at the very beginning of their venture, which came to be known first as Will-George, later The Claysmiths.

But right now 1934 cannot be viewed as a hard and fast date to represent the beginning of the movement. It is an arbitrary date, perhaps even a temporary one, because so little is known about California pottery. The ceramic plants of the Golden State, unlike the potteries of New Jersey, Pennsylvania, Ohio and other eastern states, have not been researched to any great extent. In many cases we know only the name of the pottery and the city in which it was located. And in some instances just the name is known. Consequently, some potteries about which there is little information may have been specializing in figural pieces prior to Will-George. De Lee Art, for instance, appears to have been well entrenched in the production of figural ceramic artware by the late 1930s, but at this time all we know is that De Lee was located in Los Angeles, remained in business at least into the 1950s, and scattered a tremendous number of figurines and planters across the country during the time it was active. Could owners Delores and Lee Mitchell have started it in the very early 1930s or even the late 1920s? The best answer available at the time of this writing is "Perhaps." And there are a multitude of similar questions, all with similar answers, about a multitude of other potteries.

Using 1934 as a beginning point, it must be noted that the California pottery movement did not enjoy a shotgun start. The real stampede began a few years later when people such as Brad Keeler, the McCarty Brothers, Doc and Georgia Fields (Roselane) and many more founded their figural potteries, and others such as Durlin and Webb Brayton, and Willis Prouty (Metlox), shifted emphasis, either partially or fully, and took a more creative approach than they had before.

When World War II hit the controlled stampede turned to utter chaos as potteries in California proliferated like bureaucrats in Washington. The armed forces drafted young men into service to meet the challenges of Japan and Germany; giftware buyers drafted fledgling potteries into service to meet the challenges of disintegrated Asian and European supply sources. Almost overnight hundreds of potteries sprang up in California, their initial success assured by the lack of foreign competition.

These 800+ potteries appear to have operated on three levels. The bottom level, which included the bulk, were small part-time businesses activated one or more times a year to participate in local art festivals and craft shows. They were kitchen table operations, so to speak. This seems apparent because of the many marks that are so seldom seen.

The middle level would have included both full and part-time operations, whose products were also sold at art festivals and craft shows, but whose main

source of revenue most likely came from the always strong California tourist trade. Small potteries in the first group may well have participated in the tourist trade to a limited extent by selling their wares in giftshops located along federal and state highways. But only the more moderately sized operations of the second group could keep up with orders from destination merchants, whose demand for souvenirs was always greatest. Marks of this second level of potteries are seen quite often.

The highest level, a comparative handful of companies, would have been the full-blown commercial potteries, those that set up or employed nationwide distribution systems to get their products into gift and department stores, and mail order catalogs, throughout the country. This would include the potteries whose marks are seen in profusion such as California Originals, Robert Simmons and Twin Winton.

The end of the war signalled the beginning of the demise of most of the California potteries. Even though their numbers would continue to increase for at least another three years, California's potteries, as well as those of every other state, fell victim to the whims of politicians both here and abroad. At the beginning of its rebuilding effort Japan chose to focus on its ceramics industry. That was a very logical decision considering that the main material, clay, was widely available and practically free, and the technology was simple and age old. Given Japan's low wages at the time, pottery was a sure winner, assuming that a market could be found. It could, and Washington provided it. Our politicians passively showed favor for Japan's potters over America's by steadfastly refusing to offer any protection through tariffs or import quotas, which in effect put the entire industry on the skids.

But a funny thing happened on the way to the bankruptcy. Unlike potteries in other parts of the country which often lowered their standards and put out cheaper products in order to compete, California's potters, overall, refused to compromise quality. Many of those that did remain in business into the 1950s and 1960s still turned out pieces that were equal to those they produced in the 1930s and 1940s.

Quality in the beginning, in the middle, and at the end. Isn't that just what you would expect from potteries in a state that the rest of the country often associates with uncoventional attitudes.

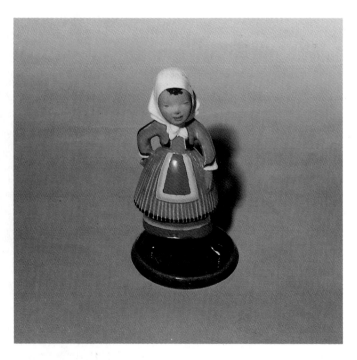

Will and George Climes were two of the earliest pioneers of California's figural pottery industry that began in the 1930s. Working out of a Los Angeles garage they began making figural pottery as early as 1934. This figurine, 5-1/2 inches high, is incised "Will-George / Made in U.S.A." on two lines. Estimated value: $45. *Oravitz Collection.*

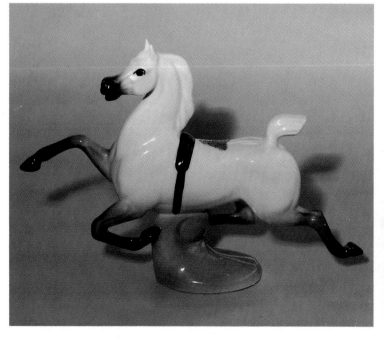

Metlox made this 8 x 11 inch "Currier & Ives" horse, which has both Metlox and Poppytrail paper labels. It was also finished in black glaze with gold trim, and possibly other colors. Metlox was founded in 1922 but did not jump on the figural pottery bandwagon until the mid- to late-1930s. Estimated value: $85. *Private Collection.*

Like Brad Keeler, McCarty Brothers Pottery was another that came along at the right time. Beginning their operation in Sierra Madre in 1941, the quality of Lee and Michael McCarty's work, combined with the bombing of Pearl Harbor later that year, guaranteed their success. Cheap imports following World War II, especially imitations of this particular planter, forced them out of business by 1952. The Oriental planter, by far their most popular, stands 7 inches high. It has a typical impressed McCarty Brothers mark similar to the one shown on page 167. Estimated value: $10. *Oravitz Collection.*

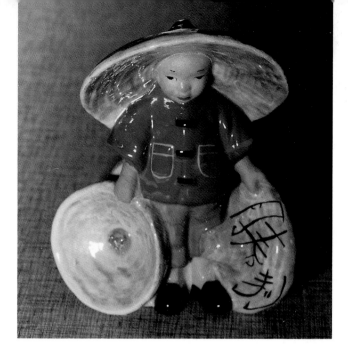

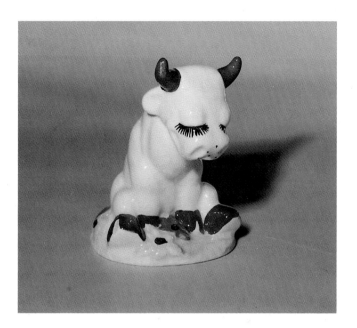

This 5-1/2 inch high cow figurine has the earliest DeLee mark I have seen, "DeLee Art / © 1938" impressed on two lines, but the company may have been in business earlier than that. Estimated value: $28. *Oravitz Collection.*

Jessie Grimes may have been one of the bottom or middle level potteries referred to in the text, possibly a part-time operation in a kitchen or basement that did work to sell at arts and craft shows, and souvenir shops. This unmarked boy figurine, 5-3/4 inches high, is shown with a marked female companion on page 133. Estimated value: $16. *Oravitz Collection.*

Brad Keeler set up a small ceramics operation in his parents' garage in Glendale in 1939, just at the time the true impact of California pottery was beginning to be felt in the giftware business across the nation. Later Keeler leased space from Evan K. Shaw at American Pottery, then built his own facility when American burned down. This bird is 11 inches high, marked "Brad / Keeler / no. 30" by impression. Estimated value: $55. *Oravitz Collection.*

Just like California Originals, Twin Winton was a large operation known mainly for cookie jars, but also did other things of interest. This raccoon, 2-1/2 x 4-1/2, fits nicely with a pair shown on page 219. It is marked "C132 / Winton" on two lines. The squirrel, which measures 4-1/8 x 7-1/4, is the largest Twin Winton animal figurine I have personally seen, but I suspect they made larger ones. It is marked "#81," and "Winton," both marks in ink. Estimated value: raccoon $15, Squirrel $38. *Oravitz Collection.*

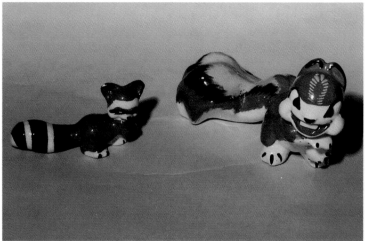

Robert Simmons Pottery, of Los Angeles, was at the opposite end of the spectrum from Jessie Grimes. Simmons worked on a high volume basis and distributed its products nationwide. The dog, *King,* is 6-3/4 x 10-1/2 inches. It carries a silver paper label, "Ceramic / Artware / Robert / Simmons / Los Angeles," a likeness of which is shown on page 190. Estimated value: $28. *Private Collection.*

California Originals was another of the big time potteries that dotted the southern California cityscape. Known chiefly for its cookie jars it also made animal figures. Standing 6 inches high, the elephant is unmarked except for its humongous paper label which measures 1-1/2 x 2-7/8 inches. A red version of this elephant is shown on page 71. Estimated value: $15. *Private Collection.*

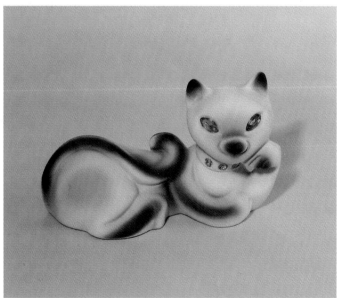

Beginning in their own home in Pasadena in 1938, Doc and Georgia Fields were forced into a factory environment within two years due to the strong demand for their Roselane Pottery products. The Roselane Sparkler line, which was initiated much later, was one of the company's most popular. Roselane experienced the same problem as the McCarty Brothers and many other California potteries when Japanese potteries, in cahoots with American importers, copied the Sparklers unmercifully. (See page 204 for a couple examples). Unlike many others, however, this company survived the challenge and operated until Georgia Fields sold it shortly after the death of her husband in 1973. The cat measures 3-3/4 x 6-1/4 inches. It is marked with an impressed "101 / USA" on two lines on one part of the bottom, and "© / Roselane-Calif." impressed on two lines on another part. Estimated value: $18. *Private Collection.*

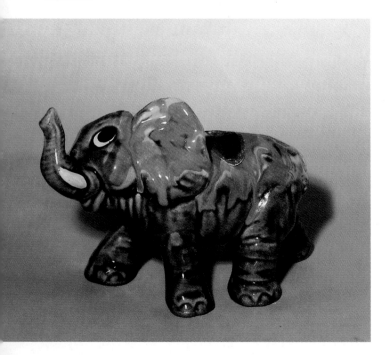

Chapter 2
Identification of California Pottery

Identification of California figural pottery can be challenging. Much of it was marked only with paper labels, and the vast majority of those labels are no longer attached to the pieces. In addition, many of the pieces that are permanently marked were made by companies that are so obscure it is unknown for certain whether they were actually based in California. Also, there were a number of copycat potteries in other parts of the country—sometimes in other countries altogether—that were not above imitating the style and designs of their hot selling competitors on the West Coast.

All those things considered, it is still my personal opinion that collectors should take a different point of view when identifying California pottery than when identifying other domestic ceramic wares of the mid-twentieth century. Simply put, if a piece appears to be from California it should be considered so until proven otherwise. In other words, if a piece has all of the signs pointing to a California origin, include it in your collection, then continue to search for a similar piece bearing a mark or paper label to verify your suspicion or to prove it false.

What are all those signs that would point to it being California pottery? They are in a broad range of things because they are different for different potteries.

How about weight? Can that tell us? A common misconception is that California pottery is lighter in weight than pottery from other states. But if you pick up a piece of De Lee, Brayton or Brad Keeler you will find it to be comparable to most other domestic pottery from the same era. On the other hand, Will-George made some of the lightest pottery ever produced in the United States. Not a cheap light, as has sometimes been imported from Pacific-Asian countries, but a fine, high quality light similar to Irish Belleek. Even more confusing is that some potteries' wares were cast both light and heavy. Hedi Schoop is a prime example. Some Schoop pieces seem almost light enough to drift away on the slightest breeze. Other pieces are so heavy they probably couldn't be moved by a hurricane.

What about decoration? Here again, it varies from pottery to pottery. Some decoration, such as Florence or Kay Finch, is very distinctive and can be spotted from a long distance. Others, such as L & F Ceramics, could easily hide on a table full of McCoy.

Sometimes distinctive decoration on certain lines of California pottery jump out at you from quite a distance. Once familiar with Florence Ceramics and the many wonderful things they did, one would have a hard time missing this 6-7/8 inch high figurine, even if it didn't have the standard Florence inkstamp shown on page 101. Estimated value: $65. *Oravitz Collection.*

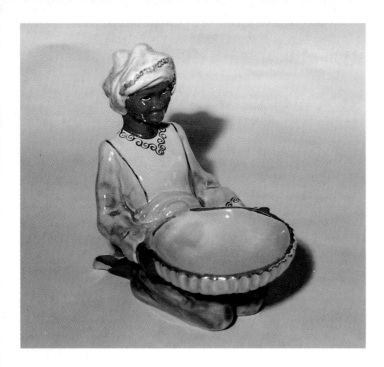

While many people have a misconception that California pottery is light in weight, that is not the case most of the time. This blackamoor, 8 inches high and inkstamped "Brayton / Calif. / USA" on three lines, is equal in weight to similarly sized pieces of Shawnee, Royal Copley, and other eastern potteries of the same era. Estimated value: $45. *Private Collection.*

Some Hedi Schoop items are quite heavy while others are quite light. Overall I guess I would classify it as medium in weight. This candleholder stands 8 inches high. It is marked "Hedi Schoop" in brown glaze on one line. Estimated value: $35. *Oravitz Collection.*

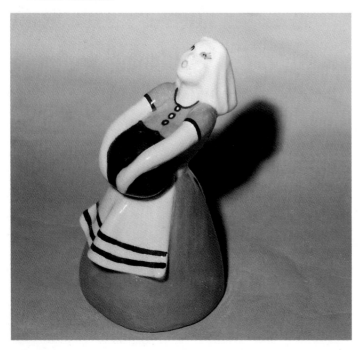

Style and design? These are two more factors that vary greatly. While after a little familiarity it would be hard to miss a planter made by The California Cleminsons, you might (as I have) pass right by a piece of Brayton Laguna or Robert Simmons, and never recognize it.

What it amounts to is that familiar old word, familiarity. Cruise the aisles at flea markets and antique shows looking for California pottery. Check out antique malls and shops. Go shopping even during those tight weeks when all of the monthly bills are due and you have little or no money to spend. Knowledge is free to those who pursue it; the least you will do is learn something. And who knows, you might find a grossly underpriced and affordable treasure.

Books are great learning tools. Study and restudy the pictures in this book, in Chipman's *Collector's Encyclopedia of California Pottery*, and in any other book you can get your hands on. My two kitchen artware books, *The Complete Cookie Jar Book* and *The Complete Salt and Pepper Shaker Book*, both have some wonderful examples of California pottery. So does *Collectible Vernon Kilns*, by Maxine Feek Nelson and *The World of Headvase Planters*, by Mike Posgay and Ian Warner. If your library has any of these, or other books that show California pottery, check them out and peruse their pages with a careful eye.

Eventually you will automatically know a piece of California pottery as soon as you see it. You might not be able to define why you know it is California, because recognition here is as much a sense as it is a science. But with a little practice you will find that sense to be accurate about nine out of ten times.

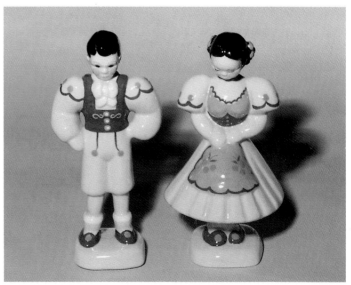

Kay Finch's normal style of decoration identified her figurines as positively as a rancher's brand identified his cattle. The *Peasant Boy* and *Girl*, 7 and 6-3/4 inches high, respectively, though unmarked cannot be missed. Estimated value: $25 each. *Oravitz Collection.*

Figurine, Planter or Flower Holder?

One of the reasons for the success of California's figural potteries as a group was that their owners and modellers were often clever enough to design their wares so the same piece would fit the needs or desires of two or more groups of consumers. Specifically, they made planters and flower holders that could be used as figurines, or figurines that could be used as planters or flower holders, depending upon which way you choose to view it.

Look at the pair of pictures below from two of my recent books, *Stangl and Pennsbury Birds* and *Royal Copley*. The Stangl *Bird of Paradise* figurine is exactly that, a figurine. It can be used as nothing else. All of Stangl's famous bird figurines from its Birds of America series were figurines only. They served no other purpose than to decorate or collect. The Royal Copley piece is a planter, nothing else. It can be used quite well as a planter, but that is all. So both the Stangl and the Royal Copley pieces here are severely limited not only in application, but also in commercial appeal.

But that's not the case with many of California's potteries' products. For example, the Brayton Laguna *Sally*. The inclusion of the small hole at the top of the figure's apron allows the *Sally* to serve double, or even triple, duty. The piece makes an attractive figurine. It can also be used as a bud vase to hold a cut flower or two from the summer garden. Or it could sit on the stove or kitchen counter where it would provide attractive storage for a couple wooden spoons, wisks, or spatulas. Small wonder that of all the different Brayton products that were made in its 36 year history, the *Sally* is the one you see the most often.

This planter-flower holder-figurine question sometimes causes collectors mild confusion. Which one are they buying? My response is, don't let it bother you. If you fancy yourself a figurine collector and see something you like but are not sure whether it really qualifies as a figurine because it has a small hole in it to hold a flower stem, buy it and enjoy it. On the other hand, if figural planters are your pas-

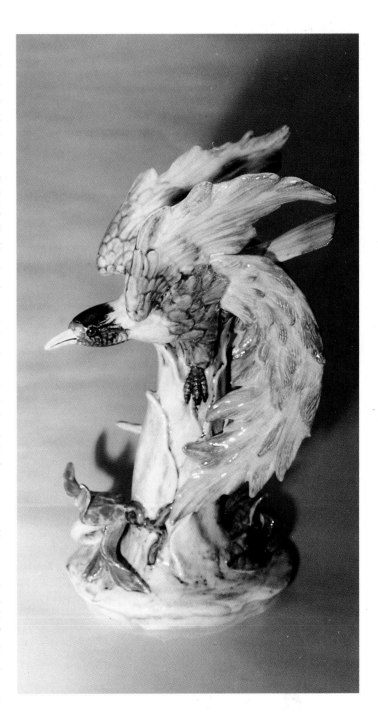

This Stangl Pottery *Bird of Paradise* figurine is exactly that, a figurine. Standing 13-3/4 inches high, it has no versatility, no second purpose.

sion but you are unsure if any botanical matter could really fit into that tiny opening, put down your money, take the piece home, admire and enjoy it. After all, it's what it looks like, not what is was made for, that should be of greatest concern to you.

A Royal Copley *Floral Arrangement Planter,* 3-1/2 inches high. It's good as a planter, but that's about it.

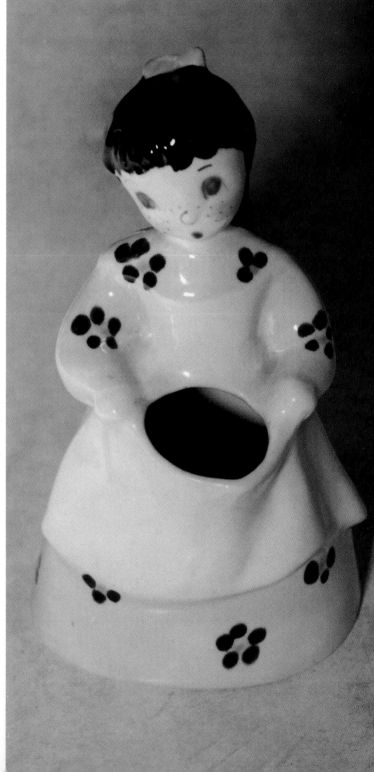

Unlike the Stangl and Royal Copley pieces, this Brayton *Sally,* with a small hole in the front, can serve as either a figurine or a bud vase, depending upon how the owner can best use it at the time. Exactly who came up with this concept to increase versatility is not known. What is known is that, once it was thrown into the public domain, the idea spread like wildfire throughout southern California, but curiously, not necessarily to the rest of the country. The *Sally* stands 7 inches high, is not marked. Estimated value: $16. *Oravitz Collection.*

Chapter 4
The Companies and Their Wares

American Pottery Company (Evan K. Shaw)

The American Pottery Company was located in Los Angeles. It was owned by Evan K. Shaw. While the date it began is unknown, it must have been active by 1939 or 1940, because it was about that time that Brad Keeler's initial garage operation outgrew its bounds and he leased space in Shaw's factory. Regardless of when it was started, by July 22, 1942, American Pottery had been in business long enough to be turning out excellent work or Walt Disney Productions never would have allowed Vernon Kilns to assign to American its rights, along with molds and inventory, to manufacture figurines and other pieces based on Disney's now classic but then unappreciated movie *Fantasia*. Shaw was granted his own license by Disney in 1945, and most sources agree that his contract with the entertainment giant lasted until 1955.

Here is *Bambi* looking back over his right shoulder. *Bambi* looking back over his left shoulder is pictured on page 8. This one is 8 inches high and unmarked. It is also rarer than the other one. Estimated value: $165. *Oravitz Collection.*

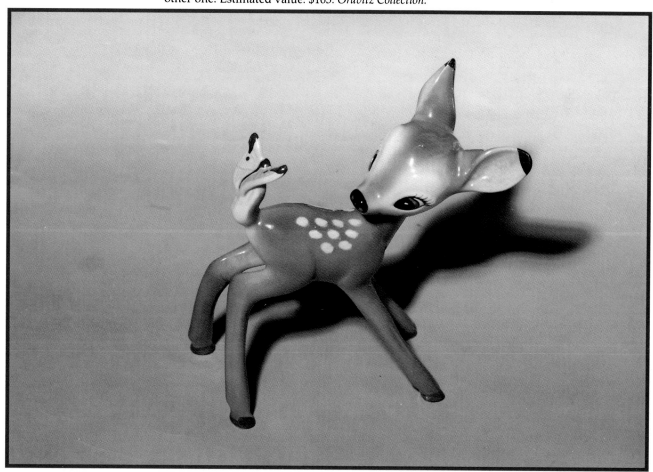

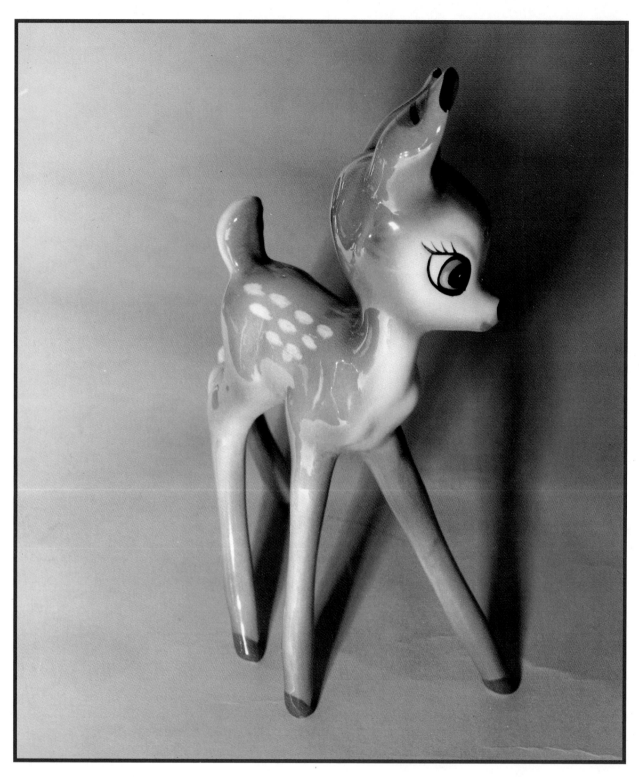

Many people mistake unmarked versions of this deer for *Bambi*, but it's actually *Faline*, *Bambi's* girlfriend. *Faline* stands 8-5/8 inches. Note that *Faline* has blue eyes while *Bambi* has brown eyes. Look closely at the back of her right ear and you will glimpse part of a paper label. It reads "© Walt Disney / Faline / American Pottery / Los Angeles" on four lines. Altogether Shaw made nine different *Bambi* or *Faline* figurines, plus a couple miniatures. Estimated value: $175. *Oravitz Collection.*

The *Bambi* and *Faline* figures shown are typical of Shaw's excellent work. But when it comes to positively stating where they were made, the picture gets a little murky. Fire destroyed the American Pottery Company plant in 1946. Shaw purchased Metlox Potteries, in Manhattan Beach, in 1947. While most of the output there was designated Metlox or Poppytrail, Shaw continued manufacturing Disney items at Manhattan Beach with either Evan K. Shaw or American

Left to right we have *Thumper, Thumper as a youngster*, and *Thumper's girlfriend*. Heights are 4-1/4, 3 and 4 inches. *Thumper's girlfriend* has a remnant of a Shaw paper label. The other two are unmarked. Estimated value: left to right $75, $85, $85. *Oravitz Collection*.

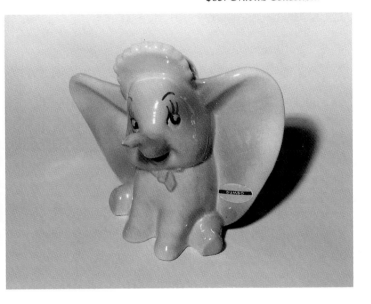

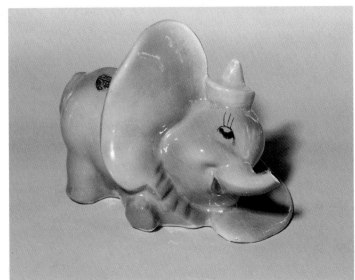

Dumbo is 5-1/2 inches high, carries a paper label that says "© Walt Disney / Dumbo / American Pottery / Los Angeles," on four lines. Estimated value: $110. *Oravitz Collection*.

An unmarked *Dumbo* with a broken trunk. It stands 4-1/2 inches high. The plastic shield attached to its back indicates it was a souvenir of Camp Bowie, Texas. Estimated value: $110 in good condition. *Oravitz Collection*.

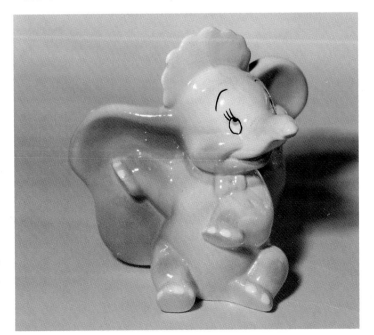

A third *Dumbo*, 5-1/2 inches high, unmarked. All three of these *Dumbo* pieces were also made by Vernon Kilns. According to Tom Tumbusch in *Tomart's Illustrated Disneyana Catalog and Price Guide* (Tomart Publications, 1987) the Vernon Kilns *Dumbos* generally have both glaze and a company mark on the bottom, while the Shaw pieces usually have neither. Estimated value: $110. *Oravitz Collection*.

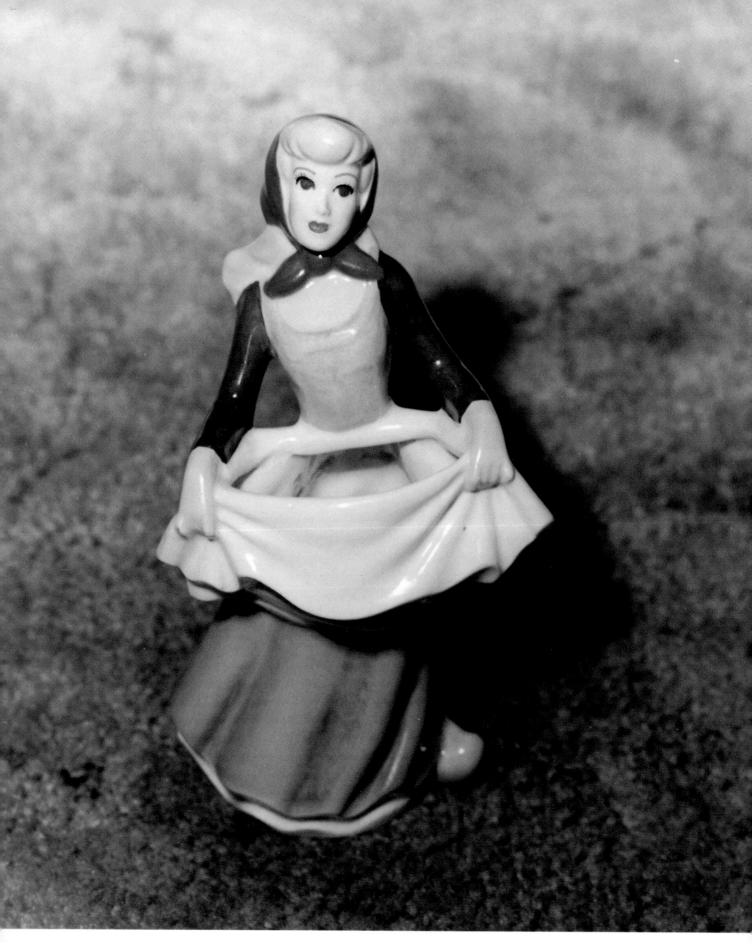

Cinderella in rags, 7-3/8 inches high, unmarked. Estimated value: $375. *Courtesy of Allen and Michelle Naylor.*

Pottery Company paper labels, presumably until 1955. (Sometimes 1956 is quoted as the ending date.) Since *Bambi* first appeared on the silver screen in 1942, four years before American Pottery burned, the figures may have been made by either company.

Other items, such as the two *Cinderella* planters, can be accurately attributed. The movie *Cinderella* debuted in 1950, several years after the fire, so all of the Shaw *Cinderella* figurals were made at Metlox.

Shaw died in 1980. Metlox continued on under the guidance his son-in-law, Kenneth Avery. Shaw's daughter, Melinda Avery, took over in 1988. Metlox went out of business in 1989.

Remnant of *Cinderella's* paper label.

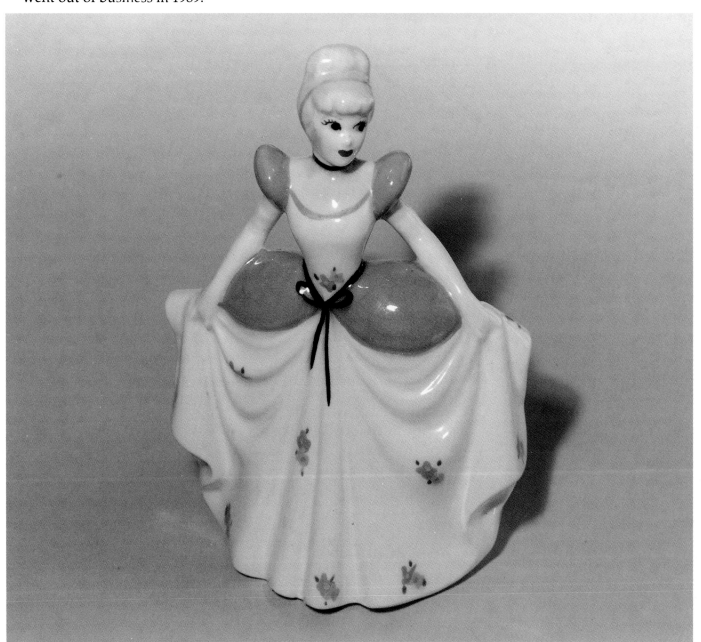

Cinderella after her makeover. Height of the unmarked planter is 7-1/4 inches. Its paper label reads "© Walt Disney / Productions / Evan K. Shaw / Los Angeles" on four lines. Estimated value $275. *Oravitz Collection.*

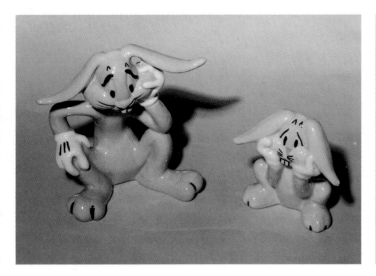

A couple of American Pottery Company *Bugs Bunnies*. Height on the left is 5-7/8 inches. The figurine has "no. 19" impressed in the bottom and "H" in ink. The 4-inch high figure on the right is unmarked save for an "S" in ink. Estimated value: left $95, right $80. *Oravitz Collection.*

Elmer Fudd stands 4-1/8 inches high. Only mark is "a" in ink. Estimated value: $60. *Oravitz Collection.*

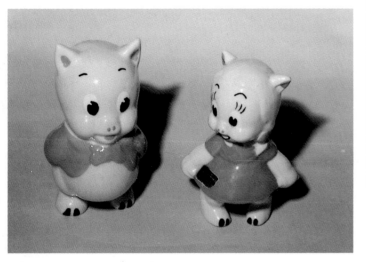

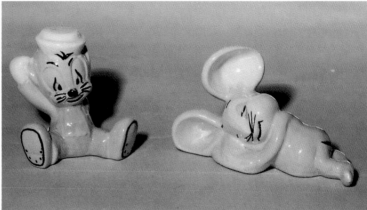

Porky and *Petunia Pig*, 5-3/4 and 5-1/4 inches high, respectively. Both are unmarked although *Porky* does have a "3" written in ink on the bottom. *Petunia* has a paper label which is shown. Estimated value: $50 each. *Oravitz Collection.*

That's *Sniffles* on the left, *Rosebud* on the right. *Sniffles* is 3-1/4 inches high, unmarked. His paper label reads "Warner Bros / Cartoons / Shaw & Co / Los Angeles" on four lines. *Rosebud*, 3-1/4 x 5-1/2 inches, carries an impressed "No. 6," along with an "E" written in ink, and a paper label, "© Warner Bros / Cartoons Inc / Rosebud / Shaw & Co / Los Angeles." Estimated value: *Sniffles* $50, *Rosebud* $50. *Oravitz Collection.*

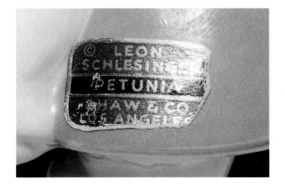

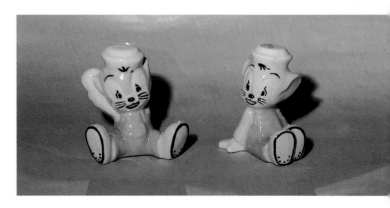

Paper label of *Petunia.* Leon Schlesinger was the producer of Warner Brothers cartoons.

Sniffles on the left is same as above. *Sniffles* on the right is the same height as the other, 3-1/2 inches. The only mark on each is a "K" in ink on the bottom. Estimated value: $50 each. *Private Collection.*

A bird figurine, 4-3/4 inches high, unmarked. Its paper label is shown below. Estimated value: $8. *Private Collection.*

American Pottery paper label of above bird figure.

This *Sniffles* planter is 4-3/4 inches high, unmarked. Estimated value: $75. *Oravitz Collection.*

Like the other bird, unmarked but one inch taller at 5-3/4 inches. Estimated value: $8. *Private Collection.*

Angee Bobbitt

Both the face and the bottom of the figurine shown below closely resemble several of those on pages 132 and 133 attributed to Jean Manley, of Pasadena, but the paper label could not be any clearer: Angee Bobbitt, Hollywood.

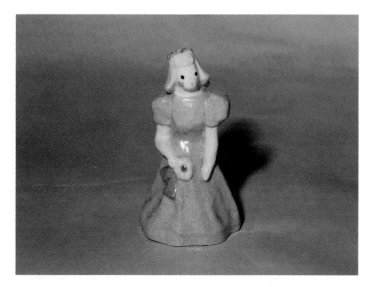

Standing 4-1/2 inches high this Angee Bobbitt figure is marked only by paper label. Estimated value: $22. *Oravitz Collection.*

Paper label of Angee Bobbitt girl.

Ball Artware. *See Ball Brothers*

Ball Brothers

Ball Brothers is apparently the same company Chipman refers to as Ball Artware, a pottery that called Inglewood home during the late 1940s. The base of the pheasant figurine Chipman shows has the same fluted edge as the base of the bird figurine shown here. No further information on Ball Brothers is available at this time.

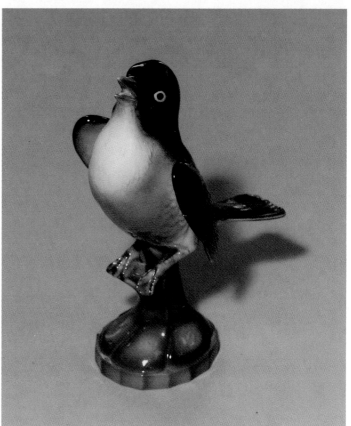

This bird is 7-1/4 inches high. Its mark is shown. Estimated value: $35. *Carson Collection.*

Mark of Ball Brothers bird.

Barnware *See Vera La Fountain Dunn*

Bea & Bill Ceramics *See California Originals*

Bernard Studios

Like so many others, this is a pottery about which little is known. As one of the paper labels shows, Bernard Studios was located in Fullerton. Most of the pieces I have seen over the years have been animals.

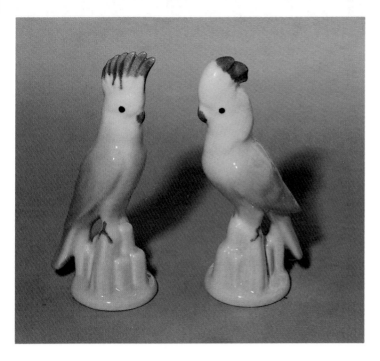

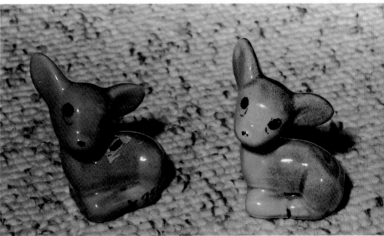

Each of these matching birds is 6-1/2 inches high. Neither is marked but the one on the left has a paper label which is shown. Estimated value: $10 each. *Private Collection.*

Another deer, 6-1/2 inches high, and unmarked. Estimated value: $8. *Oravitz Collection.*

Bernard paper label of the bird on the left.

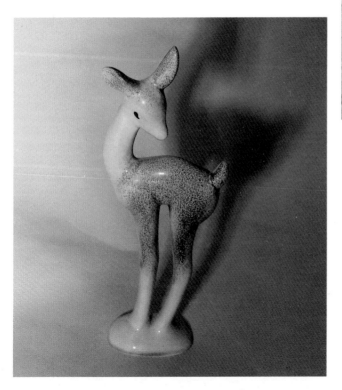

If the paper label of the deer on the left was complete, it would say the same thing as the one shown. These figurines are 4-3/8 inches high. Estimated value: $6 each. *Oravitz Collection.*

This deer stands 10-1/2 inches high. It has the same silver and black paper label as the birds. Estimated value: $15. *Private Collection.*

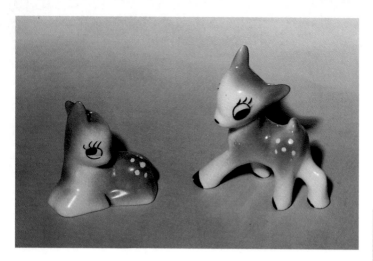

Bernard Studios liked deer, no doubt about that. These 3-1/2 and 4-3/4 inches high, left to right. One of them has a Bernard Studios paper label. Estimated value: $6 each. *Courtesy of Betty and Floyd Carson.*

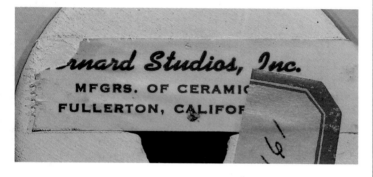

This paper label, from a pair of salt and pepper shakers not shown, places Bernard Studios in Fullerton.

Betty Lou Nichols Ceramics

Known chiefly for head vases, this firm also made other types of planters, and figurines, too. Betty Lou Nichols pottery is generally quite heavy. Keys to identification include applied hair, eyelashes and ruffles.

This may be the only pottery operation that ever started in a playhouse. According to Posgay and Warner, in 1945 when Betty Lou Nichols' husband, John, was sent overseas to fight in World War II, she went to live with her parents at 118 W. Francis St., La Habra, where she decided to go into the pottery business. An old playhouse in the backyard there held her first kiln, a one cubic foot gas fired job that could hold no more than five small pieces of pottery at once. Having studied art in high school and college, Nichols knew enough about what she was doing that Bullock's Department Store in Los Angeles felt compelled to buy her pieces, which gave her career a needed boost.

The pottery was moved to 639 West Central, La Habra, in 1949. It closed in November 1962 as a result of intense Japanese competition, which at times included copying Nichols' designs. Shortly before closing, according to Warner and Posgay, Nichols produced a line of unmarked *Fantasia* characters for Walt Disney Productions.

Betty Lou Nichols head vases were usually signed in similar fashion to the one shown, while figurines and other planters carried the "B-Lou" mark, also shown. Nearly all Betty Lou pieces incorporated the name of the piece as part of the mark.

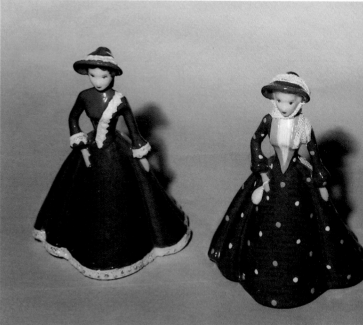

On the left is *Laurie,* on the right *Charlotte.* Each is 7-1/4 inches high. Marks are shown. Estimated value: $38 each. *Oravitz Collection.*

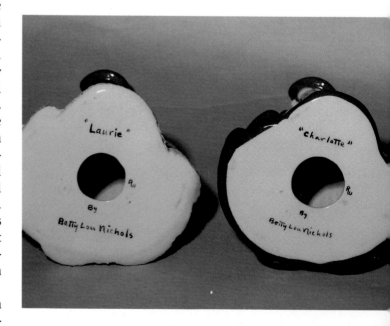

Marks of *Laurie* and *Charlotte.*

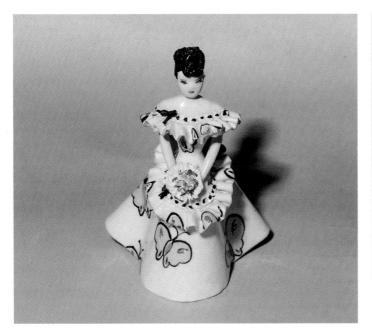

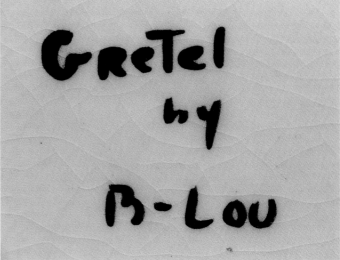

Mark of *Gretel*.

This unnamed lady stands 6-1/2 inches high. She has an open bottom and different mark, both of which are shown. Estimated value: $42. *Oravitz Collection.*

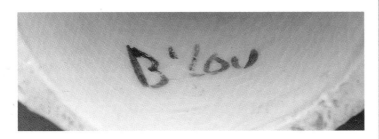

Open bottom and B'Lou mark of above figurine.

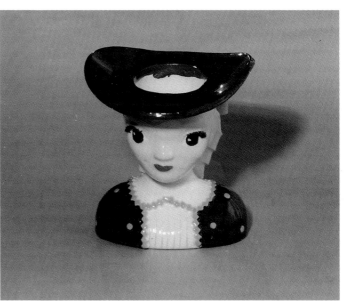

This head vase is named *Kathy*. It is 5-1/2 inches high. The mark is shown. Estimated value: $45. *Oravitz Collection.*

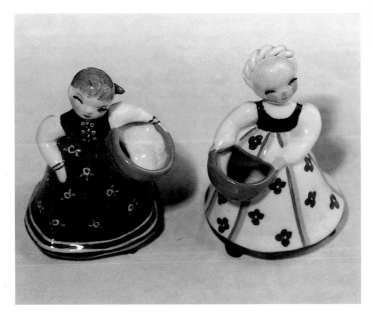

The unmarked planter on the left is 5-1/2 inches high. The planter on the right, one quarter inch taller, is named *Gretel*. The mark is shown below. Estimated value: $32 each. *Oravitz Collection.*

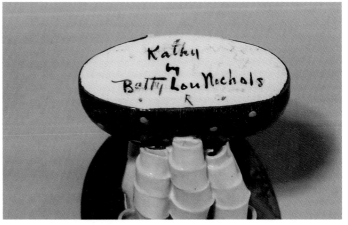

Mark of Betty Lou Nichols *Kathy* head vase.

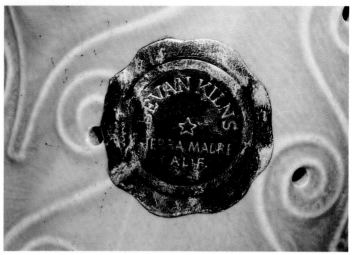

Bevan Kilns paper label of the green hog hors d'oeuvre.

In original advertising this head vase was included in a line called Demi-Dorables. It is 3-3/8 inches high, has an inkstamp mark, "Betty Lou Nichols / La Habra California" on two lines. Estimated value: $28. *Private Collection.*

B-Lou *See Betty Lou Nichols Ceramics*

Bevan Kilns

The pig hors d'oeuvre is the only item by this Sierra Madre pottery that I have seen. My guess on the date would be the 1950s.

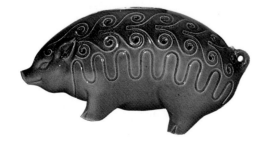

Hog hors d'oeuvres, each 3-3/4 x 8 inches. Both are unmarked except for the paper label of the green one. Recently I saw this same piece in maroon. Estimated value: $12 each. *Private Collection.*

Black Bisque *See Hagen-Renaker*

Block of California

According to Lois Lehner in *Lehner's Encyclopedia of Marks on U.S. Pottery, Porcelain & Clay* (Collector Books, 1988), the official name was Richard G. Block Pottery, and it was located on Santa Monica Boulevard in Los Angeles. Lehner found a piece with a 1940 copyright date, and found the company listed in trade publications as late as 1949 but not into the 1950s. Also according to Lehner, Richard G. Block was shown as president in 1948, Frieda C. Block in 1949. It may have been that Richard G. Block passed away during that period, and that shortly thereafter the company went out of business. This circumstance seemed to occur with some frequency among family-owned potteries, Roselane and Kay Finch being two examples.

The planter on the left stands 7-1/2 inches high, has an impressed mark, "Block / Pottery / California / Freda" on four lines. The piece on the right, 6-1/2 inches high, was made to serve either as a freestanding planter or a wallpocket. Its mark is shown. Estimated value: left $8, right $10. *Oravitz Collection.*

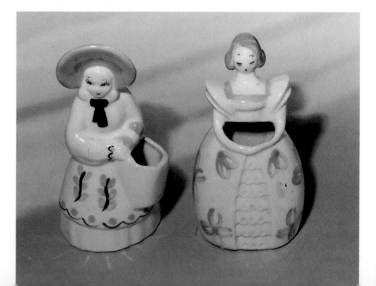

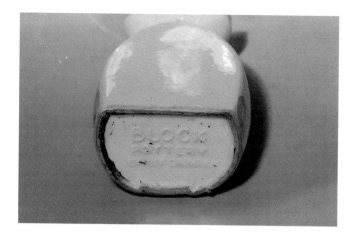

Mark of Block wallpocket/planter.

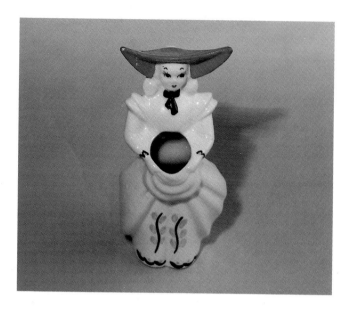

Same as above but with slightly different decoration. Different, too, is the mark, "Block / Pottery / Calif." on three lines, raised instead of impressed. Estimated value: $8. *Private Collection.*

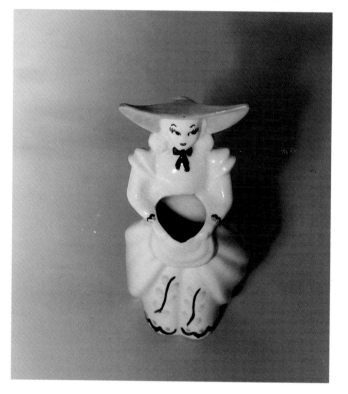

This must have been one of Block Pottery's most popular items because you see a good many of them at flea markets, shows and malls. Standing 7-1/4 inches high, its impressed mark reads "Block / Pottery / California" on three lines. Estimated value: $8. *Oravitz Collection.*

All of the Block pieces I have seen have had raised or impressed marks. But Jenny Derwich and Dr. Mary Latos, in *Dictionary Guide to United States Pottery & Porcelain (19th and 20th Century)* (Jenstan, 1984) state that paper labels-Block Pottery / Handmade / California-were used on smaller pieces.

Do not confuse this firm with the several Block china companies that operated out of New York. These were importing businesses and, as far as is known, there was no connection between any of them and the pottery described here.

Height here is 8-3/4 inches. The impressed mark reads "Block Pottery / California" on two lines. Estimated value: $12. *Oravitz Collection.*

This planter is 7-1/4 inches high. Its mark was not recorded. Estimated value: $12. *Oravitz Collection.*

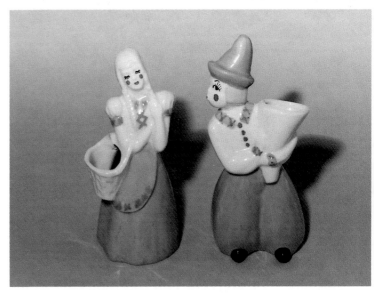

The planter on the left is 6-1/2 inches high. It is marked "Block / Pottery / California / Heidi" on four lines, the first three of which are in block letters with *Heidi* appearing in script. The boy, 7 inches high, has a much simpler mark, "Block / Cal" impressed on two lines. Estimated value: $16 each. *Oravitz Collection.*

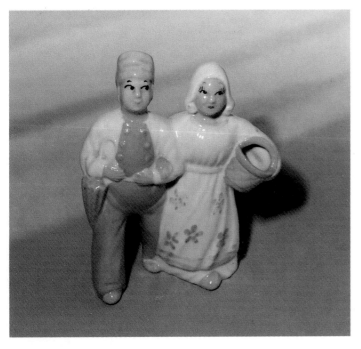

Interesting double planter, 7-1/2 inches high, marked "Block / California" on two lines in raised letters. Estimated value: $28. *Oravitz Collection.*

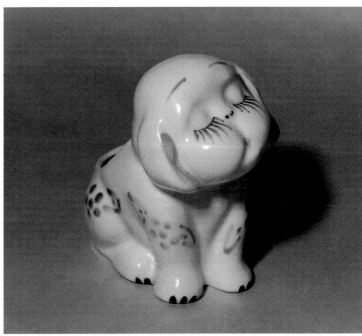

This little guy stands 4-1/4 inches high, is marked "Block / Pottery / California" in raised letters on three lines. Estimated value: $5. *Private Collection.*

Both of these dog planters are 4-1/2 inches high. The one on the left is marked by impression, "Block Pottery / California / © 1942" on four lines. The one on the right is marked "Cuddles" in black print under the glaze. Estimated value: $12 each. *Oravitz Collection.*

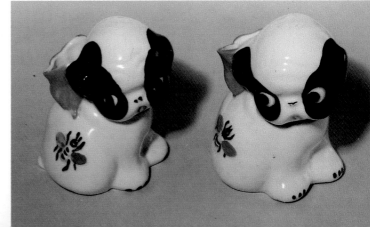

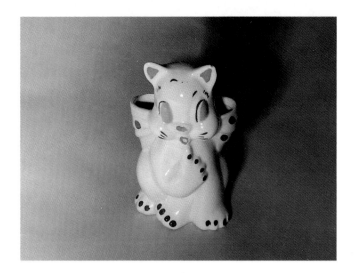

A *Purr-Ree* cat planter, 6 inches high. It has a cellophane label that reads "Purr-Ree / (two words unreadable) / Block Pottery / Hand Made / California" on five lines. I assume the name Purr-Ree signifies a cat but the cheeks make it look more like a squirrel. Estimated value: $8. *Oravitz Collection.*

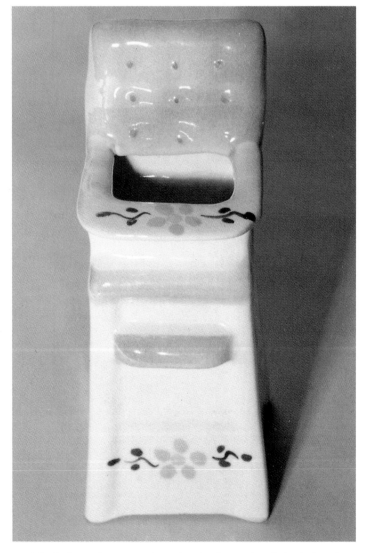

A highchair planter, 5-1/2 inches high. Mark is "Block / Pottery Co." impressed on two lines. Estimated value: $12. *Oravitz Collection.*

Bow of California

The location of this pottery is currently unknown. So is the time it was active but since the one piece shown strongly resembles California Cleminsons, we would probably be safe in assuming it operated in roughly the same time period, somewhere between 1940 and 1960.

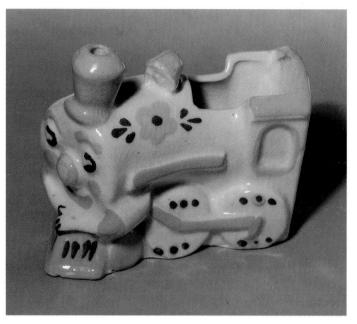

This locomotive planter is the only Bow piece I recall seeing. It stands 4-1/2 inches high, is marked "Bow / of / Calif" on three lines. Estimated value: $12. *Oravitz Collection.*

Brad Keeler

Genes were probably responsible for the talent that Brad Keeler eventually honed to a highly polished skill. His father, Rufus Keeler, worked as a designer and ceramic engineer at Gladding-McBean, and was also associated with California Clay Products and Malibu Potteries.

Brad Keeler worked as a modeller in Los Angeles at Philips Bronze and Brass prior to starting a seminal ceramics operation in his family's garage in Glendale. The year was 1939, and Brad Keeler was 26. Birds were his forte, and before long he had done so well with them that expansion proved necessary, so he struck a deal with Evan K. Shaw to take over some unused space in Shaw's American Pottery plant in Los Angeles. This arrangement lasted until fire claimed American Pottery in 1946, at which time Keeler constructed his own building, also in Los Angeles, which had about 15,000 square feet of floor space. A few years later, in 1952, Keeler was forced to expand again, this time opting to build a new facility in San Juan Capistrano. While the building was under construction, Keeler died a premature death from

a heart attack. He was 39. The company also succumbed. Eventually the San Juan Capistrano facility housed Twin Winton.

Brad Keeler made many bird figurines, more than fifty different ones while still under the roof of American Pottery. Flamingoes were probably his most popular species, as they are the ones seen most often today. Cockatoos also seem to be in relative abundance. Many birds were marketed as pairs.

Animals were made, too. Currently, Keeler's *Pryde & Joy* line, which included people, birds and animals, is becoming popular among collectors.

Most Brad Keeler items were marked by his name being impressed or printed on the bottom, and by a paper label. Some, however, such as *Mary Contrary* shown here, had only numbers impressed as a permanent mark. Others were stamped, ©B.B.K. / Made in / USA. According to Chipman, birds made while Keeler was leasing space at American Pottery, carried American Pottery Company paper labels.

A largely unknown aspect of Keeler's talent is that he modelled several of Shaw's wonderful Disney figurines.

Brad Keeler paper label of *Little Red Riding Hood.*

Two Brad Keeler Pryde & Joy planters, 6 and 6-1/2 inches high. Each has an inkstamp and a paper label. An example of each is shown. Estimated value: $28 each. *Carson Collection.*

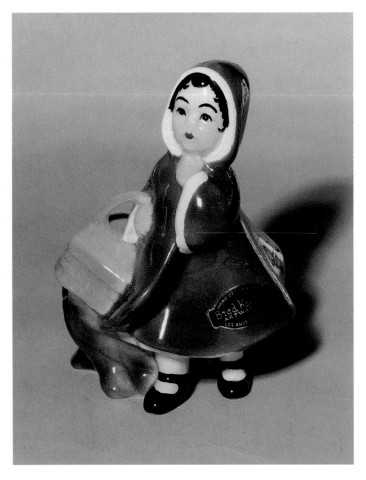

Little Red Riding Hood is 5-1/2 inches high. The figurine has an inkstamp, "Brad Keeler / Made in USA" on two lines, in addition to a paper label which is shown. Estimated value: $35. *Oravitz Collection.*

Inkstamp mark of Pryde & Joy boy planter above. People who recognize the B.B.K. mark often get some excellent Brad Keeler buys from dealers who are not familiar with it.

Paper label of Pryde & Joy boy planter. A bit hard to read, it says "Hand Decorated / Pryde & Joy / Los Angeles Calif." on three lines.

Same dog, same marks, different color. Estimated value: $26. *Oravitz Collection.*

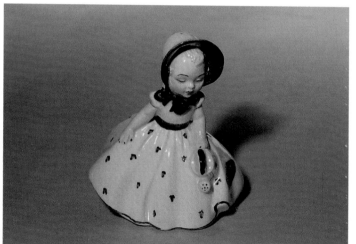

A *Mary Contrary* figurine, 5 inches high. It carries a "978" inkstamp along with a Pryde & Joy paper label. Estimated value: $30. *Oravitz Collection.*

An unmarked Pryde & Joy monkey figure, 5-3/8 inches high. Estimated value: $32. *Oravitz Collection.*

Pryde & Joy dog planter, 4-5/8 x 6-1/2 inches. It has an inkstamp mark, "© B.B.K. / Made in / U.S.A" on three lines in addition to a "520" inkstamp on another part of the bottom. Estimated value: $26. *Private Collection.*

This chicken planter is 7 inches high, is inkstamped "© B.B.K. / Made in / USA / 517" on four lines in addition to having a Pryde & Joy paper label. Estimated value: $28. *Oravitz Collection.*

A nice paper label on this 3-7/8 inch high cat. Estimated value: $30. *Private Collection.*

I forgot to record the data on this cat but do remember that it was about 7 inches long, and had a Brad Keeler inkstamp. Estimated value: $35. *Private Collection.*

This kitty measures 4-1/2 x 5-3/4 inches. Estimated value: $30. *Private Collection.*

A 5 inch high duck with "Brad Keeler" impressed. Estimated value $45. *Private Collection.*

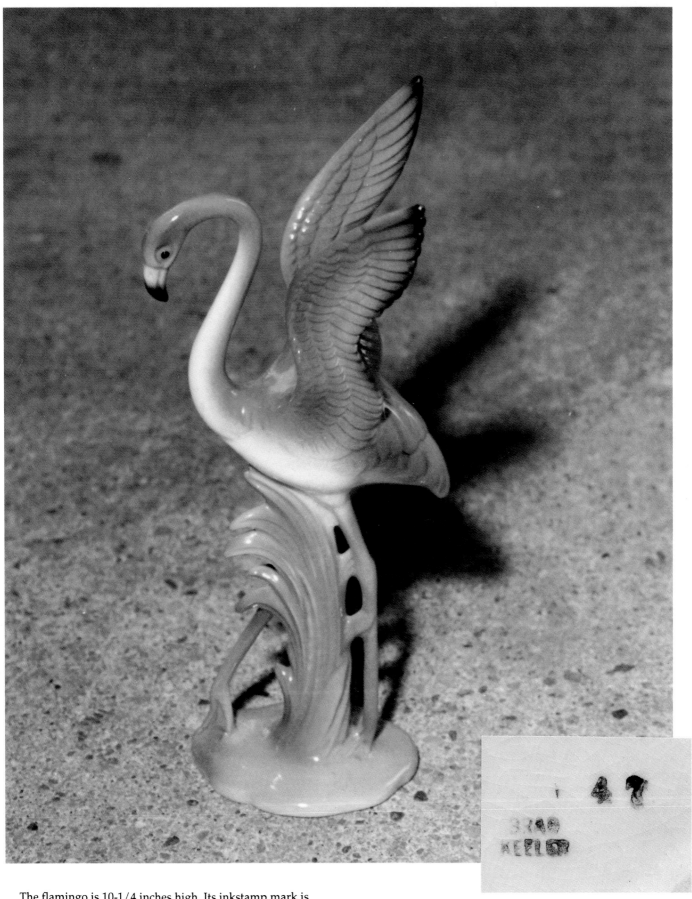

The flamingo is 10-1/4 inches high. Its inkstamp mark is shown. Estimated value: $35. *Courtesy of Knightstown Antique Mall.*

Mark of the Brad Keeler flamingo.

This beautifully decorated large hen and rooster stand 10-1/2 and 12-1/2 inches high, respectively. They are marked "Brad Keeler California." Estimated value: $75 each. *Private Collection.*

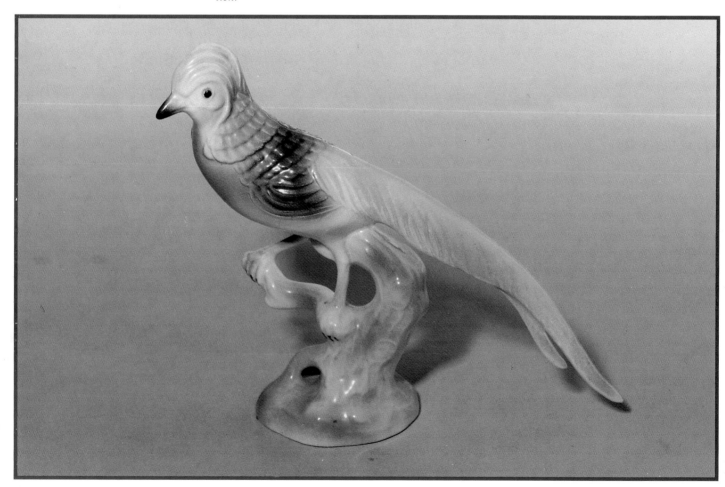

This exotic pheasant stands 6-1/8 inches high. On its bottom is an impressed "Brad Keeler." It also has a paper label that does not show in the picture. Estimated value: $28. *Private Collection.*

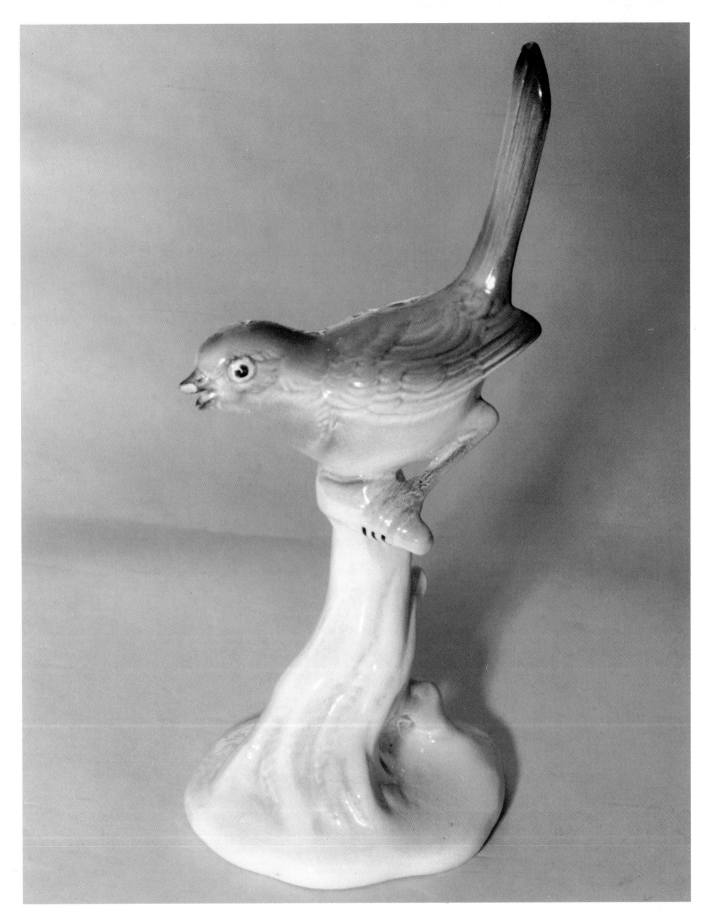

The bluebird is 8-1/4 inches high. It is marked "Brad Keeler / 118" impressed on two lines. Note that the bird has a chipped beak. Estimated value: $30 if perfect. *Private Collection.*

Height of this cockatoo is 8-3/4 inches. "Brad / Keeler," is impressed on two lines. Estimated value: $35. *Private Collection.*

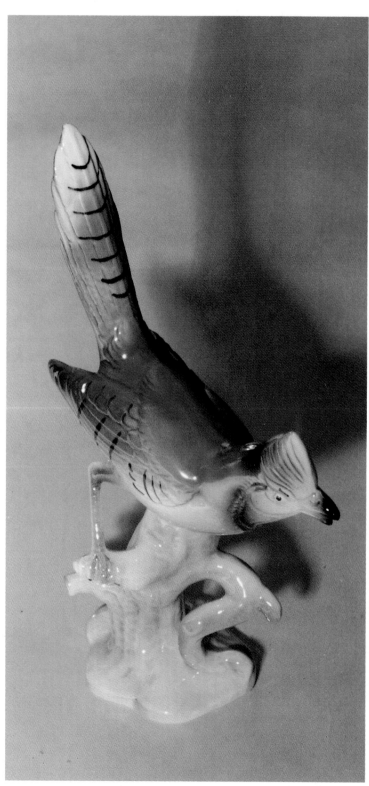

Now a bluejay, 9-5/8 inches high. "Brad / Keeler / No. 19" is impressed on three lines. An "H" is incised. Estimated value: $38. *Private Collection.*

Brayton Laguna

Durlin E. Brayton started this Laguna Beach concern in 1927 in a home shop on the Pacific Coast Highway. At that time the major output of the Chicago Art Institute graduate was colored dinnerware, along with vases and flower pots, a few figurines and other items. During this early period Brayton's front yard served as his main retail outlet.

Things changed in 1936 after Brayton married Ellen Webster Grieve, who was also an artist. "Webb" Brayton, as she was called, introduced lines of figural ware which were so well done they attracted the eye of Walt Disney, who made Brayton the first licensee to produce his animated characters. These Disney figures were marked "Geppetto Pottery" for characters from the movie *Pinnochio*, and "Walt Disney Enterprises, Made by Brayton," for characters from other animated features. That was in 1938, the same year Brayton Laguna built larger facilities on a five-acre site in Laguna Beach. The Disney figures, which included a candy jar and creamer and sugar, were made until 1940. After that Vernon Kilns obtained the license.

Webb Brayton died in 1948. Durlin Brayton survived her by only three years, passing away in 1951. The pottery continued in business, however, until 1968. Today the former Brayton Laguna Pottery facilities serve as the Laguna Art Center.

Many Brayton pieces are marked, the most common mark being an inkstamp giving the name of the pottery, and sometimes other information such as the copyright date or name of the individual piece. Sometimes marks were impressed, sometimes incised. The Weston Ware stamp, seen on the gentleman and lady in white and pink, can fool you if you do not read the entire mark, or if the part identifying it as Brayton is smeared.

After you have seen and handled a number of Brayton items, unmarked pieces can be identified by their overall general style and decoration, and weight which runs average to heavy. The style of the eyes on the *Sally* planters was used on many other Brayton items.

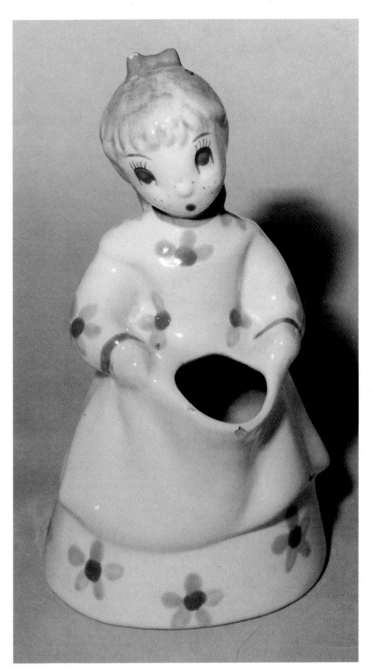

The *Sally* planter, (or utensil holder if you wish to call it that) is the most common and best known of all the pieces Brayton made. Height is 7 inches. In addition to the inkstamp mark shown, this particular example has "VI 22-178" incised. Estimated value: $16. *Oravitz Collection.*

Inkstamp mark of the above *Sally.*

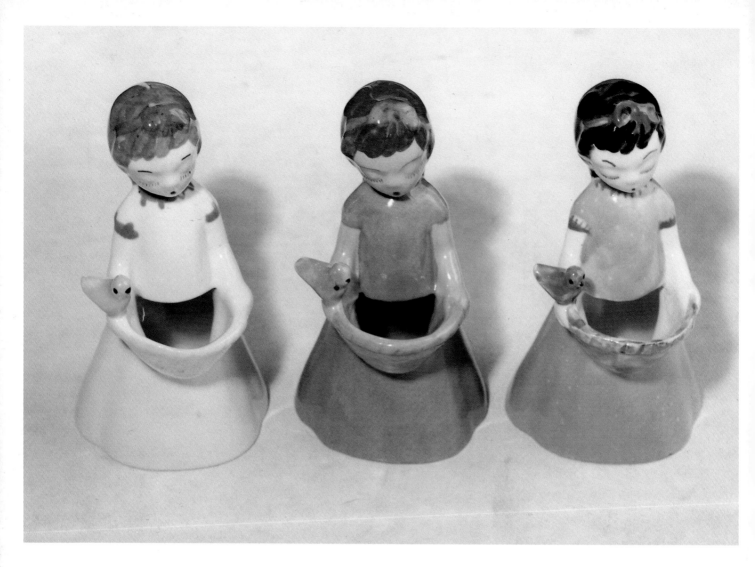

Similar to the *Sally* but not quite the same, each of these planters stand 6-1/2 inches high. The ones on the right and in the middle are inkstamped "Copyright / 1940 by / Brayton / Laguna / Pottery" on five lines, while the one on the left slipped out of the factory unmarked. Estimated value: $22 each. *Oravitz Collection.*

Here is a *Frances*, 8-1/2 inches high. Its inkstamp mark reads "Frances / Brayton / Pottery" on three lines. Estimated value: $22. *Oravitz Collection.*

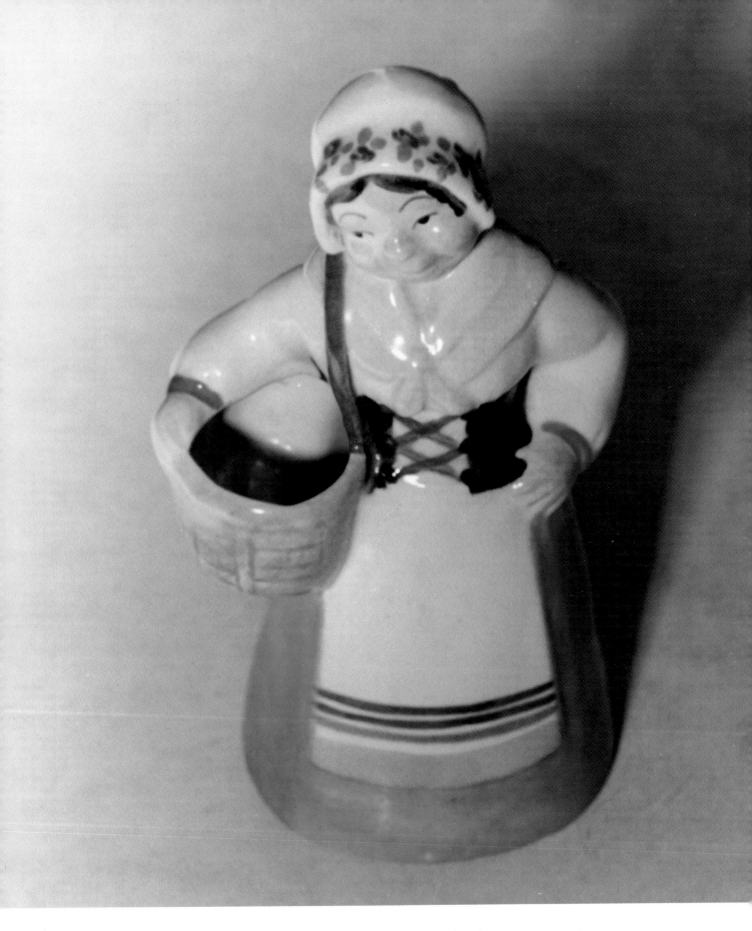

This piece is 9-1/4 inches high, has an impressed mark,
"Brayton / Laguna / Pottery" on three lines. Estimated value:
$28. *Oravitz Collection.*

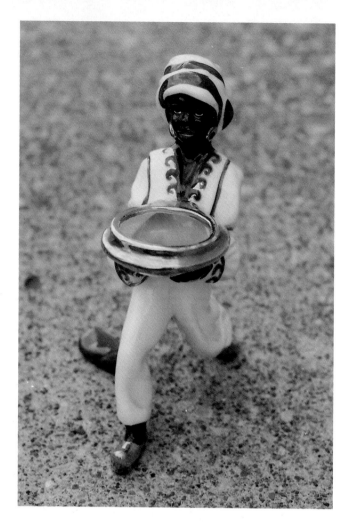

A *Blackamoor with Bowl*, is what the 1948 Brayton catalog called this 8-1/4 inch high unmarked piece. In addition to burgundy, it also came with black or green trim. In your travels look for the candlesticks that go with it, Blackamoors sitting on pillows. Estimated value: $35. *Private Collection*.

Unmarked Brayton dice players. The figurine on the left is 3-3/4 inches high, has a remnant of a paper label that reads *Little Joe*. The piece on the right is 3-1/2 inches high. Estimated value: $65 each. *Oravitz Collection*.

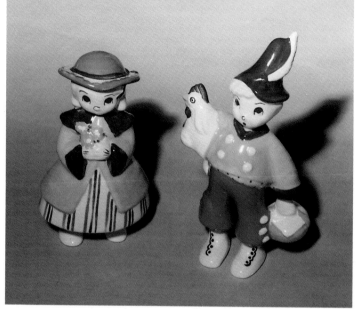

Another *Jon*, this time with *Miranda*, 7-1/4 inches high. Each has an inkstamp mark, "Miranda / Brayton / Pottery" on three lines, and "Jon / Brayton / Pottery" on three lines. In the catalog, these two were shown as a pair. Estimated value: *Miranda* $45, *Jon* $50. *Oravitz Collection*.

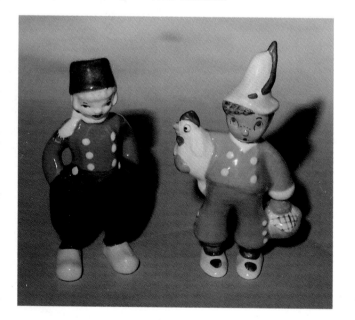

The *Dutch Boy* figurine, at left, is 7 inches high, unmarked. That's *Jon* on the right, 8 inches high, and also unmarked. Estimated value: *Dutch Boy* $60, *Jon* $50. *Oravitz Collection*.

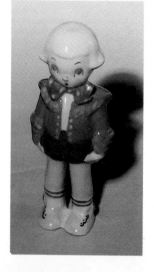

This little boy, *Maxwell*, stands 6-3/4 inches high. He is not marked. Estimated value: $70. *Oravitz Collection*.

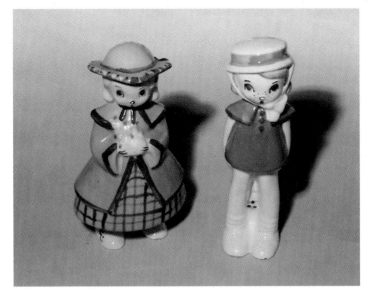

Back of *Pat*.

Miranda again, this time unmarked, and *Pat*, 7 inches high with an inkstamp that reads, "Pat / Brayton / Pottery" on three lines. The back of *Pat*, interesting in its own right, is also shown. Estimated value: *Miranda* $45, *Pat* $80. *Oravitz Collection.*

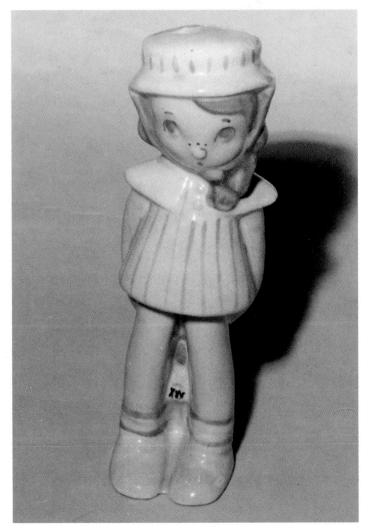

Pat in another color scheme, 7 inches high and unmarked. Estimated value: $80. *Oravitz Collection.*

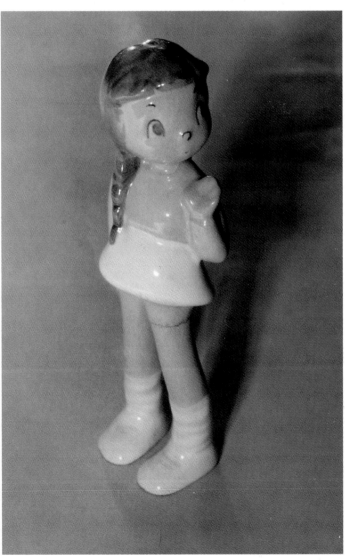

This little girl, 6-1/2 inches high, is marked with a "Lietta / Brayton / Pottery" inkstamp on three lines. Estimated value: $75 if perfect. *Carson Collection.*

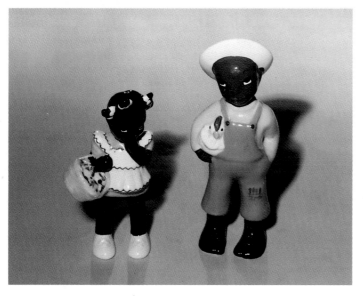

Petunia and Sambo are 6-1/4 and 8 inches high, respectively. Petunia is unmarked while Sambo carries an inkstamp, "Sambo / Brayton / Pottery" on three lines. In the original catalog they sold for $7 per pair. Estimated value: $135 each. *Carson Collection.*

Weezy is on the left, 7-1/4 inches high. She has an inkstamp, "Weezy / Brayton / Pottery," on three lines. *John* also 7-1/4 inches high, has a similar inkstamp with his name. Estimated value: $75 each. *Carson Collection.*

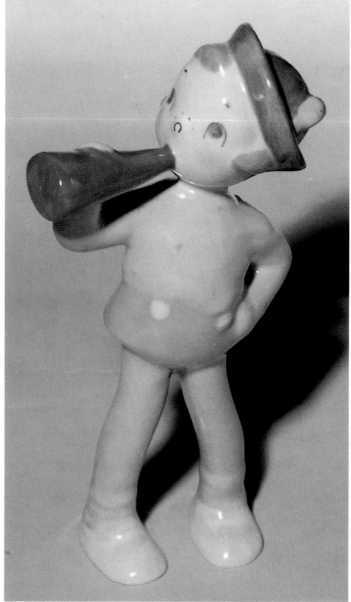

I do not know the name of the handsome young man on the left. He is 7-1/4 inches high, unmarked. That's *Eric* on the right, a 7-1/2 inch high Swedish lad who is marked with a "Brayton / California" inkstamp on two lines. *Eric's* girlfriend, *Inger,* is shown on page 53. Estimated value: left $80, *Eric* $75. *Carson Collection.*

John in a different color and unmarked. Estimated value: $75. *Oravitz Collection.*

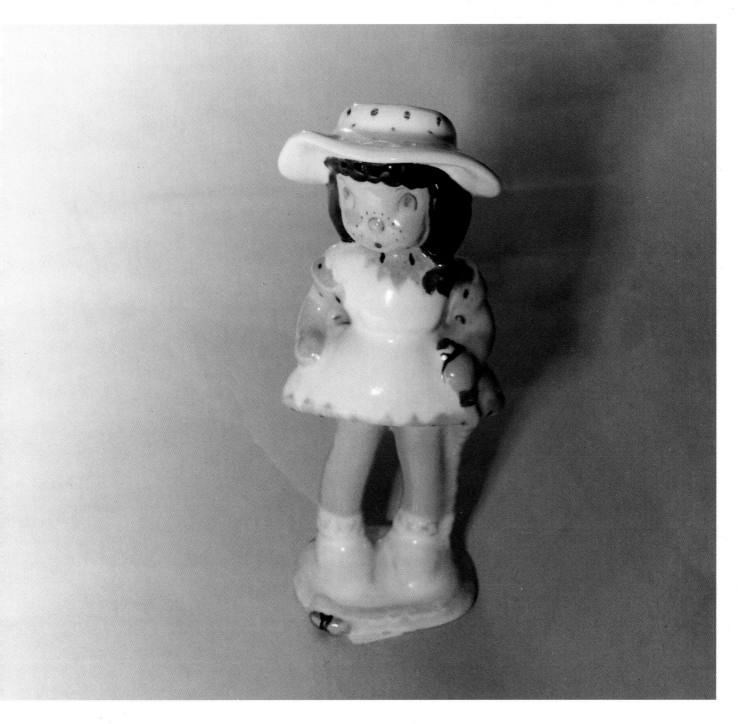

Another *Weezy,* same size but unmarked. Estimated value: $75.
Carson Collection.

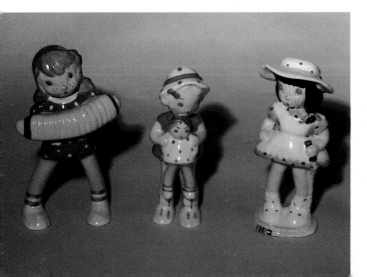

The girl playing the concertina is 7 inches high. Her inkstamp reads "Marge / Brayton / Pottery" on three lines. There is also a "7" incised. The girl holding the doll is *Julia Ray.* She stands 6-1/2 inches high. Her inkstamp reads simply "Brayton / Pottery" on two lines. And, of course, that's *Weezy* again on the right. Estimated value: *Marge* $75, *Julia Ray* $75. *Oravitz Collection.*

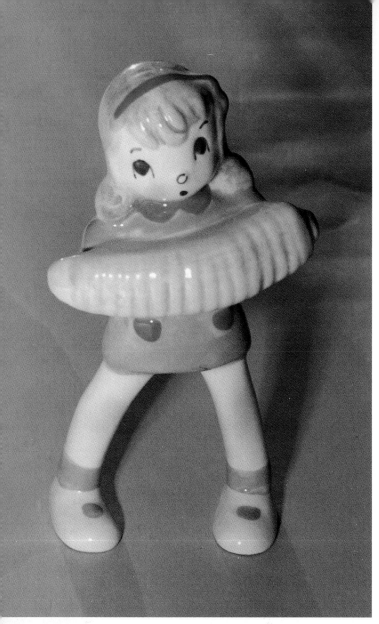

Another *Marge.* Estimated value: $75. *Carson Collection.*

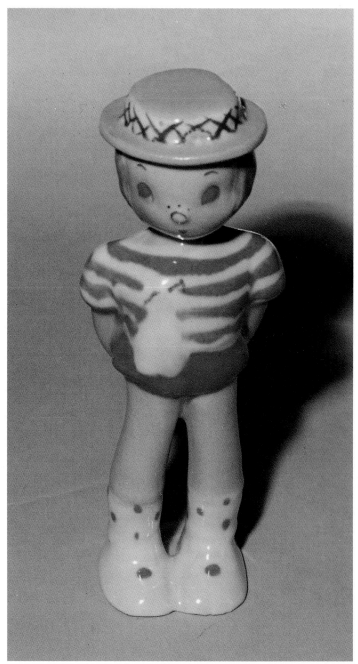

This is *Eugene.* The 6-3/4 inch high figure is stamped "Eugene / Brayton / Potteries" on three lines. There is also a 5 written in ink. Estimated value: $70. *Oravitz Collection.*

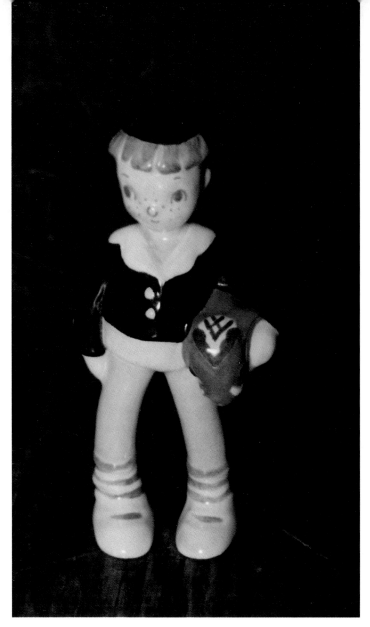

Arthur, 8-1/4 inches high. His inkstamp mark reads, "Arthur / Brayton / Pottery," on three lines. Estimated value: $80. *Graettinger Collection.*

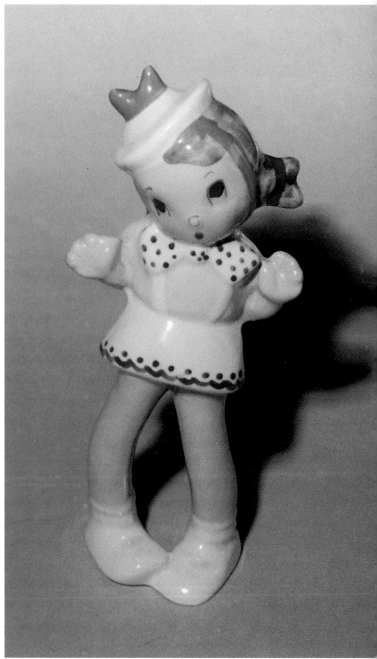

Ellen, is 7-1/2 inches high and unmarked. According to Brayton catalogs, she was sold as a partner for *Eugene*. Estimated value: $70. *Oravitz Collection.*

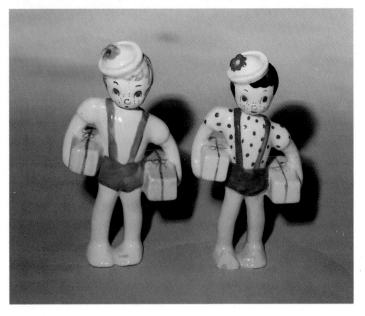

Two renditions of *Butch,* each 7-3/4 inches high. Neither is marked. The bottoms, which are slightly different, are shown. Estimated value: $65 each if perfect. *Oravitz Collection.*

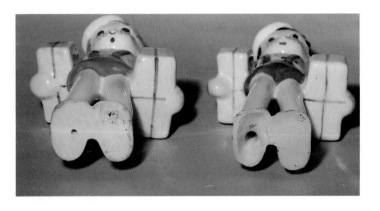

Bottoms of the above *Butch* figures, one closed, one partially open. Note, too, that one is made of white bisque, one flesh color.

This girl figurine stands 7-1/2 inches high. An inkstamp on the bottom proclaims "Peanuts / Brayton / Laguna / Pottery" on four lines. The catalog refers to her only as *Chinese Girl.* Estimated value: $60. *Oravitz Collection.*

Here is the *Chinese Boy,* 7-3/4 inches high and unmarked. Estimated value: $60. *Carson Collection.*

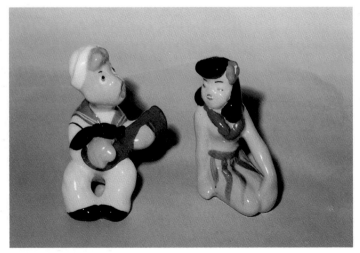

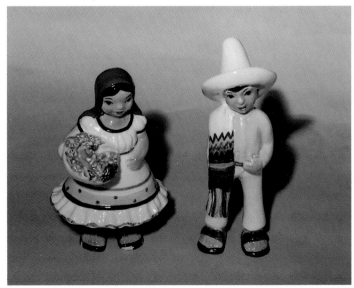

The sailor is 5-1/2 inches high, the hula girl 5-1/4 inches. Neither is marked. Estimated value: sailor $85, hula girl $90. *Oravitz Collection.*

Rosita and *Pedro,* 6-1/2 and 7-1/2 inches high respectively. Each is marked "Brayton / Laguna / Pottery" on three lines. Estimated value: $75 each. *Oravitz Collection.*

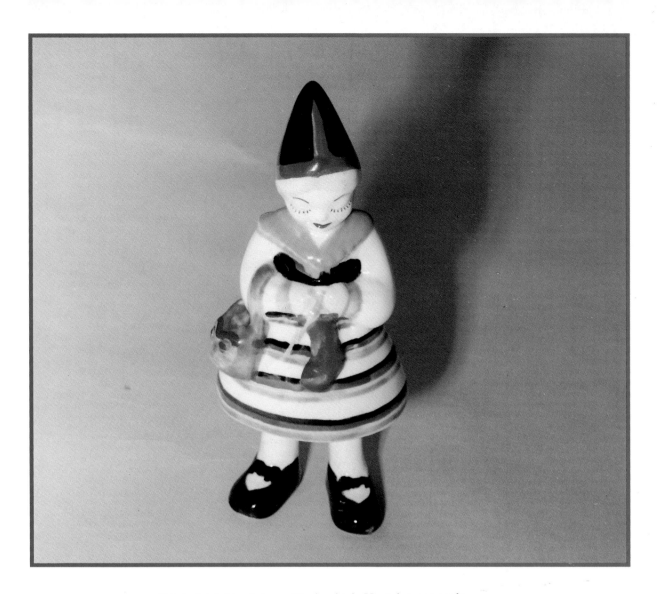

This is *Eric's* friend, *Inger,* 7 inches high. Her inkstamp reads "Inger / Brayton / Pottery" on three lines. *Eric* appears on page 48. Estimated value: $75. *Oravitz Collection.*

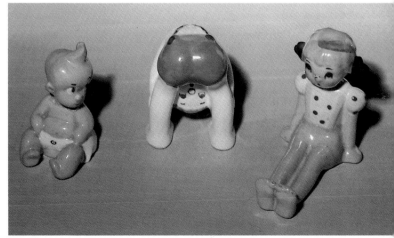

Inger again, this time unmarked. Estimated value: $75. *Oravitz Collection.*

Ann is 4-1/2 inches high, unmarked. Estimated value: $75. *Oravitz Collection.*

Heights left to right are 3-3/4, 3-3/4 and 4-1/4 inches. The only figurine in this picture that is marked is the one in the center which has an inkstamp, "Millie / Brayton / Pottery" on three lines. Estimated value: left and center $85 each, right $75. *Oravitz Collection.*

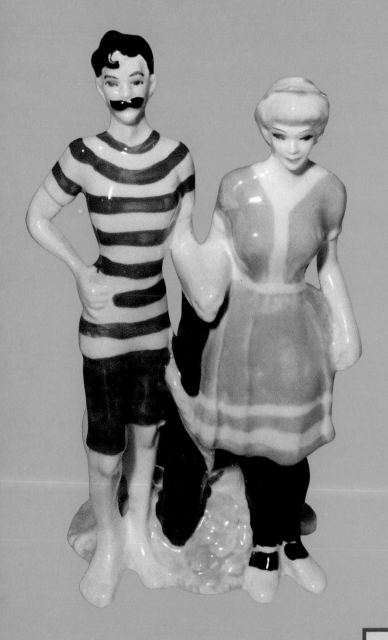

Seashore Honeymoon is the second of a four-piece series that follows a late Victorian couple through the first year of their marriage. The other three are *Bride and Groom, Bedtime,* and *One Year Later* which is shown. Height of the unmarked seashore pair is 8-3/4 inches. Estimated value: $115. *Oravitz Collection.*

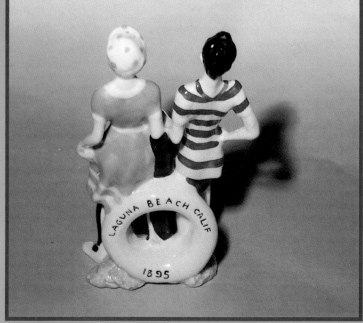

Back of *Seashore Honeymoon.*

One Year Later and the couple has become a threesome. Height is 8-3/4 inches. The figurine is not marked. Estimated value: $115. *Oravitz Collection.*

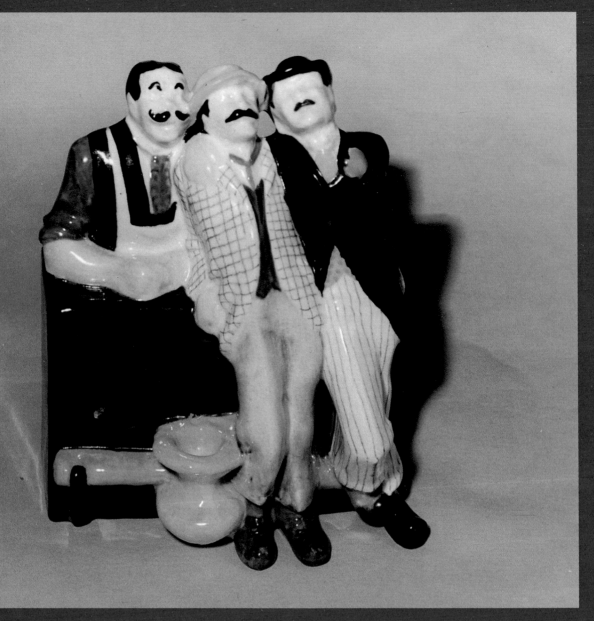

This is one of at least two *Gay Ninety Bar* figures the company made. Height is 9 inches. It is not marked. Estimated value: $100. *Oravitz Collection.*

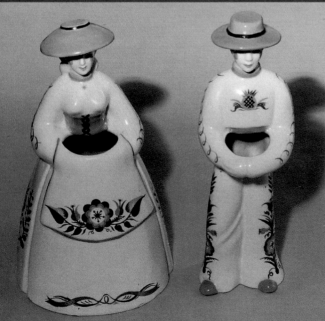

The lady in this pair of planters is 10-1/2 inches high. Her inkstamp mark, which could be a fooler if not looked at closely, is shown. The man is 11 inches high. He is not marked. Estimated value: $45 each. *Oravitz Collection.*

Weston-Ware/Brayton mark of above lady planter.

This lady planter stands 8-1/2 inches high. Its inkstamp mark reads "Copyright / 1940 by / Brayton / Laguna / Pottery," in block letters on five lines. Estimated value: $55. *Oravitz Collection.*

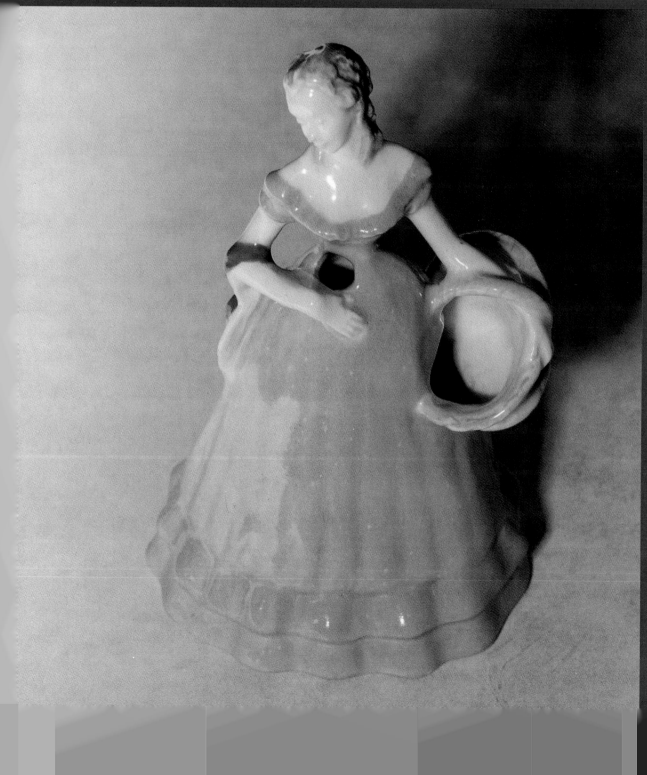

Height of this planter is 11 inches. It has a mark similar to the
girl with the lavender dress, "Copyright / 1943 by / Brayton /
Laguna / Pottery" on five lines. Estimated value: $55. *Oravitz
Collection.*

Standing 6 inches high, this figurine has "Brayton" incised.
Estimated value: $85. *Oravitz Collection.*

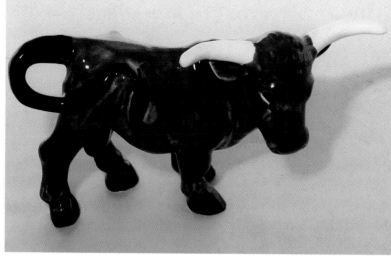

A bit of the abstract here, the "Torso" stands 6-1/2 inches high. "Brayton's / P-2 / Laguna Beach, Calif." is impressed in the bottom on three lines. Estimated value: $35. *Private Collection.*

The three pieces that comprise the *Purple Cow Family* are some of Brayton Laguna Pottery's most recognized animals. The *Purple Bull* measures 6-1/2 x 11-3/4 inches. Like all of the *Purple Cow* pieces I have seen, it is not marked. Estimated value: $95. *Oravitz Collection.*

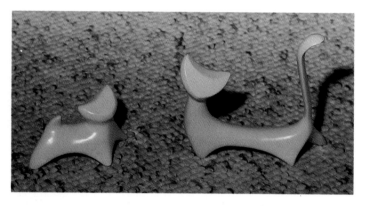

This is two pieces of a set of three, the third piece being a similar size cat facing the opposite way. The kitten is 2-3/4 inches high, the cat 6-1/2 inches. Neither is marked. Estimated value: kitten $15, cat $20. *Oravitz Collection.*

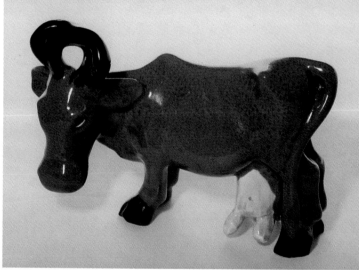

The *Purple Cow* is 6 inches high, 8-1/2 inches long. These pieces were modeled by Andy Anderson, a designer whose background included woodcarving. Estimated value: $95. *Oravitz Collection.*

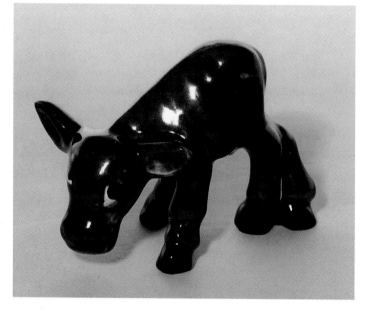

The *Purple Calf,* 4 x 6 inches, rounds out the trio. In the January, 1957, Brayton Wholesale Catalog this entire set sold for $6.25. Estimated value: $75. *Oravitz Collection.*

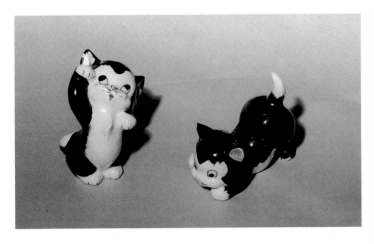

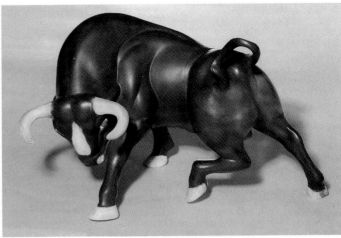

Figaro from Walt Disney's animated feature, *Pinocchio*. They were made under a Disney license Brayton held from 1938 to 1940. The figurine on the left stands 4 inches high, the one on the right 3-3/4 inches. Each is marked and, though practically unreadable, the better of the two marks appears below. Estimated value: $100 each. *Oravitz Collection.*

This unmarked *Head Down Bull* (as opposed to its companion *Head Up* model) measures 6-1/2 x 10-1/2 inches. The black matte finish is the same as on the torso above, while the white of the hooves, horns and spot on its head are simply unfinished bisque. Estimated value: $75. *Private Collection.*

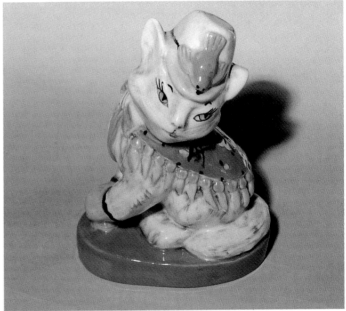

Mark of the reaching *Figaro.* Very hard to make out, it reads "Geppetto / Pottery" at the top, mentions Walt Disney at the bottom, and is enclosed in an oval. Only characters from *Pinocchio* were marked Geppetto Pottery.

Meet *Mimi,* a 9 inch high Brayton cat figurine. Her mark is shown. Estimated value: $85. *Oravitz Collection.*

Pluto is made of pink bisque. He is 3-1/4 inches high, unmarked. Estimated value: $135. *Oravitz Collection.*

Inkstamp mark of *Mimi.*

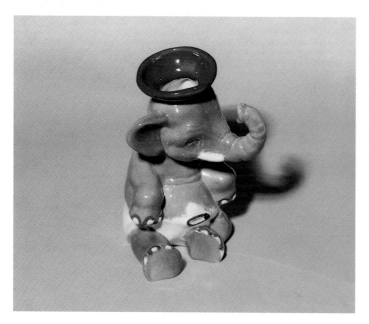

The *Donkey* planter was made in predominately red, yellow and blue, according to Brayton's 1948 retail catalog. Height is 5-1/4 inches. Mark is an inkstamp, "Copyright / 1943 by / Brayton / Laguna / Pottery," on five lines. Estimated value: $35. *Oravitz Collection.*

Junior Elephant planter, 5-1/4 inches high with a Brayton inkstamp. Its mate is *Mr. Elephant*, which is also shown. Estimated value: $40. *Oravitz Collection.*

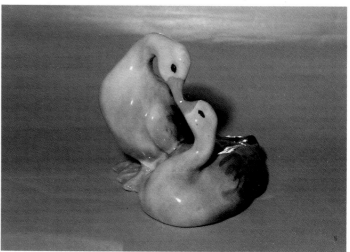

The geese are 4-3/8 inches high. Their inkstamp mark is shown below. Estimated value: $25. *Private Collection.*

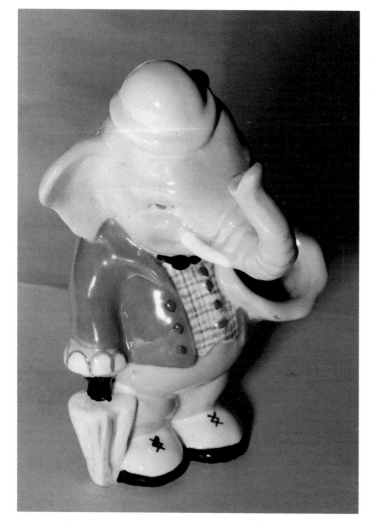

Mark of the above geese showing a copyright date of 1940.

Here's *Mr. Elephant*, 6-3/4 inches high. Unlike *Junior*, *Mr. Elephant* is not marked. Estimated value: $50. *Oravitz Collection.*

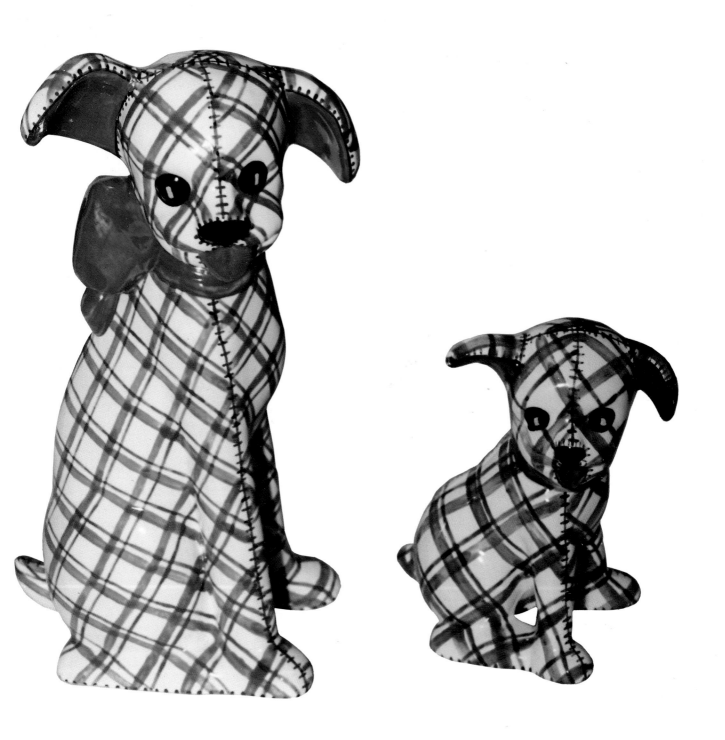

The *Fireside Gingham Dog* towers 14-1/2 inches high. Its smaller companion is 8 inches high. Neither piece is marked. Estimated value: left $175, right $95. *Carson Collection.*

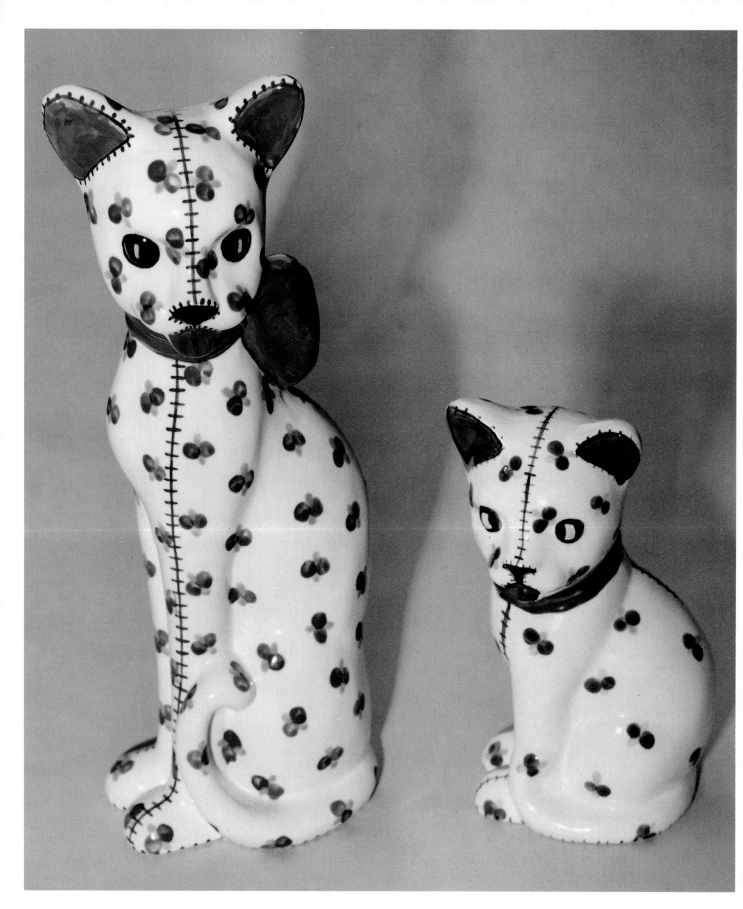

Same heights for the *Fireside Calico Cat* and its smaller clone, 14-1/2 and 8 inches. The shorter piece has an inkstamp mark, "Brayton / Calif USA" on two lines. Estimated value: left $175, right $95. *Carson Collection.*

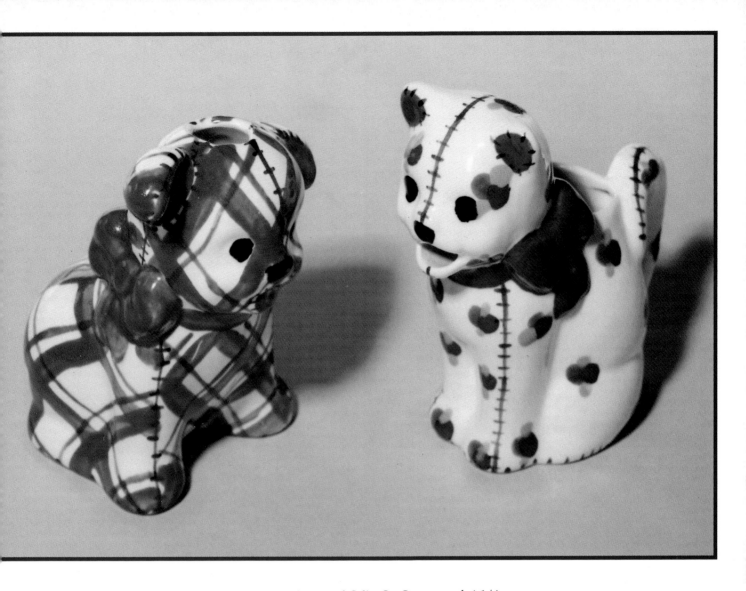

The *Gingham Dog Sugar* and *Calico Cat Creamer,* each 4-1/4
inches high, each unmarked. Estimated value: $80 per pair.
Carson Collection.

Gingham Dog and *Calico Cat Salt and Pepper,* 3-3/4 and 4-1/4
inches high, respectively. Neither is marked. Estimated value:
$45 per pair. *Carson Collection.*

Same salt and pepper shaker but in brown, yellow and green,
the other color combination in which the series was offered.
Made but not shown was a cookie jar that goes for about $225
to $250. Estimated value: $45 per pair. *Carson Collection.*

Burke-Winton *See Twin Winton*

B-W *See Twin Winton*

Caliente

Virgil K. Haldeman graduated from the University of Illinois in 1923 with a degree in ceramic engineering, worked for a Pennsylvania pottery awhile, started the Haldeman Tile Manufacturing Company in Los Angeles in 1927, sold it in 1930, and served a three-year stint with the Catalina Clay Products Company before finally opening Caliente, in Burbank, in 1933. The factory was sold in 1947, at which time the business moved to Calabasas where it eventually closed in 1953. Afterwards Haldeman worked for several other potteries. He retired in 1974, died in 1979 at age 79 or 80.

Incised mark of sailboat flower frog.

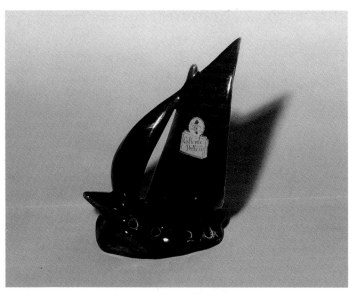

This sailboat flower frog is 6-3/4 inches high. Both its paper label and bottom are shown. Estimated value: $25 *Oravitz Collection.*

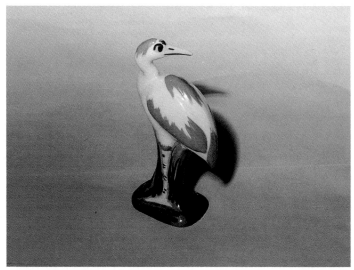

Shorebird figurine, 6-3/8 inches high. Its mark is shown. Estimated value: $38. *Oravitz Collection.*

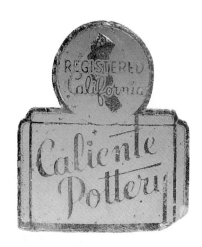

Caliente paper label of sailboat flower frog.

Impressed Made in California mark of Caliente shorebird figure.

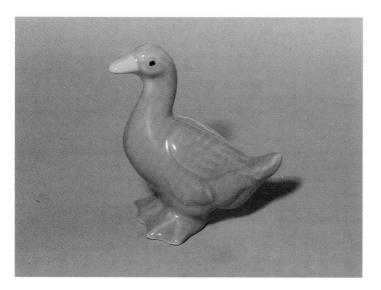

This goose is 4-1/4 inches high. It has the same impressed mark as the shorebird above. Estimated value: $28. *Private Collection.*

California Cleminsons, The

One thing about The California Cleminsons pottery, it's distinctive. Once you are familiar with it you will be surprised at how accurately you will be able to spot it from a distance.

Betty and George Cleminson started the pottery in the garage of their El Monte residence, under the name Cleminson Clay, in 1941. The name change to The California Cleminsons was made in 1943. Eventually the couple employed 165 people in a much larger facility. The company went out of business in 1963.

The California Cleminsons, anchored on the West Coast, borrowed from the country's oldest crock and jug manufacturers along the East Coast by slip-decorating their wares. Slip-decorating is the process by which colored slip (liquified clay) is applied by brush to the unfired pottery. This gives the decoration some body, some thickness, which if not decernible to the eye can nearly always be felt by the fingers.

Not all of The California Cleminsions Pottery items were marked, but as mentioned above, even those that were not are generally easy to pick out. The mark shown below is the only one of which I am aware, but there may have been others.

A butler planter, 4 inches high. It carries the standard Cleminsons inkstamp, an example of which is shown. Given this figure's small size, it may have been made as a toothpick holder or some other accessory for the table or perhaps the kitchen. Estimated value: $22. *Oravitz Collection.*

Sugar shaker? Cactus planter? Something else? Whatever it is, it stands but 3-1/2 inches high, and has a Cleminsons inkstamp. Estimated value: $20. *Oravitz Collection.*

Again, planter or something else? Height is 3-1/2 inches; it has a Cleminsons inkstamp. Estimated value: $20. *Oravitz Collection.*

This appears to me to be a cleanser. It is 6-1/2 inches high, has a Cleminsons inkstamp. Estimated value: $25. *Oravitz Collection.*

A dog ringholder, 2-7/8 inches high. This particular example carries a Cleminsons inkstamp but many do not. Estimated value: $12. *Private collection.*

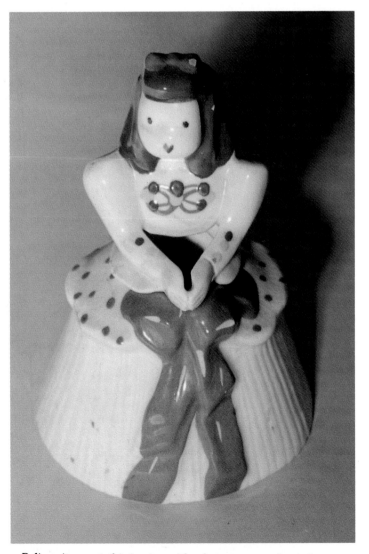

Believe it or not, this is a jar, with what appears to be a planter in the top. It is 6-3/4 inches high, carries a Cleminsons inkstamp mark. Estimated value: $20. *Oravitz Collection.*

Frying pan wallpocket, 11-3/8 inches long. Like all of the Cleminsons pieces shown, it has a standard inkstamp mark. Estimated value: $28. *Oravitz Collection.*

This wallpocket is 5-1/2 inches high *not including* the bail handle. It has a Cleminsons inkstamp. Estimated value: $28. *Oravitz Collection.*

A California Cleminsons inkstamp mark like this one is seen on most of the pieces that were manufactured by the company.

California Dresden

From the Eberling & Reuss catalog we know the company was in business in 1950. It was located in Glendale at 623 East Colorado Street. Lehner found California Dresden listed in directories as late as 1954, along with information that the firm manufactured vases, console sets and other similar pieces. Apparently Avis Wright was the company's owner or designer, as Derwich and Latos found a figurine, obviously California Dresden, which was stamped, "Avis Wright, Glendale, Calif."

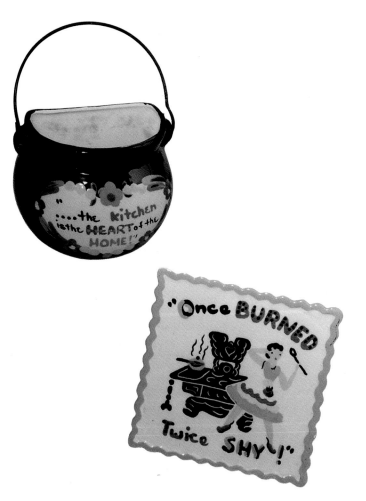

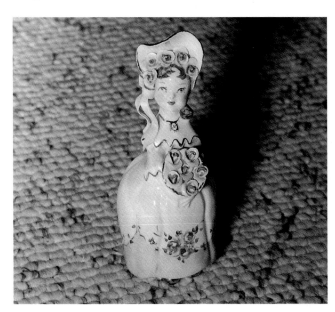

Another 5-1/2 inch high wallpocket. The sign is 5-1/4 inches high. Each has a Cleminsons inkstamp. Estimated value: wallpocket $25, sign $35. *Oravitz Collection.*

This is *Pamela*, 7-3/8 inches high. A close up of the paper labels is shown. Estimated value: $45. *Oravitz Collection.*

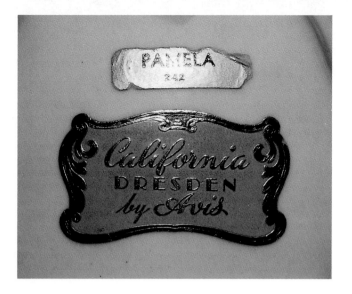

Paper labels of the California Dresden *Pamela*.

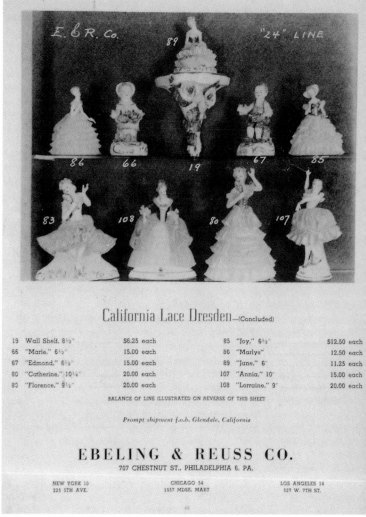

California Dresden figures offered in the 1950 Eberling & Ruess catalog.

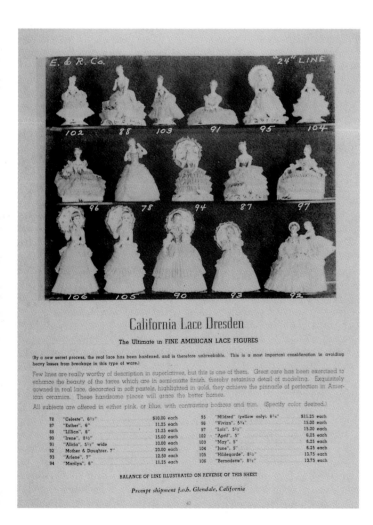

California Dresden figures offered in the 1950 Eberling & Ruess catalog.

California Figurine Company *See Weil Ware*

California Originals

Like several other California potteries, California Originals is best known for its cookie jars. But it also made many figurines and planters, along with nonfigural items such as ashtrays, lazy Susans and vases.

The general consensus of researchers is that the company was started by William D. Bailey in 1944 in Manhattan Beach, and was known as Heirlooms of Tomorrow. At some point it moved to Torrence where it eventually occupied an approximately 150,000 square foot plant. The name change to California Originals, according to Lehner, was phased in slowly over a period of several years during the 1950s. Bailey sold the plant to Roman Ceramics in 1979, it closed three years later.

While that scenario is fine as far as it goes, the paper label shown seems to indicate that at one time, perhaps very early on, the business was known as Bea and Bill Ceramics, and located in Los Angeles. While I have never seen an impressed Bea and Bill mark on anything, it wouldn't surprise me if one turned up someday. A mark you do see sometimes on products of California Originals is "Cal-Style Ceramics." But much of the ware was unmarked so familiarity is often the only means of identification.

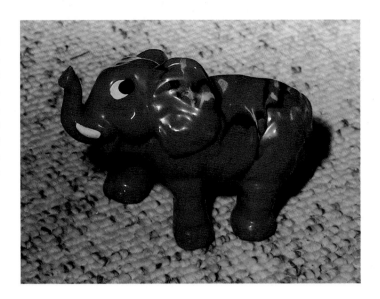

This unmarked elephant stands 6-1/8 inches high. Another of a different color is shown on page 16. Estimated value: $15. *Oravitz Collection.*

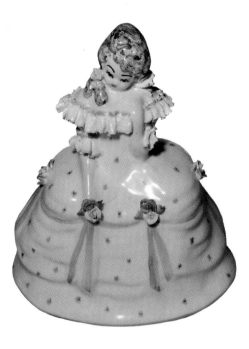

In the beginning California Originals was operated under the name Heirlooms of Tomorrow, and this figurine is one of its early products. It stands 8-3/8 inches high. Its paper label is shown. Estimated value: $50. *Oravitz Collection.*

Paper label of above Heirlooms of Tomorrow figurine. The shoe must have been a common theme with the company, as figural shoes are seen more often than figures of people.

This 16 inch high bird is unmarked but was sold with a bull that had the same glaze and a California Originals paper label. Estimated value: $15. *Oravitz Collection.*

California Pottery Company

It's a longshot but this may be the company that was owned by Orville Kirby prior to his purchase of Sleepy Hollow Pottery (see that listing) in Laguna Beach in 1947. According to Derwich and Latos, Kirby made wares in Los Angeles under the name California Pottery. No mention of the word "Company," but who knows, it may be.

The double bird figurine is 9-7/8 inches high. Its bottom is impressed, "California / Pottery Co. / ©" on three lines. This is the only piece to date that I have seen so marked. Estimated value: $25. *Private collection.*

Capistrano Ceramics

'Capistrano Ceramics is the name of a line made by John R. Stewart, Inc., of San Juan Capsitrano. According to Lehner, John R. Stewart was a manufacturing concern that made both figural and nonfigural pottery. She found it listed in various directories between 1948 and 1951, but not in 1953.

So far, so good. But there is more.

Immediately below the Capistrano Ceramics/ John R. Stewart listing there is another for Capistrano Mission Potteries showing the same years and a nearly cloned mark, but located in Los Angeles. The Stewart company was shown in the directories as manufacturing figurines, animals, vases, wallpockets and similar items, while the mission firm was mainly dinnerware and salt and peppers.

Were these two plants of the same company? One company with separate manufacturing and office facilities? Perhaps a split within a company, one faction ending up with the artware line, another the dinnerware line, or two totally separate companies? It is just one of the many mysteries surrounding California pottery that make the subject so interesting to collectors.

Height of this Oriental lady figurine is 11 inches. Its mark is shown below. Estimated value: $40. *Oravitz Collection.*

Bottom of above figurine showing the Capistrano swallow mark.

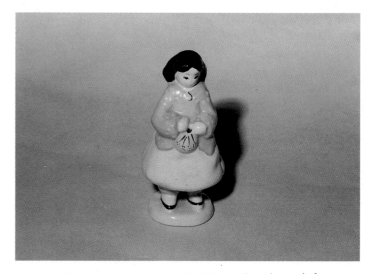

This is *Victoria*, 5-3/4 inches high. Her mark is shown below. Estimated value: $25. *Oravitz Collection.*

Bottom of *Victoria*.

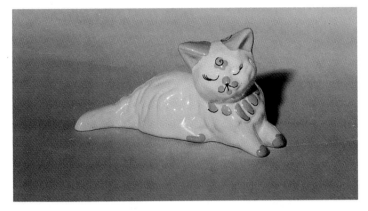

Height of this cat figurine is 3-1/4 inches, length is 5-1/4 inches. It has the swallow mark of the Oriental lady above. Estimated value: $25. *Oravitz Collection.*

Cemar Clay Products Company

Located in Los Angeles, this pottery was in business from 1945 or before, until at least 1957. Lehner speaks of, "...a line of Art Deco figurines and animal figures in quaint form," of which I assume the piece shown must be a part.

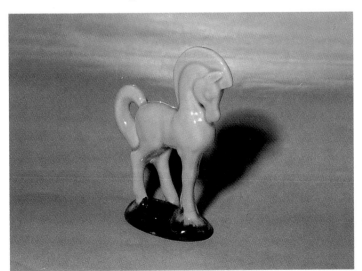

An unmarked Cemar horse, 4-1/2 inches high. Its bottom is shown. Estimated value: $15. *Private collection.*

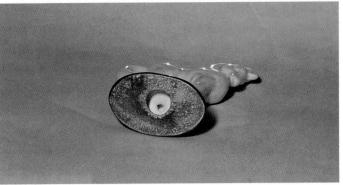

Telltale bottom of the Cemar horse. While I have only seen four or five Cemar figurines, each one that I have seen has exhibited this same burnt looking bottom.

Ceramicraft

Anchored in San Clemente, according to the mark, but no other information. The company did seem to like yellow and very dark blue.

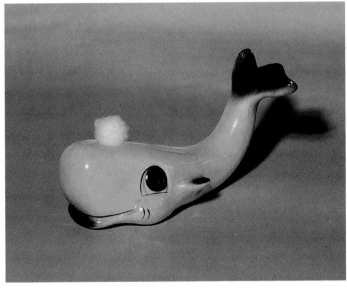

A Ceramicraft whale cotton holder which measures 3-1/4 x 6 inches. Its inkstamp is shown. Estimated value: $12. *Private Collection.*

Mark of the whale cotton holder.

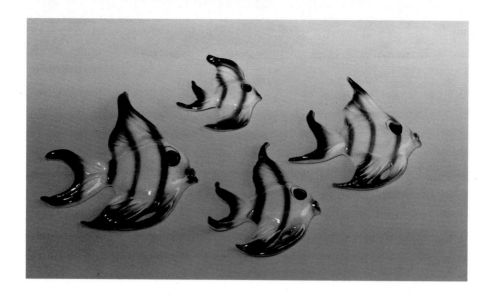

Heights of these fish wall plaques, left to right, are 7-1/2, 4, 5-1/2 and 5-3/4 inches. They are marked the same as the whale. Estimated value: $25 per set. *Private Collection.*

Claire Lerner Studios

Claire Lerner Studios, Los Angeles, is believed to have operated from the mid-1940s to the mid-1950s. The only figural pieces of which I am aware are of the type shown, which were made to decorate console sets.

Impressed mark of Claire Lerner mandolin player.

Like its mate above, this figurine stands 9 inches high. Its impressed mark reads "Claire Lerner / 236 / Calif." on three lines. Estimated value: $8. *Oravitz Collection.*

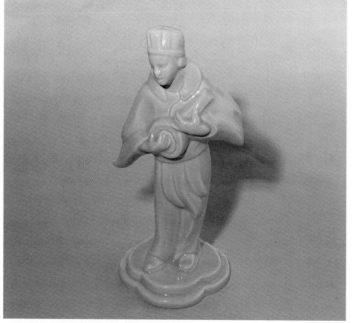

Oriental mandolin player, 9 inches high with a wonderfully readable mark that is shown. Estimated value: $8. *Private collection.*

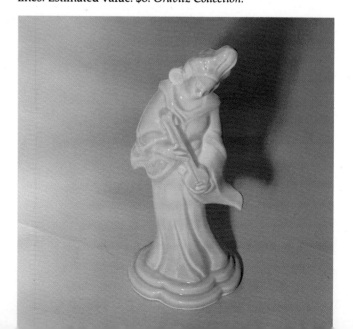

This planter depicting a frog pulling a snail, measures 3 x 7-1/2 inches. Its mark is shown. Estimated value: $30. *Private collection.*

These birds, which I have seen before as an accessory for a console set, are 9-1/2 inches high. The figurine is marked, "Claire / Lerner" on two lines by impression. Estimated value: $8. *Oravitz Collection.*

Clay Sketches

This Pasadena pottery was started by Cy and Edna Peterson in 1943. The original shop was at the corner of Mentor Avenue and Green Street, but volume soon demanded a move to larger facilities (5000 square feet) on South Chester. Over the years a succession of partners were brought in and later bought out as business conditions required or allowed. Eventually the pottery was wholly owned by the Petersons. It appears to have remained active until 1956 or 1957, although that date is not 100 percent sure. It may have continued on a time longer.

The bud vase with two birds on a branch was apparently the company's most popular piece. I believe it would be a rare occassion today if you went to a flea market, antique show or mall of any size and did not find one somewhere among the offerings.

The most commonly used mark of the pottery is the one shown below. Another seen quite often is Clay Sketches / by Ball-Calif., while yet another gives the location of Pasadena as Southern California.

Inkstamp mark of the Clay Sketches frog and snail planter.

The shore bird stands 12-1/2 inches high. It has an inkstamp mark, "Clay Sketches / Pasadena Calif.," on two lines. Estimated value: $25. *Oravitz Collection.*

A bud vase, 8-1/4 inches high. Its mark is shown. Estimated value: $18. *Courtesy of Rick and Jan Pleska.*

Mark of the bud vase.

Claysmiths, The *See Will-George*

Cleminson Clay *See California Cleminsons, The*

Dan Davis

The wallpocket shown here is the only example I recall seeing with this mark. The work has a professional quality about it, and the mark indicates Dan Davis was active in 1950.

This chicken wallpocket is the only Dan Davis piece I ran across. It is 6-1/2 inches high, and its mark is shown below. Estimated value: $25. *Oravitz Collection.*

Mark of the above Dan Davis rooster.

This flower holder measures 8-1/2 inches in height. It is marked the same as the frog and snail planter. Estimated value: $20. *Carson Collection.*

Davey, A.L.

All I have been able to determine for sure about this company is the information on its paper label, which gives the name and states it was located in Glendale. Considering the style of the planter, along with its metal accessory, it would seem the firm may have been active in the 1950s or 1960s.

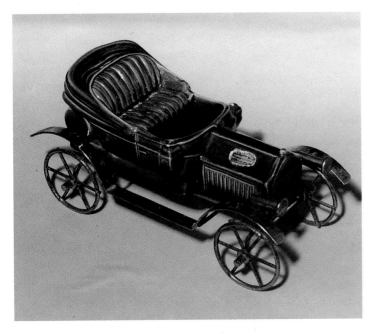

The metal frame of this automobile planter is 10-1/4 inches long. The planter itself is 8 inches long and 5-1/4 high, but there is a windshield missing that would made it somewhat higher. The paper label on the hood reads, "A.L. Davey / Ceramics / From California / Glendale," on four lines. Estimated value: $10 if perfect. *Private collection.*

Decora Ceramics

According to the June 1952 *Gift and Art Buyer*, Decora Ceramics was located at 136 North Ash Avenue, Inglewood. Pryor & Co. was its sales representative. While the quality of the company's work was quite high, it may have been a short-lived operation. Lehner also found them in trade literature from 1952, but not listed in either 1948 or 1954. She shows a slightly different mark than the one shown here.

This DeCora planter, similar to the Brayton Sally, is 6-3/4 inches high. Its mark is shown below. Estimated value: $18. *Oravitz Collection.*

Mark of DeCora girl planter.

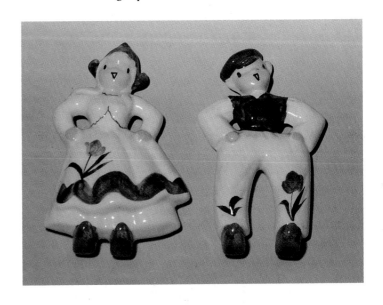

Nice pair of DeCora Dutch boy and girl wall plaques. The girl is 6-1/4 inches high with two inkstamps. One reads simply, "2111," while the other states, "DeCora Ceramics, Inc." The boy, 6 inches high, has a mark like the one shown above, plus the "2111" present on his mate. Estimated value: $50 per pair. *Oravitz Collection.*

De Lee Art

De Lee Art produced some top notch planters, and people and animal figures, too. It used both impressed marks and paper labels so identification is often just a matter of reading what is on the piece. Since De Lee used a rather distinctive mark, you can often recognize it even when it too light to read, as when a mold that was past its prime was used to form a piece. Note that a couple of the captions say "unreadable De Lee Art mark."

Style characteristics of many De Lee people figurines and planters include rather thin waists in combination with full skirts that form wide stable bases. Heads are generally tilted one way or another. Handpainted flower decoration is often present, too. De Lee Art pottery is fairly heavy.

According to a letter from Jack Chipman that appeared in the May-June 1991 issue of *Cookie Jarrin'-The Cookie Jar Newsletter*, De Lee stood for the names of the owners, *Delores* and *Lee* Mitchell. Chipman said Delores designed most of the pieces, carved most of the blocks, but that on occassion freelance designers were called upon, too.

De Lee Art was one of the few companies that often impressed copyright dates into its wares. The earliest I have seen is 1938, which appears on a *Sally* below. The company was still in business in 1952 as the *Mr. and Mrs. Skunk* planters shown appeared in the June issue of *The Gift and Art Buyer* that year. At that time the wholesale price was $1.25 each, and *Mrs. Skunk* wore a large hat.

According to information gleaned from various sources, this could almost be termed a nomadic pottery. In the above-mentioned ad, and on the hang tag shown, the address is given as 734 E. 12th Street, Los Angeles. Chipman, however, in his letter to *Cookie Jarrin'*, shows the address as 5413 West Washington Boulevard, Los Angeles. Two of the planters illustrated that carry copyright dates of 1940 and 1943, show the location as "L.A. U.S.A." But one from 1944 shows both L.A. and Hollywood, while one from 1947 shows only Hollywood. Go figure.

Sometimes you can identify De Lee pieces by the silver and black paper labels that state the names of the figures. Be aware, however, that other California potteries such as Robert Simmons Ceramics used the same labels.

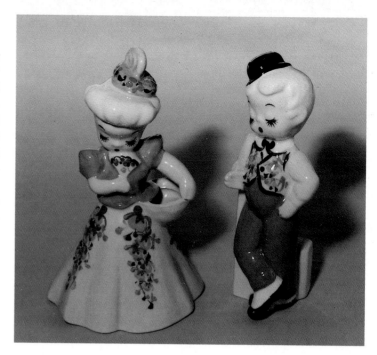

Girl and boy planters, 7-1/2 and 7-1/4 inches high. She is unmarked except for a De Lee Art paper label. He also sports a paper label in addition to an impressed mark, "De Lee / Art / © 43 / L.A." on four lines. As you can see in the other pictures, many De Lee Art figurines and planters carry silver and black name labels. I am not aware of the girl's name but have seen the boy with one that said *Hank*. Estimated value: $22 each. *Oravitz Collection.*

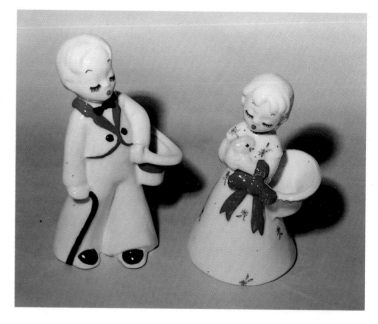

Another nice pair of planters. He is 7-1/4 inches high with an impressed mark, "De Lee Art / USA" on two lines. She stands 6-1/2 inches and has a more informative impressed mark, "De Lee Art / © 1938 / Sally" on three lines. Estimated value: $17 each. *Oravitz Collection.*

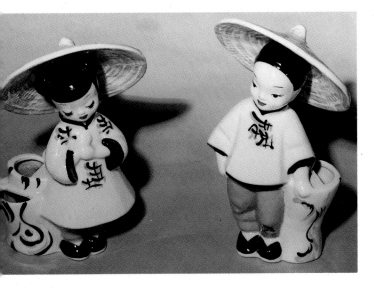

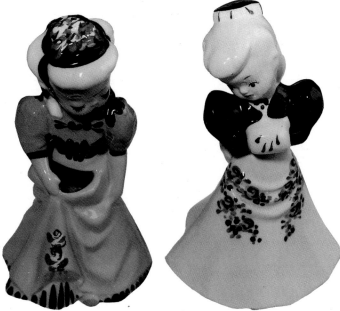

Chinese planters, 8-3/4 and 9-3/8 inches high. She has an impressed mark, "De Lee / Art / Hollywood / 1948 / ©" on five lines. His is similar, "De Lee / Art / Hollywood / © / 1943." Estimated value: $25 each. *Oravitz Collection.*

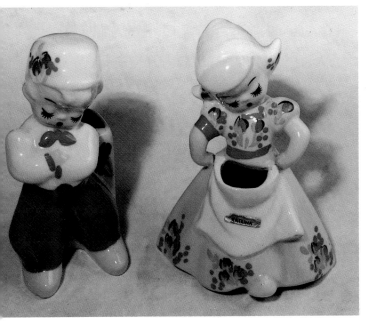

Height of each of these girls is 8-1/4 inches. Both are planters, the one on the right having the hole at the back. The pink planter is unmarked. The white one has a paper label in addition to, "De Lee / Art / Hollywood / © 1947" impressed on four lines. Estimated value: $20 each. *Oravitz Collection.*

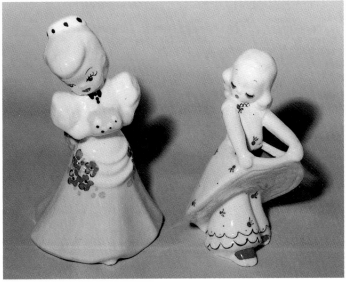

Dutch boy and girl, 7-3/4 and 7-1/4 inches high, respectively. Both have De Lee Art paper labels. *Katrina* (note the silver name label) has an impressed mark that is too light to be readable. Estimated value: $22 each. *Oravitz Collection.*

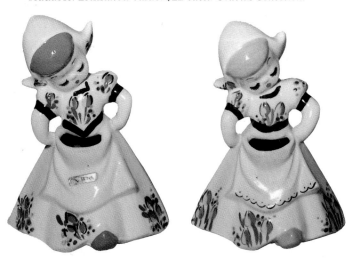

The planter on the left is the same as the one on the right directly above. The planter on the right stands 6-3/4 inches high, has an impressed mark, "De Lee / © 1940 LA / USA" on three lines. Estimated value: left $20, right $22. *Oravitz Collection.*

Two more *Katrinas*, and this time the impressed mark of the one on the right is clear enough to read. It says, "DeLee / Art / Hollywood © 44 LA / USA" on four lines. Estimated value: $22 each. *Oravitz Collection.*

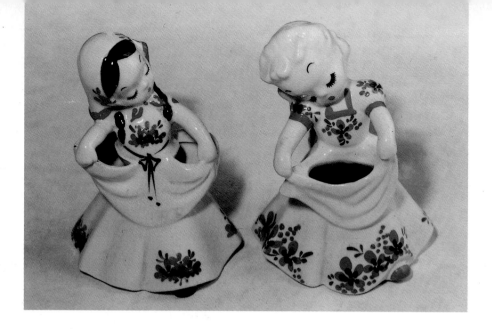

Height on the left is 6-1/2 inches. Height on the right is 7 inches. Both planters have unreadable but distinguishable De Lee Art marks impressed, which is a common occurrence with the products of this company. Estimated value: $20 each. *Oravitz Collection.*

This planter is 7-1/4 inches high. My notes show it to have an impressed De Lee mark but the exact wording was not recorded. Estimated value: $20. *Oravitz Collection.*

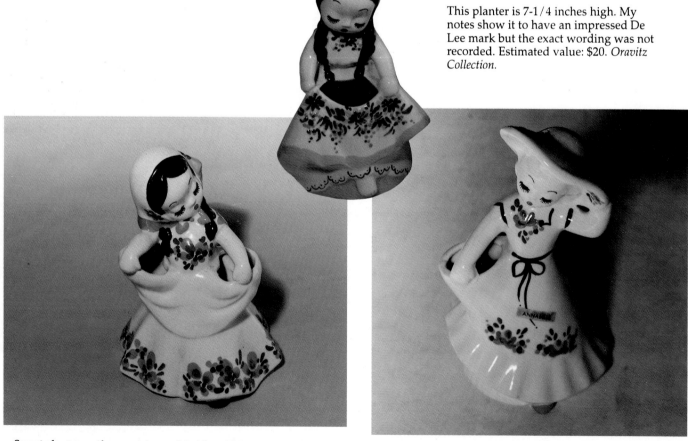

Same planter as the one trimmed in blue. This one, however, measured in at 6-3/4 inches instead of 6-1/2 inches. That's a common occurrence with any company. Estimated value: $20. *Oravitz Collection.*

Here is *Annabelle,* 7-3/4 inches high with a De Lee Art paper label and an unreadable impressed De Lee mark. Estimated value: $20. *Oravitz Collection.*

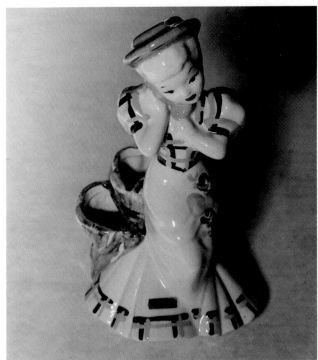

Two more De Lee planters with marks too light to read. Heights are 7-1/4 inches on the left, 6-3/8 inches on the right. Estimated value: $17 each. *Oravitz Collection.*

This is *Lou*, as her silver paper label states. She is 8-3/4 inches high. The impressed mark is "De Lee Art / of / California" on three lines. She also has a paper label. Estimated value: $20. *Oravitz Collection.*

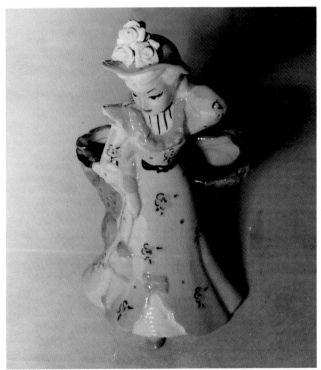

The girl on the left stands 7-3/4 inches high, the one on the right 6-1/2 inches. Neither is marked but the one on the left has a De Lee paper label. Estimated value: left $20, right $15. *Oravitz Collection.*

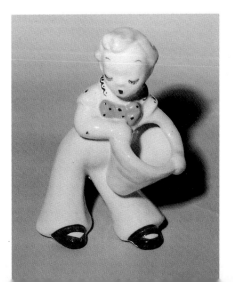

No marks or paper labels here, just a 9-1/2 inch high planter somewhat similar to *Lou*. Estimated value: $28. *Oravitz Collection.*

Boy planter, 6-1/2 inches high, no mark. Estimated value: $20. *Oravitz Collection.*

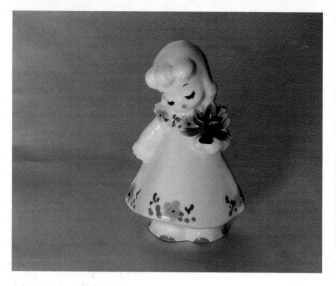

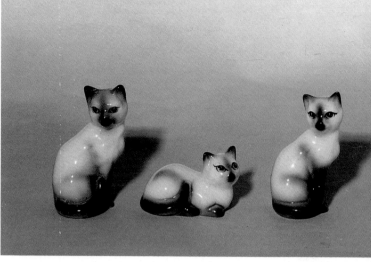

This girl figure, holding plastic flowers that appear to have come with it, stands 4-3/4 inches high. It is not marked. Estimated value: $15. *Courtesy of Dan Borgis.*

The Siamese cats on the ends are each 3-1/4 inches high, unmarked. They may look the same but they are not. Note that the tail of the one on the left ends behind the front leg, while the tail of the one on the right disappears into it. Differences like this are often the result of a redesigned mold; in this case I suspect the one on the right may have come first because the one on the left looks more natural. Now to the cat in the middle. It measures 1-5/8 x 2-1/2 inches and has a De Lee Art paper label. Estimated value: $8 each. *Private collection.*

Siamese cats, the one on the left being 4-1/4 x 7-1/4 inches, while the one on the right is 6 inches high. Neither is marked. Estimated value: $18 each. *Private collection.*

Two more unmarked cats. The left one measures 4 x 5-1/2 inches, the right one 5-1/2 inches high. Each is unmarked. Estimated value: $18 each. *Private collection.*

This cat was made to hang on the side of a fishbowl. Its length is 6-1/4 inches from the tip of its tail to the tip of its ear. It has a De Lee Art paper label. Estimated value: $25. *Private collection.*

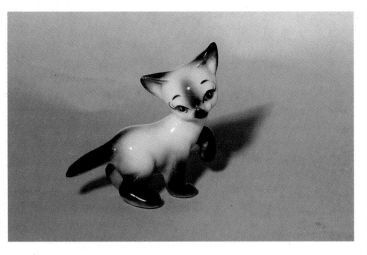

Height of this one is 3-1/2 inches. It is not marked. Estimated value: $12. *Private collection*.

Skunk figurine, 4-1/4 inches high. It has an unreadable impressed De Lee Art mark. Estimated value: $15. *Oravitz Collection*.

Figurine, Super Skunk, maybe? Height is 4-3/4 inches. It is unmarked. Estimated value: $20. *Oravitz Collection*.

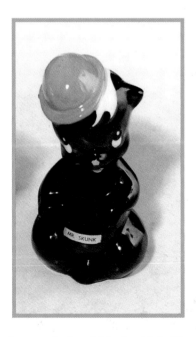

Skunk salt and pepper shakers *Snuffy* (left) and *Sniffy* (right). Height of each is 3-1/2 inches. No impressed marks but one of them has a De Lee Art paper label. Estimated value: $30 pair. *Oravitz Collection*.

This is *Mr. Skunk*, unmarked and 6 inches high. His companion would be *Mrs. Skunk*, who wears a large white hat with some extruded (screened clay) decoration which is rare for De Lee. Estimated value: $20. *Oravitz Collection*.

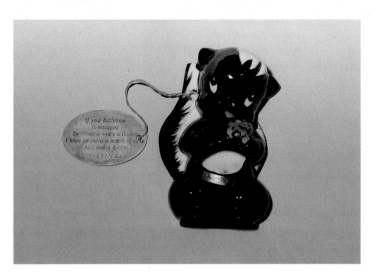

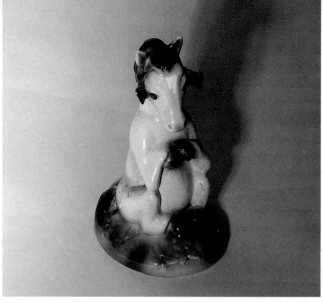

I always thought this was a wallpocket for flowers until I found this one bearing its original hang tag. *De-Stinker* is 5-1/8 inches high with an impressed "De Lee / Art / ©" on three lines. Another example that was photographed had a different impressed mark, "De Lee / Art / © / Destinker." Estimated value: $25. *Private collection.*

Except for the Siamese cats, which seem to lend themselves to it, this donkey figurine is the only airbrushed piece of De Lee I ever recall seeing. It is 7-1/4 inches high, has "De Lee / Art / ©" impressed on three lines. Estimated value: $22. *Oravitz Collection.*

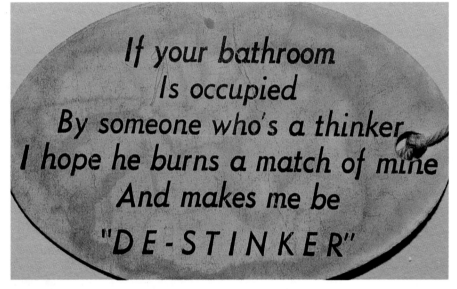

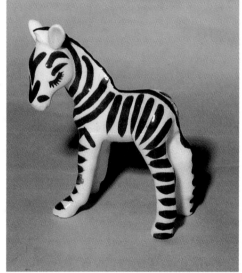

The verse on the hang tag reveals the real purpose of De Lee's skunk wallpocket.

The zebra figurine stands 5-1/2 inches high, has a De Lee paper label. Estimated value: $20. *Oravitz Collection.*

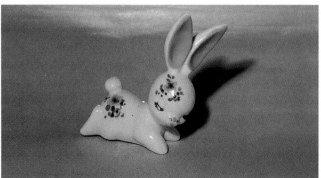

Opposite side of *De-Stinker's* hang tag showing the then-current De Lee Art address.

This bunny is 4 inches high. Impressed very lightly is, "De Lee / Art / © 1947." Estimated value: $12. *Private Collection.*

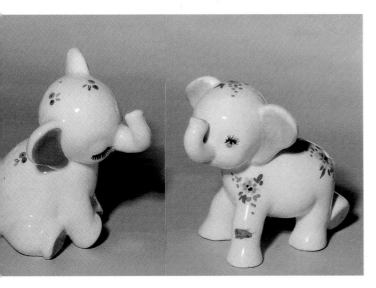

A pair of elephant figurines, 4-3/4 and 4 inches high left to right. The one on the left has a silver paper label that says *Happy*, in addition to a De Lee paper label and an unreadable impressed mark. The one on the right is unmarked with a remnant of a De Lee paper label. Estimated value: $15 each. *Oravitz Collection.*

Paper label of *Kitty*. All of the De Lee Art paper labels I have seen have been the same except that the size will vary according to the size of the piece it is on.

Puppy and lamb, 3-3/4 and 3-1/4 inches high, respectively. The puppy has "De Lee / Art / © 41" impressed on three lines. The lamb carries a De Lee paper label. Estimated value: $10 each. *Oravitz Collection.*

This piece has a silver name label that reads *Henny Penny*, which seems very appropriate since it is a bank. Height is 6 inches. There is also a De Lee Art paper label. Estimated value: $35. *Oravitz Collection.*

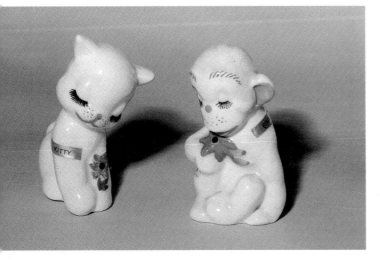

Cat and monkey better known as *Kitty* and *Bimbo* according to their silver name labels. *Kitty*, who has an unreadable impressed mark and a De Lee paper label, is 4-1/4 inches high. *Bimbo* also has a De Lee paper label and an impressed mark that can be read, "© 40 / De Lee / Art / USA" on four lines. Estimated value: $12 each. *Oravitz Collection.*

Edwina

The only reference I have ever seen to this pottery is by Derwich and Latos, where the authors simply state that no information was available other than it was located in Hollywood. Whoever Edwina was, she certainly did some very nice work.

El Cerrano

The only thing I have been able to find out about this pottery is its location, Hollywood, which is included in its mark.

This planter is 5-1/2 inches high. Its El Cerrano mark is shown. Estimated value: $12. *Oravitz Collection.*

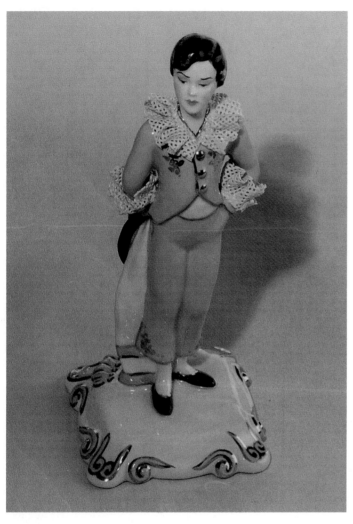

The bisque of this 7-5/8 inch high figurine is the same color as the base, an off white. Impressed on two lines is "Edwina / Hollywood" Estimated value: $25. *Private Collection.*

The El Cerrano mark of girl planter.

Elzac

A very elusive, if minor, pottery about which I have been able to find no information. In the picture below the boy is made of flesh color bisque while the bisque of the girl is white.

The boy figurine is 5-1/4 inches high. The girl is 5 inches. Neither has an in-mold mark but each carries a paper label, "Gift art by Elzac / Made in California." Estimated value: $18 each. *Private Collection.*

Evan K. Shaw *See American Pottery Company and Metlox*

Figurine by Zaida *See S-Quire Ceramics*

FLMP

Nothing is known (to me, anyway) about this pottery except what the mark of the donkey says, that it was located in Glendale.

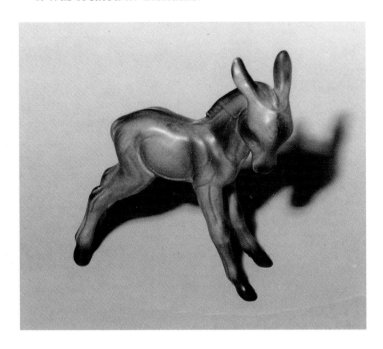

Somehow I forgot to measure this green donkey but as I recall it is on the small side, probably no more than 4 inches high. Its impressed mark, "© FLMP / Glendale / Calif" is shown. Estimated value: $8. *Oravitz Collection.*

Mark of above green donkey.

Florence Ceramics Company

Florence Ward, of Pasadena, began dabbling in ceramics in the early 1940s to take her mind off of the death of one of her two sons. Commercial efforts be-

gan in her garage in 1942, when both her husband, Clifford Sr., and surviving son, Clifford Jr., were away from home due to World War II. Upon their return both men worked at the business, and a move to larger quarters was required in 1946. In 1949 a still larger and more modern plant was secured at 74 South San Gabriel Boulevard. Eventually more than 100 people were employed there. The company was sold to Scripto Corporation in 1965 following the death of Clifford Ward Sr. one year earlier. Scripto made advertising ware under the Florence name until the plant closed in 1977. It did not make Florence figurines.

Florence Ceramics was one company that apparently didn't think twice about standing up to unfair competitors. According to an article in the October 1955 issue of *China Glass & Tablewares*, the firm won a lawsuit against the George Zolton Lefton Company and Lefton Pacific, Inc., in which Florence charged Lefton was importing Japanese figurines that infringed upon Florence copyrights. In the the settlement Florence received $4725, and Lefton was enjoined from "...future importing, selling, distributing, and causing to have made any figurines which infringed upon Florence copyrights," according to the magazine.

Sometimes confusion exists between the Florence Ceramics Company and the Florence Pottery. They were not connected. Florence Pottery, which was managed by Lawton Gonder before he founded Gonder Ceramic Arts, and which made pottery for Rumrill, was located in Mt. Gilead, Ohio. It was destroyed by fire in 1941.

In addition to the pieces shown here, Florence Ceramics made some truly breathtaking pieces that I was not fortunate enough to locate and photograph. Some to be on the lookout for would include *Cinderella and Prince Charming,* 11-1/2 inches high, *Pinkie* and *Blue Boy* 12 inches, *Louis XV* and *Madame Pompadour* 12-1/2 inches, and *Lillian Russell* 13-1/4 inches. Additionally, *Virginia* and *Caroline,* from the *Fashions in Brocade* line, each stand 15 inches high. Also not shown are seated pieces such as *Catherine,* 7-3/4 x 6-3/4, and *Victoria,* 8-1/4 x 7, in which the figurines appear sitting on Victorian love seats or couches.

One more thing we should discuss before going on is the status of Florence figurines as collectibles. For some reason the collecting public doesn't seem taken by them, at least in the midwest where I live. When set out at antique shows and tagged in the $40 to $100 price range, depending upon size and complexity, they do little more than collect dust. That fact, combined with their obvious high quality, might make them a perfect target for one who either has limited funds, or who wishes to spectulate in California pottery.

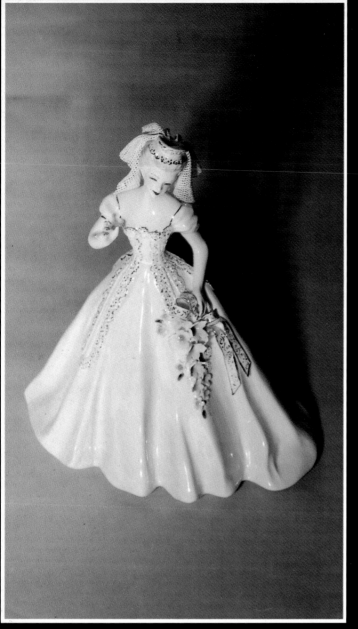

The *Bride* is 8-3/4 inches high. She has a standard Florence inkstamp. Note the separated fingers. Estimated value: $115. *Carson Collection.*

Vivian, 10 inches high with a Florence inkstamp, along with her name impressed. Estimated value: $100. *Carson Collection.*

A 10 inch high figure, Florence inkstamp, *Georgette* impressed.
Estimated value: $100. *Carson Collection*.

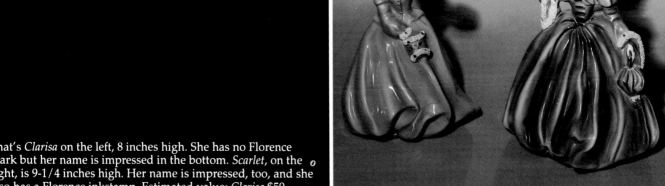

That's *Clarisa* on the left, 8 inches high. She has no Florence
mark but her name is impressed in the bottom. *Scarlet*, on the
right, is 9-1/4 inches high. Her name is impressed, too, and she
also has a Florence inkstamp. Estimated value: *Clarisa* $50,
Scarlett $70. Carson Collection.

This is *Rhett*, 9-1/4 inches high. He has a standard Florence mark. Estimated value: $100. *Carson Collection*.

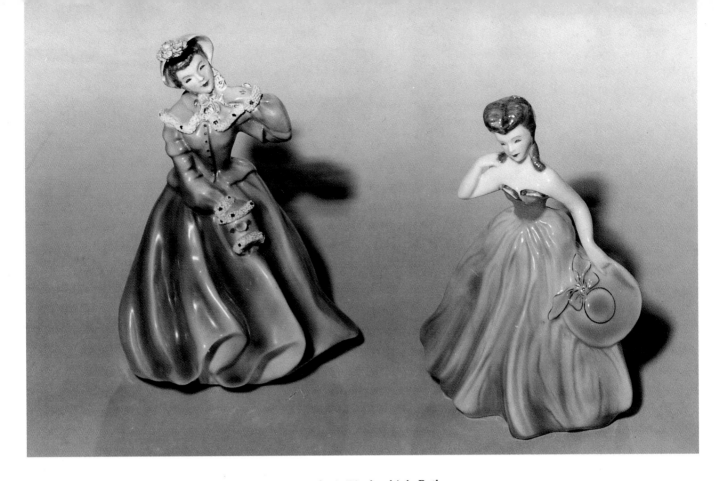

Another *Clarisa*, and *Nancy*, who is 7 inches high. Both are marked. Both have impressed names. Estimated value: *Clarisa* $50, *Nancy* $40. *Carson Collection.*

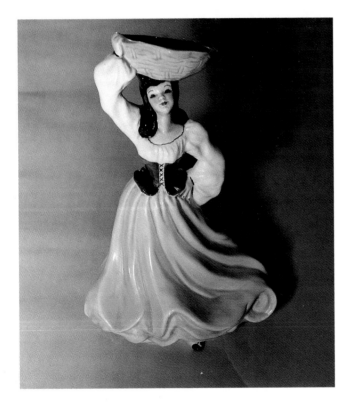

Standing 10-3/4 inches high, this is *Ava*. The figurine is not marked, nor is the name impressed. Estimated value: $80. *Carson Collection.*

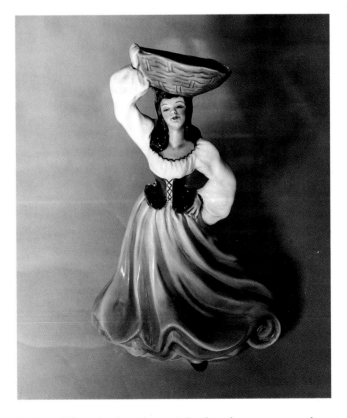

Ava in a different color scheme. Like the other one, no mark or name. Estimated value: $80. *Carson Collection.*

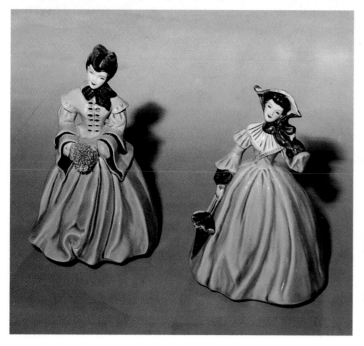

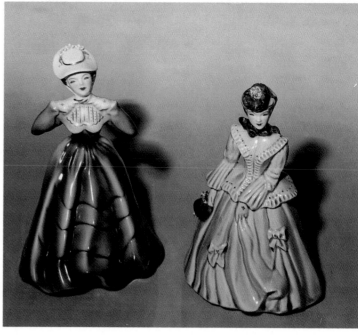

On the left is *Delia*, 8-1/4 inches high. *Louise*, 7-3/4 inches high, is on the right. Both have Florence marks, both have their names impressed. Estimated value: *Delia* $55, *Louise* $55. *Carson Collection.*

The lady in the green dress is *Laura*, 7-1/4 inches high. The one in the gray outfit is *Sarah*, of course, 7-3/4 inches. Both have inkstamps and names on their bottoms. Estimated value: *Laura* $60, *Sarah* $60. *Carson Collection.*

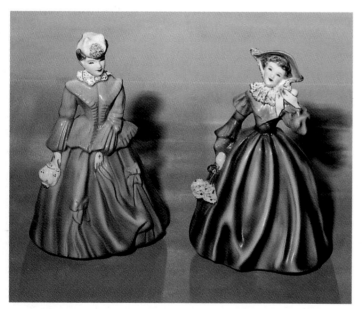

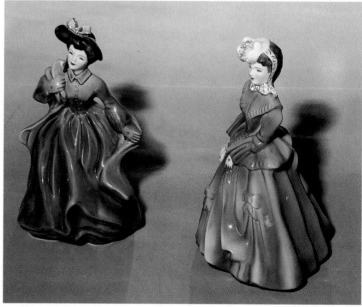

Sarah, on the left, is 7-3/4 inches high. This *Louise*, at 7-1/2 inches, is a tad shorter than the gray model. Both are marked, each has its name impressed. Estimated value: *Sarah* $60, *Louise* $55. *Carson Collection.*

Two ladies in blue, *Ethel* and *Sarah*, each 7-3/4 inches high. Both are marked. Both are named. Estimated value: *Ethel* $50, *Sarah* $60. *Carson Collection.*

This figure has *Ann* impressed in the bottom. It is 6-1/8 inches high, and carries a Florence inkstamp. Estimated value: $60. *Carson Collection.*

Edith stands 7-1/2 inches high. She is marked and named. Estimated value: $65. *Carson Collection.*

This is *Diane*, 8-1/2 inches high, with an inkstamp, an impressed name, and a tag, parts of which are shown. Estimated value: $60. *Carson Collection.*

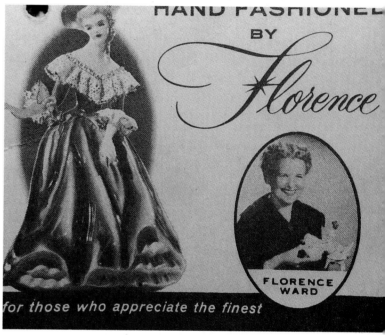

This figure is 6-1/8 inches high. She carries a Florence inkstamp with *Elaine* impressed. Estimated value: $40. *Carson Collection.*

Front of the hang tag.

The shorter figure here is *Sue*, 5-1/4 inches high with a Florence inkstamp and her name impressed. The marks are unreadable on the taller one, which is 7-1/2 inches high. Estimated value: *Sue* $40, other unknown. *Carson Collection.*

"*...a thing of beauty is a j[oy]*

Personally created by Florence Ward, every Florence Figurine is an individual work of art. More than sixty delicate hand operations by highly specialized artists make each Figurine an exact, life-like counterpart of the original model. Exquisite China colors, rich touches of 22K gold and authentic period costumes give Florence Figurines an heirloom loveliness that can be handed down from generation to generation.

Florence FIGURIN[E]

Inside of hang tag.

THE PERFECT *Gift!*

Florence Figurines are always in excellent taste as a most welcome gift, to be treasured for a lifetime. Like few other fine gifts, a Florence Figurine becomes the incentive for a choice collection to which you can add on succeeding occasions.

FLORENCE CERAMICS CO. 74 S. San Gabriel Blvd., Pasadena, Ca

Back of hang tag.

rever..."

FACE—Deft artistry brings the charm of living colors to every facial detail.
LACE—Imported real lace, all hand-applied, is impregnated with clay and fired to preserve its rare beauty indefinitely.
ARMS AND HANDS —These delicate parts have to be molded separately and added to the semi-moist figurines with infinite care.
DRESS FOLDS—There's no way to mold dress folds, so each segment must be meticulously hand-formed and applied by a skilled artisan.

[F]inest in the American Tradition

Inside of hang tag.

These figures are each 6 inches high. They have Florence inkstamps in addition to the name *Irene*. Estimated value: $35 each. *Carson Collection*.

Here's *Ellen*, 6-3/4 inches high. She carries a Florence inkstamp and an impressed name. Estimated value: $45. *Carson Collection*.

The inkstamp mark of *Kay*.

The pink lady is *Dolores*, the gray one *Lillian*. Heights are 8-1/2 and 7-3/4 inches, respectively. Both have their names impressed. *Dolores* doesn't have a Florence inkstamp, *Lillian* does. Estimated value: *Dolores* $65, *Lillian* $65. *Carson Collection*.

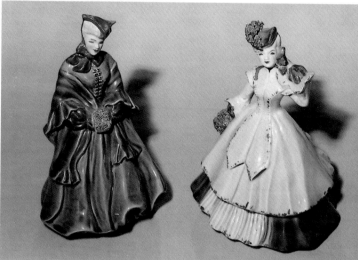

On the left is *Camille*, on the right *Matilda*. Heights are 9 and 8-1/2 inches, respectively. Both are marked and named. Estimated value: *Camille* $80, *Matilda* $60. *Carson Collection*.

The shorter figure here is *Kay*, 6-1/4 inches high. She is marked and named. Her mark is shown. As with the blue model, *Dolores*, is 8-1/2 inches high, and this time is marked. Estimated value: *Kay* $45, *Dolores* $65. *Carson Collection*.

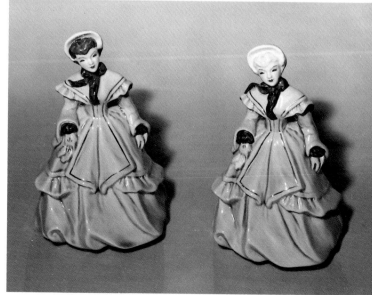

Here is a pair of *Melanies*, each 8-3/4 inches high, and both marked and named. Note that their scarves are applied differently. Estimated value: $50 each. *Carson Collection*.

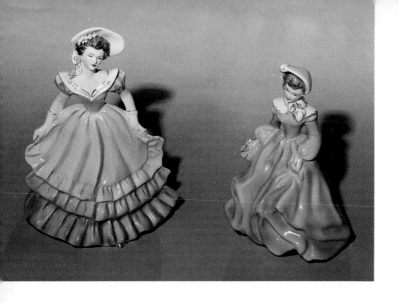

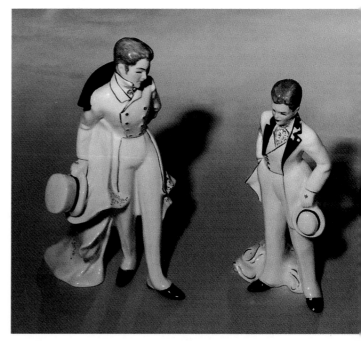

The tall lady in pink is *Jennifer*, the short lady in pink is *Sally*. They are 8-1/8 and 7 inches high. Each is marked and named. Estimated value: *Jennifer* $55, *Sally* $45. *Carson Collection*.

Two versions of *Douglas*, both marked and named. Height is 8-1/4 inches. Estimated value: $35 each. *Carson Collection*.

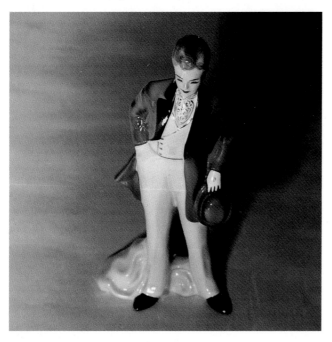

Gary, both marked and named, is 8-1/2 inches high. Estimated value: $75. *Carson Collection*.

This is *Victor* on the left, 9-1/2 inches high, *Gary* on the right, 8-1/2 inches high. Each has its name impressed but neither has a Florence inkstamp. Estimated value: *Victor* $70, *Gary* $45. *Carson Collection*.

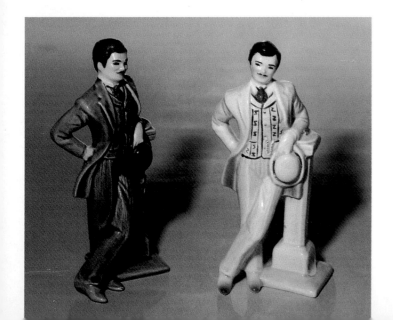

Two *Jims*, 6-1/4 inches high. Neither has a Florence mark, both bear inkstamps of their name. Estimated value: $40 each. *Carson Collection*.

This figure, 7-3/8 inches is not marked in any way. I am not aware of his name. Estimated value: $50. *Carson Collection*.

Paper label of the unmarked boy figurine.

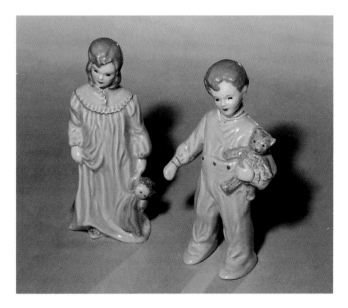

The little girl, 5-1/2 inches high, is *Wynkin*. The little boy is *Blynkin*. He is 5-3/8 inches high. The only mark on this pair is *Wynkin's* name impressed. According to a Florence catalog, they were made in pink or blue only. Estimated value: *Wynkin* $50, *Blynkin* $50. *Carson Collection*.

This unmarked figure is named *Mike*. It is 6-1/4 inches high. Estimated value: $65. *Graettinger Collection*.

These figurines are almost the same height, 5-7/8 inches for the boy, 5-3/4 inches for the girl. Neither is marked, each has a paper label, an example of which is shown. Estimated value: $50 each. *Oravitz Collection*.

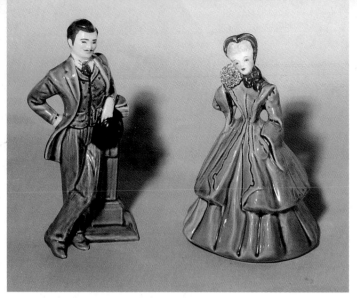

A pair of figurines named *Jim* and *Irene*, according to their incised marks. *Jim* is 6 inches high, *Irene* 5-3/4 inches. Each has a Florence Ceramics gold stamp. Estimated value: $45 each. *Private Collection.*

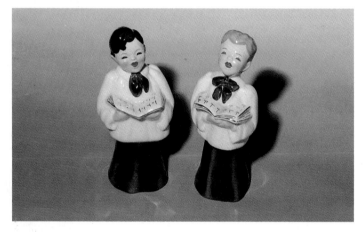

These *Choir Boys*, two of the three the company made, each has Florence inkstamps. The one on the left is 5-3/4 inches high, the one on the right 6-1/4 inches. Estimated value: $35 each. *Oravitz Collection.*

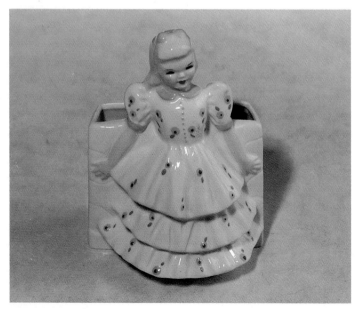

Height here is 6 inches. Inkstamp mark reads "Pasadena / Florence / Ceramics / California" on four lines. Estimated value: $30. *Oravitz Collection.*

This planter is 6-1/2 inches high. Its mark is simply "Florence / Ceramics," a two-line inkstamp. Estimated value: $30. *Oravitz Collection.*

This planter is 6-1/4 inches high. It has an inkstamp mark, "Pasadena / Florence / Ceramics / California" on four lines. Estimated value: $30. *Oravitz Collection.*

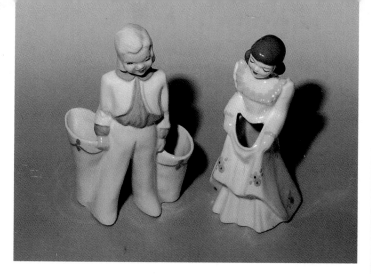

The boy is 7 inches high. It is marked but not named. The girl is 6-1/2 inches high. She is not marked. Estimated value: $45 each. *Carson Collection.*

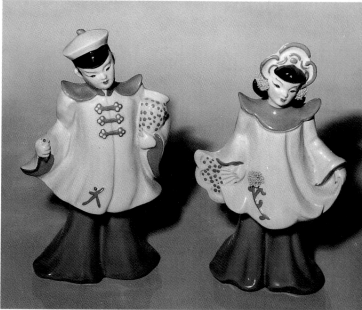

The *Chinese Boy* and *Chinese Girl* planters are each 8-1/4 inches high. Each has a Florence inkstamp. Estimated value: $20 each. *Carson Collection.*

This is a planter, 6 inches high. It has the normal inkstamp mark, "Pasadena / Florence / Ceramics / California" on four lines. Estimated value: $30. *Oravitz Collection.*

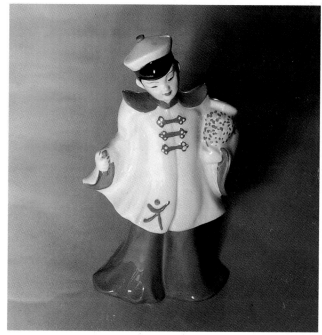

The *Chinese Boy* in blue. Estimated value: $20. *Carson Collection.*

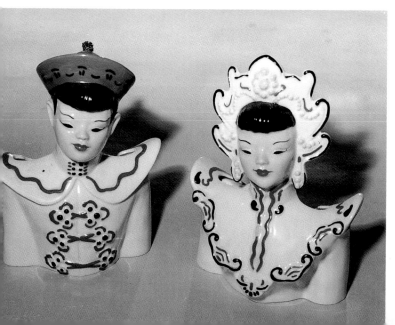

A pair of vases. *Shen* is on the left, *Yulan* is on the right. Heights are 8 and 8-1/4 inches, respectively. Both have Florence marks. Estimated value: $25 each. *Carson Collection.*

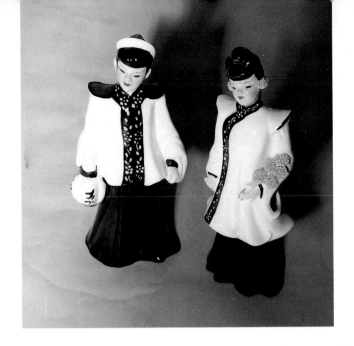

These are the *Lantern Boy* and *Blossom Girl* planters. He is 8-1/2 inches high; she is 8-3/4 inches high. Neither is marked. Estimated value: $20 each. *Carson Collection.*

No names here. No marks, either. Heights of these two planters, left to right, are 6-3/4 and 6-1/2 inches. Estimated value: $30 each. *Carson Collection.*

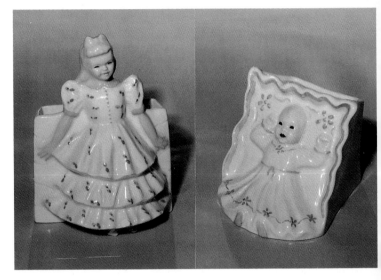

The planter on the left is 6-3/8 inches high. The one on the right is 3-3/4 inches high. Neither is marked. Estimated value: left $30, right $15. *Carson Collection.*

The name of this 6-1/2 inch high unmarked planter is *Wendy*. Estimated value: $25. *Carson Collection.*

There is *Wendy* again in the center 6-1/2 inches high, *Emily* on the right 8-1/4 inches. I am not aware of the name of the 7 inch planter on the left. Estimated value: left $25, center $25, right $30. *Carson Collection.*

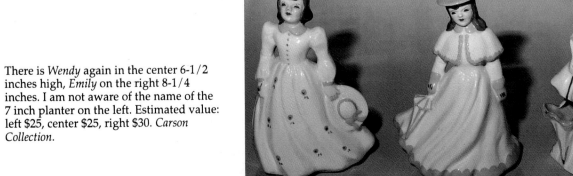

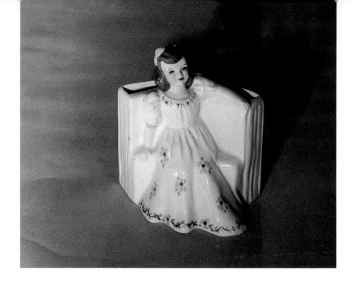

This is *May*, 5-1/2 inches high with a Florence inkstamp. Estimated value: $25. *Carson Collection.*

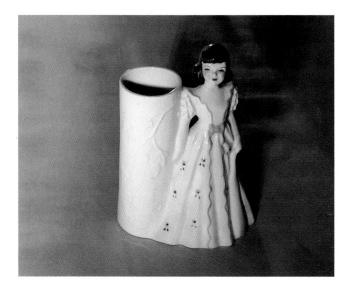

Molly is 6-3/4 inches high, and is not marked. Estimated value: $25. *Carson Collection.*

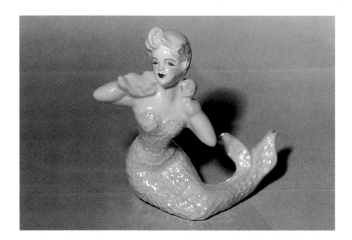

Florence's mermaids were billed as *Merrymaids*. This one is *Betty*, 4-3/4 inches high, and carrying a Florence inkstamp. Two others were *Jane*, also sitting, and *Rosie*, lying. Estimated value: *Betty* $70, *Jane* and *Rosie* (not shown) $80 each. *Carson Collection.*

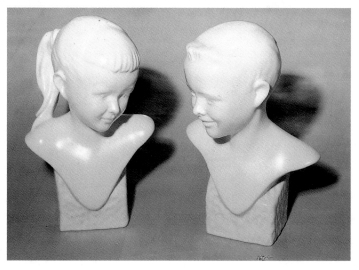

The height of each of these figures is 9-3/4 inches. Each carries a Florence mark. The catalog referred to them as *Girl Bust, Modern*, and *Boy Bust, Modern.* Estimated value: $25 each. *Carson Collection.*

This plaque was identified as *P7* in Florence catalogs. It came in gray, as shown, and also brown and orange. Height of the plaque is 7-1/4 inches. Its mark is shown. Estimated value: $25. *Carson Collection.*

Standard Florence inkstamp on *P7* plaque.

Each of these plaques is 9 inches high. Each carries a Florence inkstamp. Company catalogs identified them as *Figurine Plaque (with muff)* and *Figurine Plaque (with fan)*. Estimated value: $35 each. *Carson Collection.*

A Florence pin, 2-1/8 inches high. Its mark is shown. Estimated value: $60. *Carson Collection.*

This is the *Nosegay* frame, 5-3/4 inches high. It is marked, "Pat-Pend / Florence Ceramics / California," impressed on three lines. These frames came in three sizes, according to Florence catalogs, 3 x 4, 4 x 5 (shown), and 5 x 7 inches. Estimated value: 3 x 4 $12, 4 x 5 $15, 5 x 7 $18. *Carson Collection.*

Back of the pin.

Fred Kaye Ceramics

Can't state positively that this company was in California. However, since Chipman mentions Fred Kaye as a designer who worked for Brad Keeler, it seems likely that it may have been.

The only other Fred Kaye Ceramics piece I have seen was a dandy looking racoon planter that I sold before I realized the possible California connection.

Heights left to right are 1-7/8, 1-1/2, 1-1/2, 2, and 2 inches. The chipmunk at far left has two inkstamps, "632," and "Made in USA." The inkstamps of the remaining four all read the same, "Fred Kaye / © / Ceramics," on three lines. Estimated value: $5 each. *Oravitz Collection.*

Freeman-McFarlin

Gerald McFarlin founded McFarlin Potteries in El Monte in 1927. (See that listing for an example.) In 1951 he entered a partnership with Maynard Anthony Freeman, at which time the name was changed to Freeman-McFarlin. A second plant, this one in San Marcos, began operating in 1968. In 1975 the original factory in El Monte was shut down in favor of the more modern San Marcos facility. Toward the end of the 1960s McFarlin sold his share of the enterprise and retired. Then in 1972 Freeman and his new partners sold out to International Multifoods. Eight years later Hagen-Renaker bought the whole shebang-building, molds, glazes, etc.

Freeman was the firm's top designer, although others were used, too, including Kay Finch in the 1970s. Most of Freeman's pieces are marked "Anthony." The brown and white pieces shown are all marked "Anthony," and because of their extremely light weight, dull glazes and in mold marks that look incised, they are often mistaken for home ceramic efforts. But close scrutiny with a discerning eye will peg them as something far beyond the efforts of a 1950s era hobbyist.

Aside from the low luster and matte glaze shown, their most popular products appear to have been dresser caddies, a couple of which are displayed. Dresser caddies are often mistaken for planters, and sometimes used as them.

There are two more problems you might run into with Freeman-McFarlin. One is that when Kay Finch closed her business in 1963 Freeman-McFarlin bought her molds and continued using them. But since they decorated in their own style and not hers, it is very easy to tell the difference.

The other thing you may find is Freeman-McFarlin pieces with Hagen-Renaker paper labels. According to Gayle Roller, Kathleen Rose and Joan Berkwitz in *The Hagen-Renaker Handbook* (privately printed, 1989), when Hagen-Renaker purchased Freeman-McFarlin from International Multifoods in the early 1980s, it referred to it as a division, and continued making and marketing the Freeman-McFarlin line, even adding a few of their own designs, before closing it in 1986. The possibility exists that a few of the later Freeman-McFarlin pieces may have left the factory with Hagen-Renaker stickers on them.

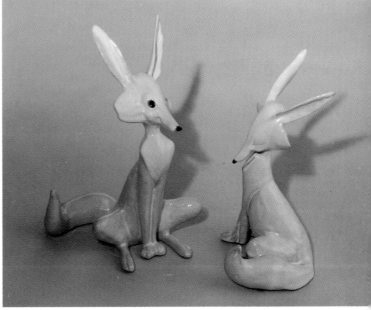

These stylized coyotes are fairly tall at 10 and 9 inches. The larger one (eyes open) has "144 Anthony" impressed on the bottom. Estimated value: $40 each. *Private Collection.*

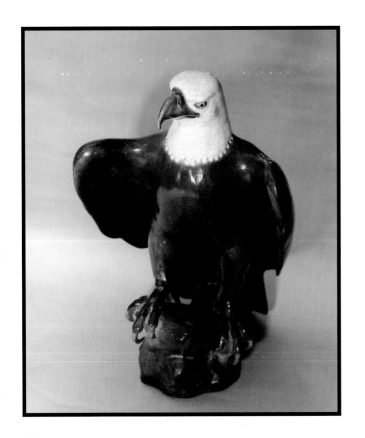

A large piece, this eagle figure stands 12-3/4 inches high. Its impressed mark reads "Anthony / © / Calif. USA / 120" on four lines. Estimated value: $75. *Private Collection.*

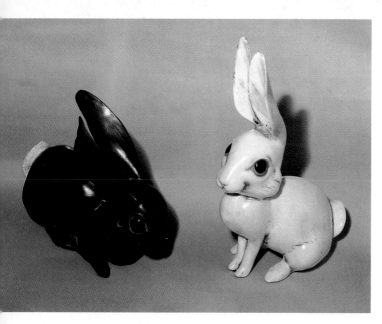

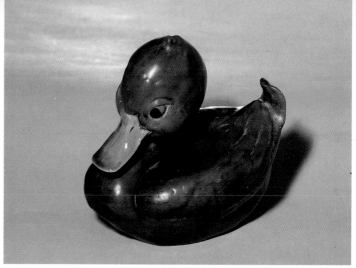

The duckling is 5 inches high, has "Anthony / © / USA 126" impressed. Estimated value: $15. *Private Collection.*

The brown rabbit is 6-1/2 inches high, the white rabbit 10-3/4 inches. Mark of the brown rabbit is "Anthony © / USA M5" impressed on 2 lines. Mark of the white rabbit, and its paper label, is shown below. Estimated value: $25 each. *Private Collection.*

Impressed mark of the white rabbit above.

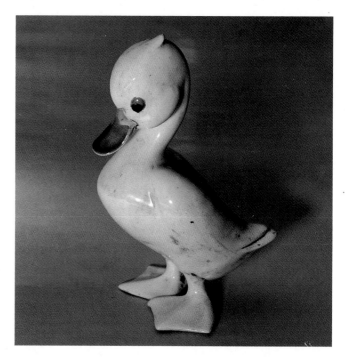

Another duckling, probably a mate, as its number is 125. It is 7-3/4 inches high with an impressed mark, "Anthony / 125 / BR / © USA" on four lines. Estimated value: $15. *Private Collection.*

The strange looking owl stands 5-3/4 inches high, is unmarked but has a Freeman-McFarlin paper label. Estimated value: $18. *Private Collection.*

Paper label of the white rabbit above.

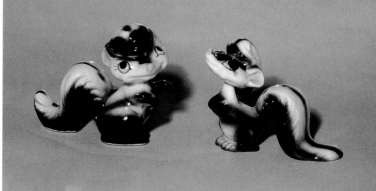

Interesting situation here. Although the two skunks bear several similarities, they were not done by the same company. The Freeman-McFarlin piece is the one on the right, a bobble head 2-7/8 inches high. It has a Freeman-McFarlin paper label which is shown below. The piece on the left, also 2-7/8 inches high but imported from Japan, is inkstamped "© / Kreiss / 1955" on three lines. Estimated value: left: $10, right $10. *Private Collection.*

A gold cat, 7-1/2 inches high. It has an impressed mark but only the words "Anthony, © 1970," and "USA" are visible due to felt pads such as those shown on the bottom of the rabbit. I find those pads on most pieces of Freeman-McFarlin pottery so I assume they must have been applied at the factory. Estimated value: $20. *Private Collection.*

Paper label of bobble head skunk.

This mouse is larger than it looks, 5-3/4 inches high. It is marked, "142 / Anthony / USA / 1970," impressed on four lines. Estimated value: $15. *Oravitz Collection.*

Heights of the purple cows are, left to right, 3-3/4, 2-1/4, and 4 inches. The one on the left has a paper label, "Freeman-McFarlin / Originals / © / El Monte Calif.," on four lines. The other two are not marked. Estimated value: $25 per set. *Oravitz Collection.*

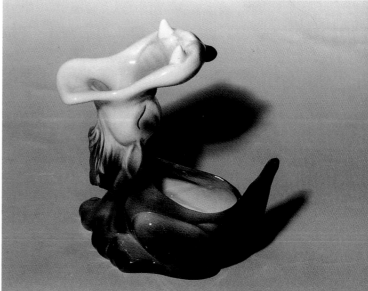

This is a dresser caddie, planter, or both depending upon how an owner chooses to use it. It is 7 inches high, has a Freeman-McFarlin paper label like that of the skunk. Estimated value: $15. *Private Collection.*

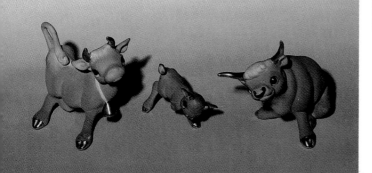

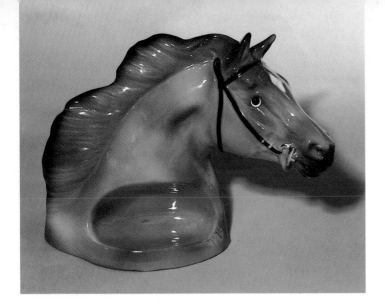

Horse dresser caddie or planter, 6-1/8 x 8-1/4 inches. It has a long slot in back for a wallet or plant. It also has an unreadable mold mark along with a Freeman-McFarlin paper label which is shown. Estimated value: $15. *Private Collection.*

Freeman-McFarlin paper label of horse dresser caddie.

Geppetto Pottery, *See Brayton Laguna*

Gilner

Probably best known for its mammy head cookie jar that has now been reproduced into oblivion, Gilner was located in Culver City. The earliest mark shown here is 1952 but I have heard of a 1951 mark from people I consider trustworthy. It may, of course, have been in business long before that.

According to Fred and Joyce Herndon Roerig in *The Collector's Encyclopedia of Cookie Jars-Book II* (Col-

lector Books, 1994), a fire destroyed the plant in 1957. Immediately after the fire Gilner struck an agreement with California Originals that amounted to California Originals manufacturing the Gilner line so Gilner could fullfil its existing orders while rebuilding. After several months, however, Gilner decided not to rebuild, and sold out to California Originals, which continued to manufacturer many Gilner designs, presumably under the California Originals name. California Originals also absorbed some of Gilner's more important employees.

Both of the greens shown are often seen on Gilner pieces. Pixies and native boys and girls are typical themes. Wallpockets, with fruit on them, were made, too.

A television planter, 5-3/16 inches high. Impressed mark is simple and straight forward, "Gilner." Estimated value: $5. *Oravitz Collection.*

The planter, on the right, measures 5-3/4 x 9 inches. It is not marked. The ashtray, or miscellaneous dish, on the left was not measured but has an impressed mark, "Gilner / Calif 1952" on two lines with "©" impressed in a separate area. Estimated value: $10 each. *Oravitz Collection.*

Goldammer Ceramics

This is another mystery company about which little is known. All five pieces shown carry the same paper label, which indicates the firm was located in San Francisco, yet the planters themselves have a distinctly southern California look about them. As very few things are for sure in the California pottery game, the possibility exists that Goldammer Ceramics may not have been a pottery at all but simply a northern California marketing firm that dealt in southern California pottery. Goldammer pottery appears to be of average weight. All of the pieces I have seen have been hand decorated, not airbrushed.

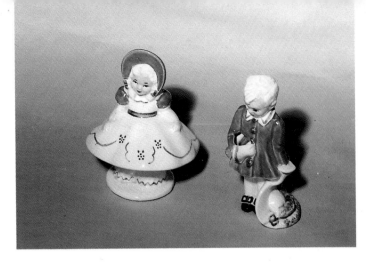

Two planters, each 5-3/4 inches high. The girl has a remnant of a Goldammer paper label while the boy carries an octagon paper label that is shown below. Estimated value: $12 each. *Oravitz Collection.*

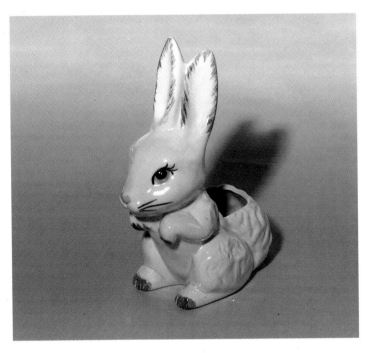

This pink rabbit planter is 7-1/4 inches high. Its paper label is shown below. Estimated value: $18. *Oravitz Collection.*

Octagon paper label of above boy.

Paper label of pink rabbit planter.

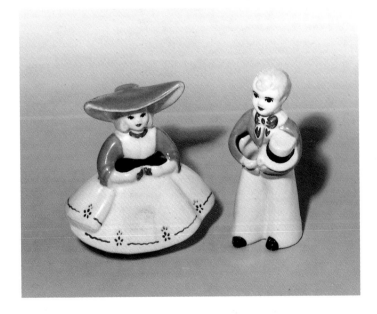

Heights here are 5-1/4 inches on the left, 5-3/4 inches on the right. Each planter has a Goldammer paper label. Estimated value: $10 each. *Oravitz Collection.*

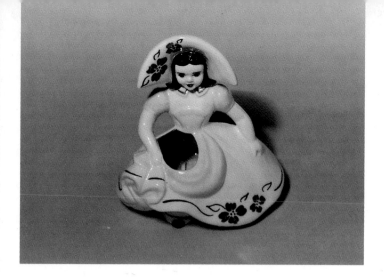

A 6 inch high planter with a Goldammer paper label. Estimated value: $12. *Oravitz Collection.*

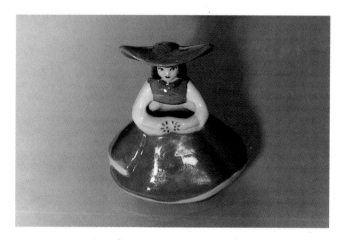

This planter is like the one standing next to the boy but is unmarked except for a curious inkstamp, "2079." Estimated value: $10. *Oravitz Collection.*

Hagen-Renaker

This company, still in business today making miniatures, was started just after World War II. Over the years it has attracted an almost cult-like following. Most collectors are reluctant to have their pieces photographed, or to even discuss them. And when you mention prices, which can run up to $1000 or more, they clam up tighter than a submarine on a deep dive, apparently afraid the word will get out to the general public and they will no longer be able to pick up flea market or garage sale bargains.

So here is a little public education about this almost unknown company.

Hagen-Renaker was founded in 1946, in Monrovia, by John and Maxine Renaker. Financial backing is said to have come from Maxine Renaker's father, Ole Hagen. John Renaker had previously been employed by the Walker Potteries, also of Monrovia. The company moved to San Dimas in 1966. In 1980 it purchased the San Marcos plant of Freeman-McFarlin as a second manufacturing base, then closed it down and sold it in 1986.

Fairly early on Maxine Renaker began modelling miniature animals which became very popular and still are today. They are currently sold in gift shops and at antique shows. While most newer and current miniatures sell for a couple dollars to about $15, some of the older ones are quite pricey, especially those made under a Disney license during the late 1950s. *Nanny* the St. Bernard from *Peter Pan*, currently brings about $75, even though it is only 1-1/2 inches high. *Ruffles*, from *Lady and the Tramp*, only 5/8 of an inch high, goes for $30 to $40. But the grande dame of Hagen-Renaker miniatures is *Malificent*, the witch from *Sleeping Beauty*. Only 1-1/2 inches high, the asking price often tops $1000!

The main goal of many Hagen-Renaker collectors is to acquire the numerous horses of the Designer Workshop line, a line that also included other animals. The *Amir* shown, while rather benign at first glance, currently commands about $150. Others sell for $800 or $900 or more. Other Designer Workshop animals bring good money, as do pieces from the Pedigree Dogs line.

According to Chipman, Maureen Love Calvert modelled most of the horses, Helen Perrin Farnlund the majority of miniatures, and Tom Masterson the Pedigree Dogs line. Another pair of designers who worked for Hagen-Renaker from time to time are Will Climes (Will-George) and Don Winton (Twin Winton), with whom you may be familiar.

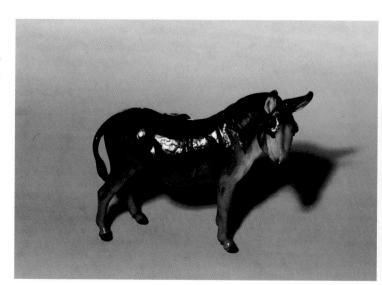

Adelaide is a jenny donkey, 5-3/8 inches high, that was offered a total of 28 seasons beginning in 1956 and ending in 1986. No mark except for the paper label. Estimated value: $125. *Private Collection.*

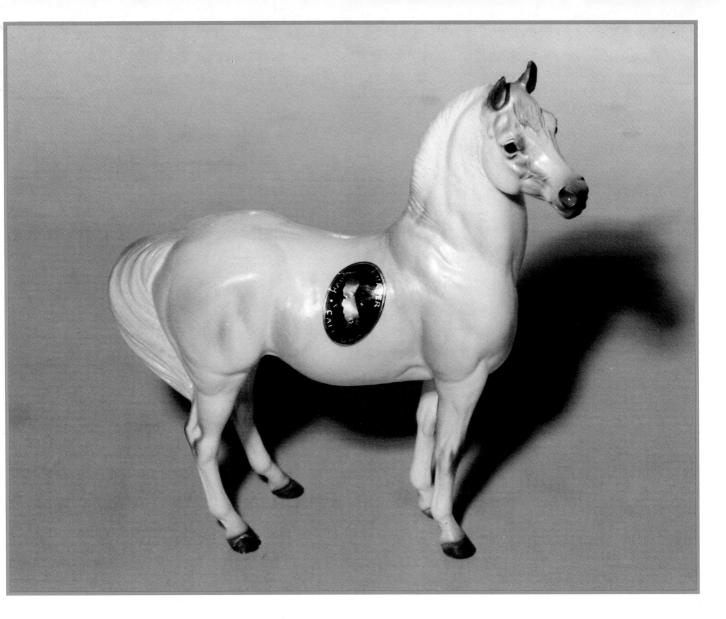

Amir, an Arabian stallion, is 6-7/8 inches high. The figurine
was offered for 29 seasons, from the fall of 1959 through the
spring of 1973, and again in the spring of 1975. *Amir* is marked
by paper label only. Estimated value: $150. *Private Collection.*

On larger Hagen-Renaker figurines such as *Amir* and *Adelaide,*
the roundness and size of the pour hole can often be an
identifying feature.

Percheron #459 is 2-3/4 inches high, unmarked. It was offered only four seasons, spring and fall 1959, fall 1965, and spring 1966. Estimated value: $65. *Private Collection.*

Quan Tiki, often called the sitting Siamese kitten, stands 4-1/8 inches high and is unmarked with a paper label. It was offered for 19 seasons between spring 1957 and spring 1975. Estimated value: $30. *Private Collection.*

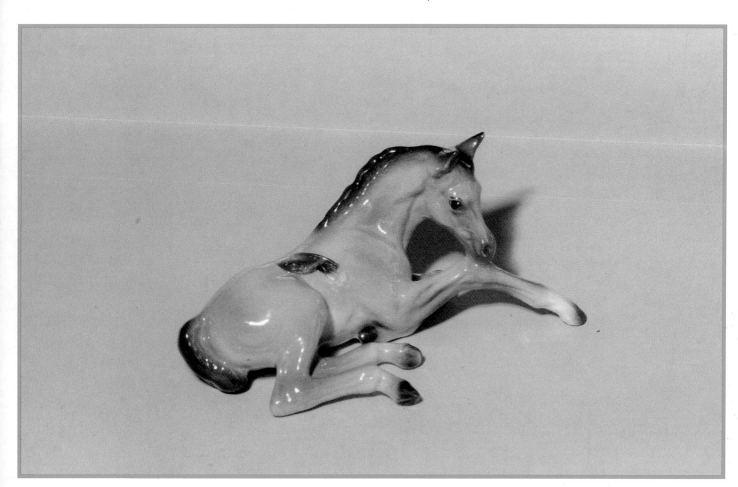

This is *Clover*, a Morgan foal measuring 2-3/8 x 5-1/8 inches. Its paper label reads, "Designers' Workshop / Clover / 19©53," on three lines. *Clover* was offered eight seasons, from spring 1954 through fall 1957. Estimated value: $175. *Private Collection.*

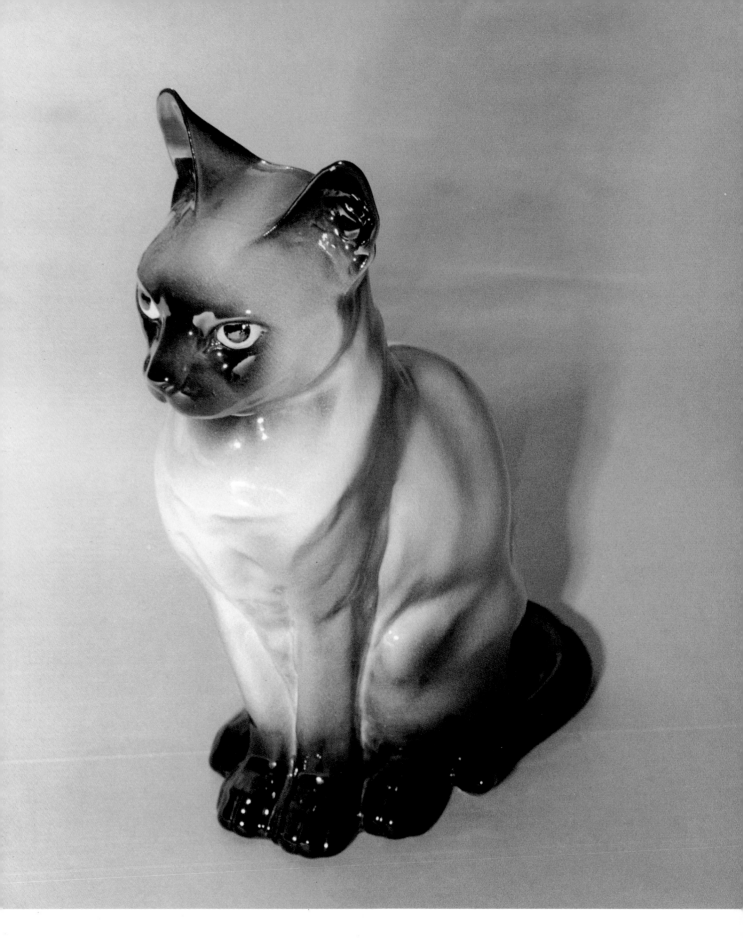

This Hagen-Renaker cat is 8-7/8 inches high, is not marked.
Estimated value: $75. *Private Collection*.

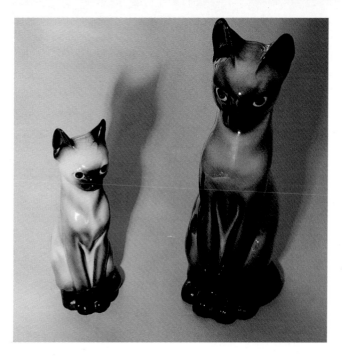

The Siamese cat on the left is *Kwei Li*, 7-3/8 inches high. It was offered 16 seasons between fall 1957 and spring 1975. It is unmarked but has a paper label. The one on the right, *Choo San*, 11-1/8 inches high, is also unmarked. It was offered 17 seasons between fall 1956 and spring 1975. Estimated values: *Kwei Li* $45, *Choo San* $65. *Private Collection*.

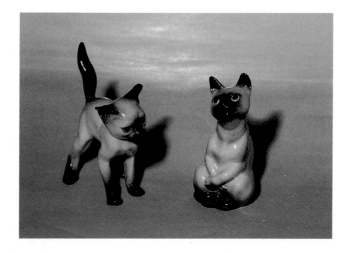

Although one is sitting and one is standing, both of these Siamese cats are the same height, 4-1/4 inches. The one on the left is *Kwei Li* (same as the 7-3/8 inch Siamese), offered 17 seasons between 1950 and 1984. *Calypso Cat Tabbie* is on the right. It was offered only four seasons, the dates being between 1957 and 1964. Estimated value: *Kwei Li* $40, *Calypso Cat Tabbie* $65. *Private Collection*.

This is *Silver*, 6-1/2 inches high, unmarked. *Silver* was offered for 18 seasons between fall 1958 and spring 1968. Estimated value: $90. *Naylor Collection*.

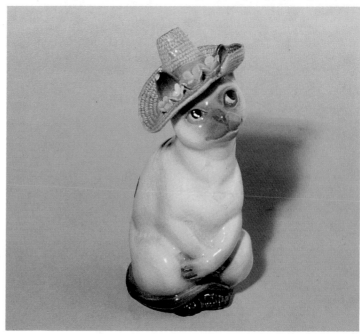

Calypso Cat Tabbie with a hat and also a paper label that reads, "Hagen-Renaker / Tabbie" on three lines. Estimated value: $110. *Private Collection*.

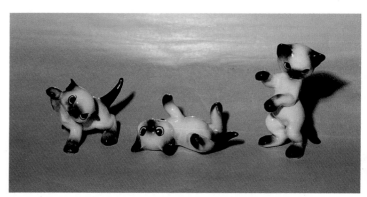

On the left is *Khitti Kat* 2-3/8 inches high, unmarked, and offered for nine seasons between fall 1952 and spring 1959. The unmarked one in the center is simply called "Siamese kitten lying on back." Measuring 1-5/8 x 3-3/4 inches, it was offered for only four seasons, from fall 1952 through spring 1954. Standing at the right end of the picture is *Pitti Pat*, 3-3/4 inches high. Unmarked, it was offered for nine seasons between fall 1952 and spring 1959, and again in the fall of 1984. Estimated value: left and right $35 each, center $50. *Private Collection*.

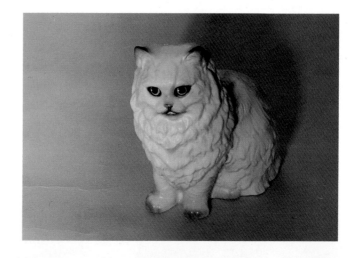

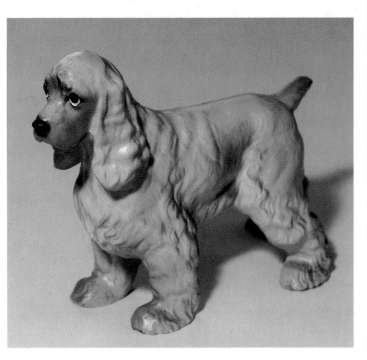

This is *Ranger*, a running pointer 2-5/8 inches high. *Ranger* was offered for four seasons, spring and fall 1954, fall 1955, and fall 1964. The piece is not marked except by the paper label on its back. Estimated value: $75. *Private Collection.*

Honey Girl, a cocker spaniel from the Pedigreed Dogs line which was offered from 1954 through 1968. *Honey Girl* stands 5-1/4 inches high. Her paper label reads, "Honey Girl / Hagen-Renaker / 19©55" on three lines. Estimated value: $75. *Private Collection.*

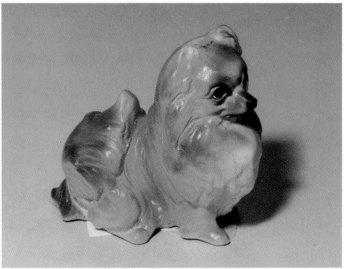

Spooky, also a Pedigreed Dog, is 6 inches high. His paper label is shown below. Estimated value: $100. *Naylor Collection.*

This Pomeranian is named *Mickey*. It is unmarked, 3-3/8 inches high, and was offered for 10 seasons between spring 1956 and spring 1968. Estimated value: $45. *Private Collection.*

Paper label of *Spooky*. A bit hard to read, it says, "Hagen-Renaker / Spooky / 19©54," on three lines.

The Pekingese *Ming Toy* stands 3-1/4 inches high, and is unmarked. Production ran nine seasons between fall 1956 and spring 1968. Estimated value: $40. *Private Collection.*

Bobby is an English bulldog puppy that stands 2-1/2 inches high. He is unmarked. *Bobby* was offered only three seasons, spring 1955 through spring 1956. Estimated value: $65. *Private Collection.*

This collie is *Bonnie*, who measures 1-7/8 x 4-1/4 inches. It is not marked but has a remnant of a Hagen-Renaker paper label. This was offered for 12 seasons from spring 1954 to spring 1959, and again in spring 1970. In your searches look for longer ears because the ears of this example have been broken. Estimated value: $45 if perfect. *Private Collection.*

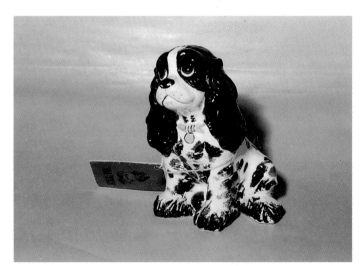

Butch stands 5-1/4 inches high, has "A. Straehle / ©" impressed in the bottom. He was offered seven seasons, from spring 1957 through fall 1959, and spring 1968. Estimated value: $140 as shown, $110 without the hang tag. *Private Collection.*

Nana, a Disney character from *Peter Pan*, is only 1-1/2 inches high. It was offered three seasons, spring 1957 through spring 1958. It is not marked. Estimated value: $75. *Private Collection.*

This is "Butch", the famous "Cover Dog". Butch is a real, live cocker spaniel, owned by the well known artist, Albert Staehle. Pictures of Butch, drawn by Mr. Staehle, have appeared on the covers of leading national magazines, posters, calendars and bill boards, all over the world. Butch's fan mail from everywhere, tells how well loved this dog model is. Now, for the first time, he is available to you, true as life in fine ceramic.

Hagen-Renaker Potteries
Monrovia, California

Text of *Butch's* hang tag or studio card.

The dog on the left may look like *Butch* but is not. Instead it is *Dot*, 3-3/4 inches high and unmarked. Hagen-Renaker offered *Dot* for three seasons, spring and fall 1954 and spring 1959. That's *Butch* on the right, in miniature, 1-3/4 inches high. The miniature version is unmarked but does carry a paper label, Butch / © A. Straehle / ©, on three lines. The miniature was offered just two seasons, spring and fall 1957. Estimated value: *Dot* $65, miniature *Butch* $55. *Private Collection.*

On the left is *Lady* from Disney's *Lady and the Tramp*, 1-3/8 inches high. On the right is the same figure but not made as a Disney character. Big difference in decoration, big difference in value. That's one of *Lady*'s puppies in the middle standing 7/8 of an inch high and missing the end of its left ear. Estimated value: left $50, middle $35 if perfect, right $3. *Private Collection.*

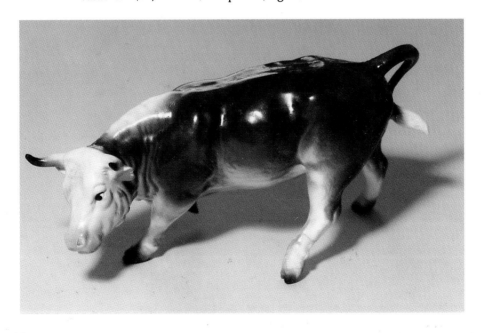

Dodging Hereford Steer, 3-1/2 inches high, 7 inches long. It is unmarked, was offered a total of 26 seasons between fall 1958 and spring 1986. Its mate would be a quarter horse and rider. Estimated value: $65. *Private Collection.*

This hen, *Elizabeth,* is 4-3/4 inches high, unmarked. *Alexander,* a rooster, is her mate. They were both made 31 seasons from fall 1955 to fall 1971. Estimated value: *Elizabeth* $25, *Alexander* (not shown) $30. *Private Collection.*

Unnamed robin, 3-1/4 inches high and unmarked. This figurine was offered 23 seasons, the first time in spring 1957, the last in spring 1986. Be sure to compare it to the Will-George robin on page 232. Estimated value: $16. *Private Collection.*

Paper label of the frog.

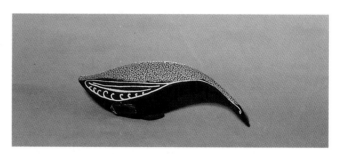

Here is *Poppa City Mouse*, all 3-1/2 inches of him. He has a Hagen-Renaker (H-R) inkstamp. He was first offered in spring 1953. *Mama City Mouse* and *Baby City Mouse* were also offered, as was a similar country family. Estimated value: $45. *Private Collection.*

Black Bisque goose, which my wife likes to describe as looking like a shoehorn. The goose measures 1-1/2 x 4-7/8 inches. Its paper label is shown. Black Bisque apparently did not catch on with the public as it was offered only one season, spring 1959. Estimated value: $60. *Private Collection.*

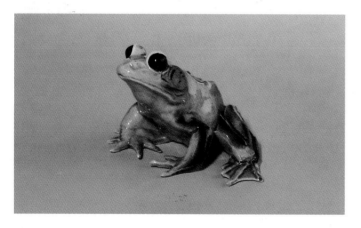

I am not sure of the name of this frog or exactly when it was made. Height is 2-7/8 inches; its paper label is shown. Estimated value: not determined. *Private Collection.*

Paper label of Black Bisque goose.

Hagen-Renaker sign, 2 x 7-1/4 inches. Date of manufacture is unknown. Estimated value: $45. *Private Collection.*

Hedi Schoop Art Creations

Hedi Schoop, one of America's most original pottery designers, ended up in California as a result of the Nazi party's rise to power in Germany. Swissborn, and performing in the German theater at the time, Schoop and her husband, composer Frederick Hollander, fled Germany for Hollywood in the early 1930s when the young dancer was in her mid-twenties. By that time she had attended some of Europe's finest art instituitions and had studied, among other things, fashion design.

In 1938 when she began experimenting with plaster of Paris figures, her education and experience blended together to create some wonderfully original and lavishly dressed mannequin type figurines. Before long she was making slipcast ceramic pieces, and by 1940 the popularity of her work had grown to the point that a full fledged factory was required to continue. Hedi Schoop Art Creations, which was not incorporated until 1942, was located on Burbank Boulevard in North Hollywood. Volume eventually reached 30,000 pieces annually. The company stayed in businesss until 1958, its demise coming surely and swiftly, and in the same form that claims many potteries: fire resulting in a total loss. For a while after the fire Schoop freelanced her designs to other potteries before retiring sometime in the early 1960s.

More so than with most potteries, the weight of Hedi Schoop figurines runs from medium light to very heavy. Even matched pairs will often vary dramatically in weight. Identification of an occassional unmarked piece can sometimes be narrowed down, if not confirmed, by tapping it with your fingernail, which will cause it to emit a high pitched, brittle sound. My personal impression of this sound is that the piece has been frozen at something like 100 degrees below zero, and if I tap it much harder it might shatter into a thousand tiny shards. Sometimes handmade decoration such as flowers were added. Schoop's roughly textured and often quite sharp incised design of major areas on a figure is generally a dead giveaway.

Fan vase, 6-3/4 inches high, marked "Hedi Schoop / Hollywood Cal." under the glaze with black marker. Estimated value: $25. *Oravitz Collection.*

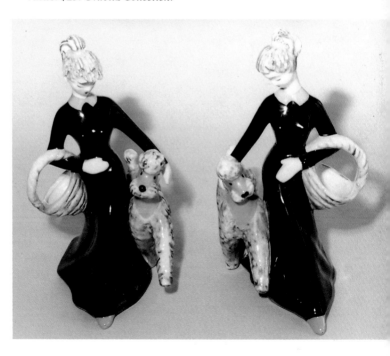

Height of these unmarked (note the hair and mannequin-like appearance for identification) Hedi Schoop figures is 10-1/4 inches high. Estimated value: $65 each. *Oravitz Collection.*

Each of these ladies is 12 inches high. Each has "Hedi Schoop" impressed in the bottom. The fan vase shown goes with them. Estimated value: $60 each. *Oravitz Collection.*

The reason identification of unmarked pieces becomes cloudy is that Hedi Schoop was widely imitated. For starters check the sections on Kim Ward, Yona and Ynez and you will see what I mean. The people who copied Hedi Schoop made some nice figurines. They are worthy of collecting and, given the perspective of time, are as much a part of the California pottery movement as Schoop's figurals are. But from what I have seen, none of her imitators, even on their best day, ever made anything that could equal the exquisiteness of what Hedi Schoop created on her worst day.

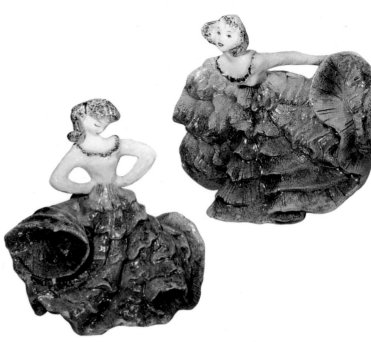

Heights here are 9-3/4 and 9 inches left to right. Each figurine has an impressed mark which is shown. Estimated value: $45 each. *Oravitz Collection.*

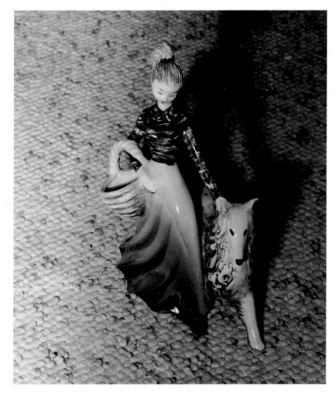

Impressed mark of above figurines.

Another lady with a dog, this time with an impressed mark, "Hedi / Schoop," on two lines. Height is 10-1/2 inches. Almost undoubtedly, this figure is half of a pair. Estimated value: $65. *Oravitz Collection.*

Heights are same as above. The figure on the left is not marked. The one on the right is marked twice, "Hedi / Schoop" impressed on two lines, accompanied by an inkstamp, "Hedi Schoop / Hollywood," on two lines. Estimated value: $45 each. *Oravitz Collection.*

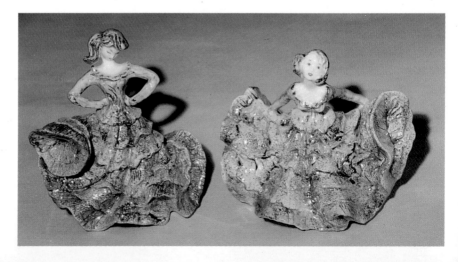

A pair of planters, 10 inches high on the left, 10-1/2 inches on the right. The one on the left has "Hedi / Schoop" impressed on two lines. The one on the right is unmarked. Estimated value: $45 each. *Oravitz Collection.*

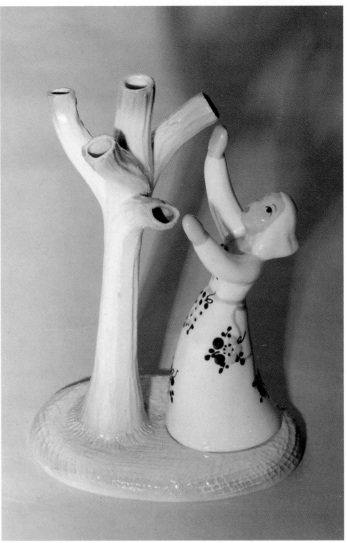

Height here is 11-1/2 inches. This piece is not marked. Estimated value: $55. *Oravitz Collection.*

This pair goes with the woman at the tree. The planter on the left stands 7 inches high, the one on the right 7-1/2 inches. Both are stamped "Hedi Schoop / Hollywood Cal." on two lines. Estimated value: $40 each. *Oravitz Collection.*

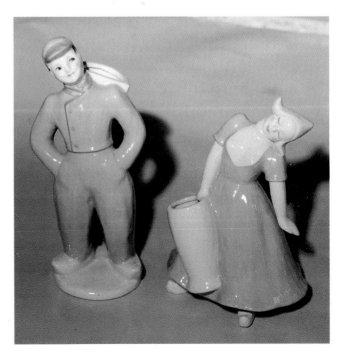

Dutch boy and girl planters, 10-1/4 and 9-1/2 inches high, respectively. Each has a Hedi Schoop mark. Estimated value: $35 each. *Oravitz Collection.*

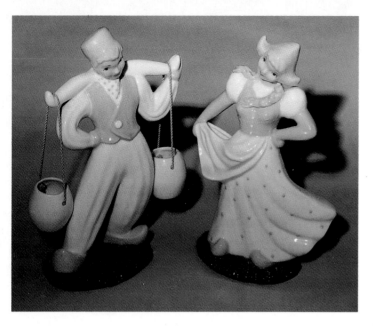

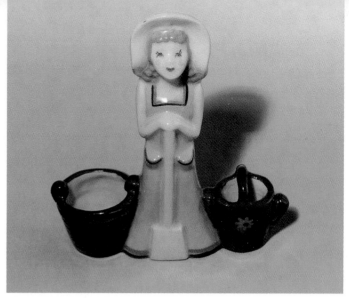

Farm girl planter, 7 inches high. Its mark is shown. Estimated value: $35. *Oravitz Collection*.

A second Dutch boy and girl. He is 11-1/2 inches high, she is 11 inches. Both are marked "Hedi Schoop" under the glaze. Estimated value: $45 each. *Oravitz Collection*.

Mark of farm girl planter.

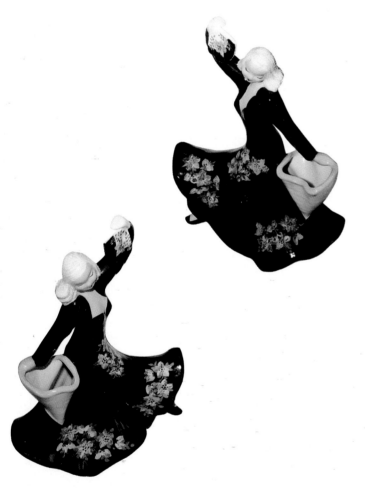

These planters are tall, each of them towering, 13-1/4 inches. They each have an inkstamp mark, "Hedi Schoop / Hollywood Cal." on two lines. Estimated value: $50 each. *Oravitz Collection*.

This planter is 9 inches high. It is marked "Heidi / Schoop" on two lines in brown. Estimated value: $40. *Oravitz Collection*.

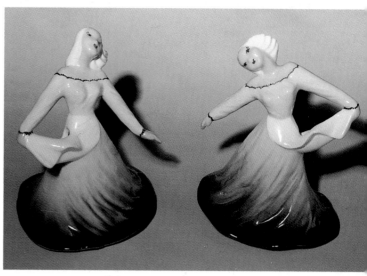

Each of these planters is 7-1/4 inches high. Each is marked, "Hedi Schoop / Hollywood Cal." under the glaze. Estimated value: $35 each. *Oravitz Collection.*

Another tall pair, 12-3/4 at left, 13-1/4 inches at right. They are marked "Hedi Schoop / Hollywood Cal." on two lines in brown like the farm girl planter. Estimated value: $45 each. *Oravitz Collection.*

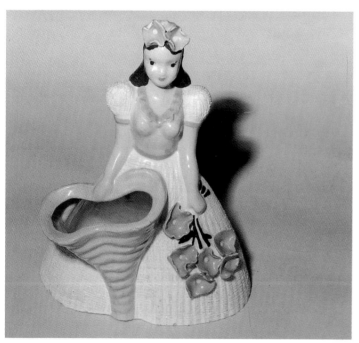

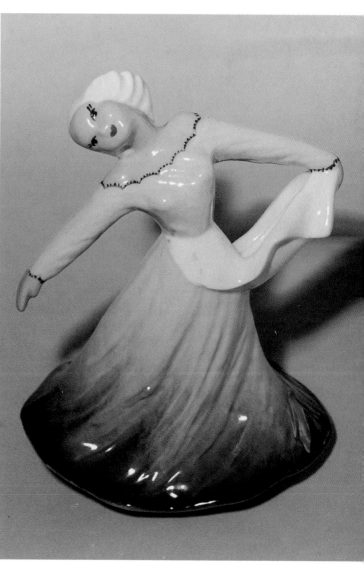

This planter is 9-1/2 inches high. Its mark is shown. Note the applied flowers. Estimated value: $65. *Oravitz Collection.*

Mark of the girl with applied flowers.

One of the above pair in blue instead of black. Everything else is the same. Estimated value: $35. *Oravitz Collection.*

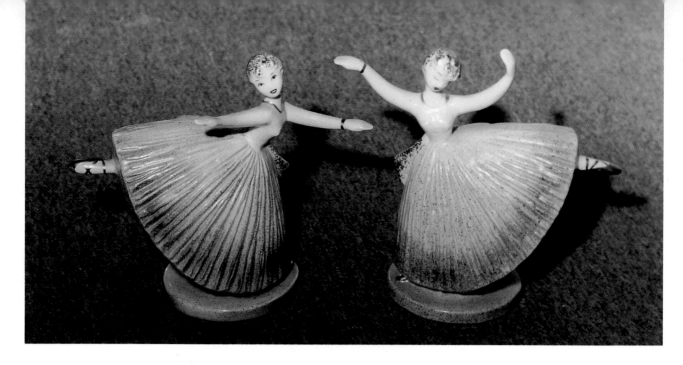

These dancing girls are 9-1/4 inches high on the left, 9-3/4 inches high on the right. Both have "Hedi / Schoop" impressed on two lines. Estimated value: $45 each. *Oravitz Collection.*

A pair of planters 12-1/2 and 13-1/4 inches high. Each is marked with an impressed "Hedi / Schoop," on two lines. Estimated value: $45 each. *Oravitz Collection.*

As above but in a different color; the mark is shown. Estimated value: $45. *Oravitz Collection.*

Mark of green lady planter above.

And a third color. Sometimes the colors are almost endless. This one has a different mark, an inkstamp that says "Hedi Schoop / Hollywood Cal." on two lines. Estimated value: $45. *Oravitz Collection.*

This one does have a mark, an inkstamp reading "Hedi Schoop / Hollywood Cal." The planter is 12-1/2 inches high. Estimated value: $45. *Oravitz Collection.*

No mark on this 12-1/2 inch planter but for my money the heart-shaped lips, treatment of the hair, and the applied flowers all speak of Hedi Schoop. Estimated value: $60. *Oravitz Collection.*

Definitely a planter here, but look at the similar piece immediately below. Height is 9-1/8 inches. Its inkstamp mark reads, "Hedi Schoop / Hollywood Cal." on two lines. Estimated value: $30. *Oravitz Collection.*

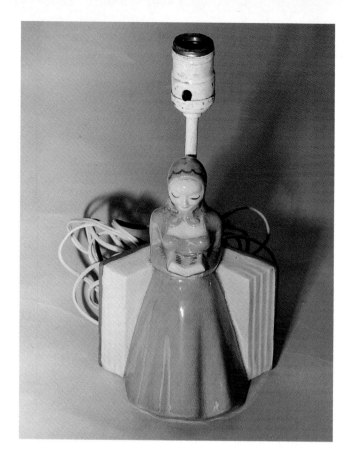

A little shorter, 8-1/2 inches, but still the same design as above. Felt covered the bottom of this lamp so I could not tell if there was a mark there. A mark on the spine, however, is shown. Estimated value: $60. *Oravitz Collection.*

Back of Hedi Schoop book lamp.

An 11-1/2 inch high planter, "Hedi Schoop" incised. Estimated value: $50. *Oravitz Collection.*

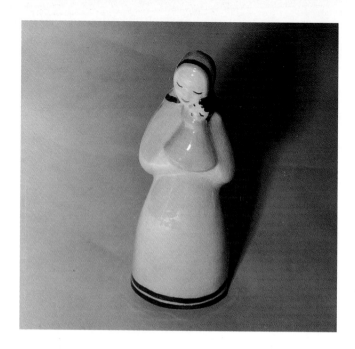

This may have been a bell at one time as the bottom is open but it had no clapper when I photographed it. Height is 8 inches, the mark is shown. Estimated value: $35. *Oravitz Collection.*

Mark of above girl figure.

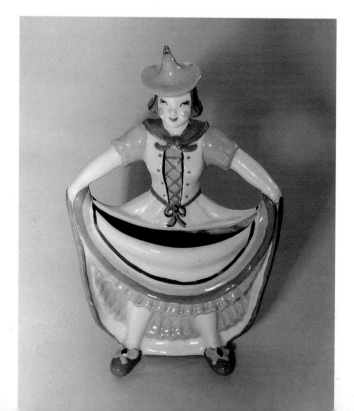

As you can see, this drummer's drumsticks are missing and the piece has been repaired. It is 13-1/4 inches high, marked "Hedi Schoop" in brown under the glaze. Estimated value: $35 (if perfect). *Oravitz Collection.*

A pleasing pair of planters, 7-1/2 inches high on the left, 8-1/2 inches high on the right. The left example is inkstamped, "Hedi Schoop / Hollywood Cal" on two lines. The example on the right is unmarked. This is just one of numerous California designs that was copied by the Japanese. Estimated value: $30 each. *Oravitz Collection.*

This unmarked planter is 11 inches high. Again, telltale signs such as the shape of the lips, contours of the dress, treatment of the hair, and the above mentioned brittle sound when tapped identify it as Hedi Schoop as sure as if the name appeared on it. Estimated value: $40. *Oravitz Collection.*

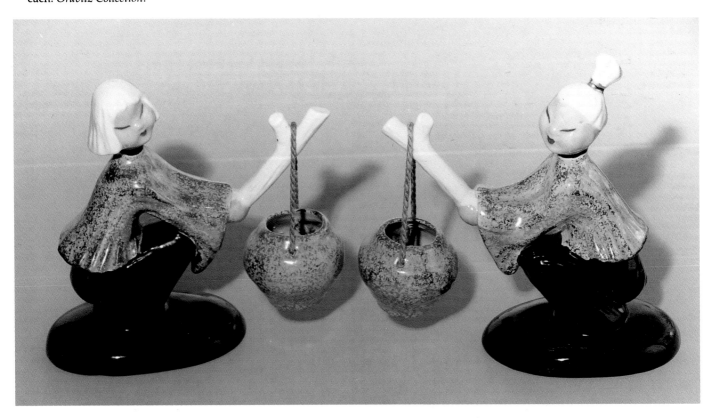

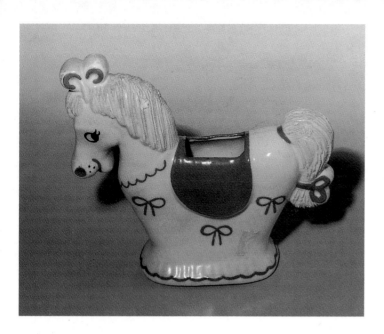

A horse planter, 7-1/2 inches high with a Hedi Schoop mark. Estimated value: $30. *Oravitz Collection*.

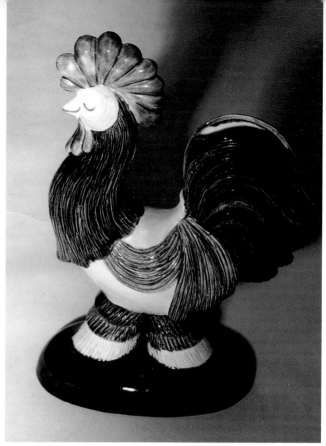

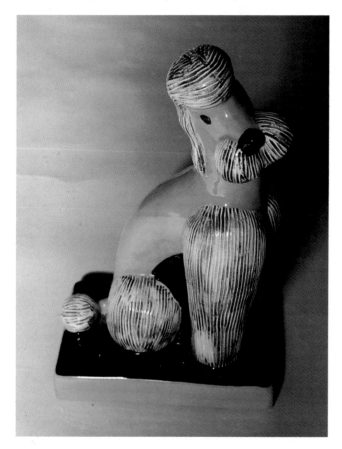

A rooster flower holder, 15 inches high. It is marked "Hedi Schoop / Hollywood California" in brown. Estimated value: $75. *Oravitz Collection*.

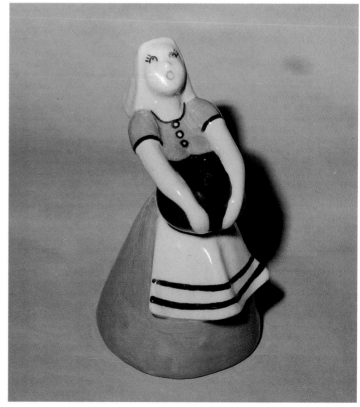

One tall dog figurine, 12-1/4 inches high. It has an impressed mark, "Hedi Schoop / California." Estimated value: $125. *Oravitz Collection*.

This planter stands 8 inches high, is marked "Hedi Schoop" in brown glaze. Estimated value: $30. *Oravitz Collection*.

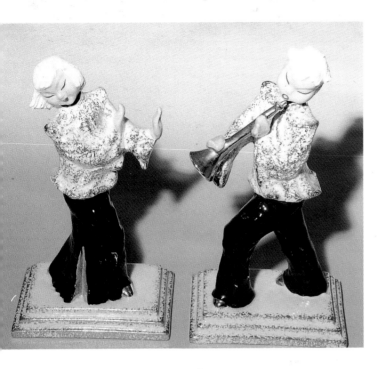

These are figurines, the one on the left standing 10-1/2 inches high, the one on the right measuring 10-3/4 inches. The right one is unmarked. The left one has "Hedi Schoop / 147" impressed on two lines with the 147 in a circle. Estimated value: $60 each. *Oravitz Collection.*

This figure is inkstamped, "Hedi Schoop / No. Hollywood Cal." on two lines. It is 13 inches high. Estimated value: $35. *Oravitz Collection.*

A shell bowl, 7 inches high, marked "Hedi Schoop / Hollywood Cal." on two lines. Estimated value: $25. *Oravitz Collection.*

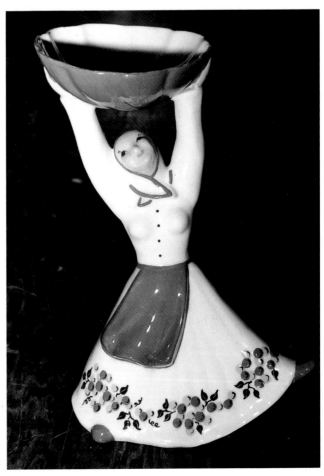

Same figure, different decoration. The mark is also different, "Hedi Schoop / Hollywood," in brown on two lines. Estimated value: $45. *Graettinger Collection.*

The wood grain on the piece shown comes very close to the highly detailed wood grain and bark detail Maddux obviously favored.

Accounts are conflicting, but apparently sometime prior to 1956, most likely the very early 1950s, Hollywood Ceramics was purchased outright by Maddux of California. Whether or not Maddux continued to use the Hollywood Ceramics name after the acquisition is unknown at this time.

The figure is 5-3/4 inches high, while the dish measures 2 x 6-1/4 x 11-1/2 inches. "Hedi Schoop" is impressed on the bottom of the dish. The fairy is fused to it. Estimated value: $50. *Oravitz Collection.*

This planter is 4-7/8 inches high. On its bottom "©" is impressed under the bucket, "Hand / Made" under the pump, and "Hollywood / Ceramics / Calif" under the trough. Estimated value: $5. *Private Collection.*

The figure on this Lucite lamp is 11-1/2 inches high. Estimated value: $195. *Oravitz Collection.*

Heirlooms of Tomorrow: *See California Originals*

Hollywood Ceramics

As is unfortunately the case with many of California's lesser known potteries, a writer's best friends when attempting to relate their sketchy histories are the words apparently and most likely.

According to Lehner, Hollywood Ceramics was located at 3061 Riverside Drive, Los Angeles, in 1948. At that time it apparently did some contract work for Maddux of California, a pottery that to some extent doubled as a selling agency. That makes sense.

Howard Pierce

Unlike many California potteries that were catapaulted to fame and fortune when World War II cut off imports, Howard Pierce bucked the trend and didn't start his business until the war was over. Beginning in a rented building in Claremont late in 1945, Howard Pierce, then 33 years old, went on to become one of the state's most outstanding potters. In 1968 he moved to Joshua Tree where he continued turning out pottery, but at a much slower pace.

Pierce gained his education in art and ceramics at the University of Illinois, Chicago Art Institute and Pomona College. Practical experience included a three-year stint at William Manker Ceramics, and a year or two running a pewter-casting business of his own.

Most Howard Pierce pottery is signed, though some isn't. Often, when items were sold in sets, only one piece in the set was marked, usually the largest. Over the years some of the signature pieces of these sets have been broken or lost, leaving the remainder floating around unmarked. Develop a good eye for Howard Pierce and you should be able to pick up some unmarked pieces at bargain basement prices.

Typical marks were "Pierce," "Howard Pierce," "Howard Pierce Porcelain," and "Howard Pierce Claremont California." Most of the time marks were inkstamped. Occasionally they were incised.

Inkstamp mark of above bird.

The hen is 5 inches high and unmarked. The rooster stands 6-7/8 inches. It has an inkstamp mark, "Howard / Pierce," on two lines. Estimated value: hen $25, rooster $30. *Oravitz Collection.*

An 8-inch high owl inkstamped "Howard / Pierce," on two lines. Estimated value: $45. *Naylor Collection.*

This bird is 4-3/4 inches high. Its two line inkstamp is shown. Estimated value: $25. *Private Collection.*

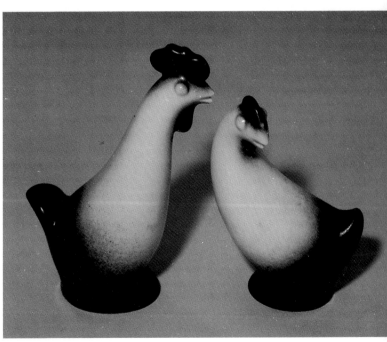

The rooster is 9-1/4 inches high, the hen 7-1/2 inches. At least one of them has "© 251P / Howard / Pierce," impressed on three lines. Estimated value: rooster $30, hen $25. *Carson Collection.*

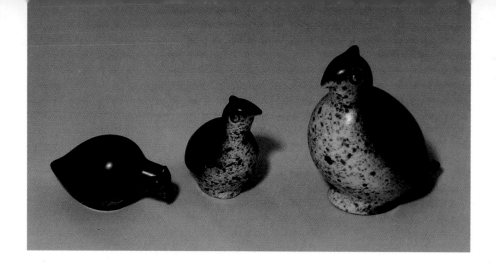

The quail on the left is 6 inches long. The one in the middle is 4 inches high, and the one on the right is 6 inches high. It is inkstamped "Howard / Pierce" on two lines. The two smaller pieces are not marked. Estimated value: small $20 each, large $30. *Carson Collection.*

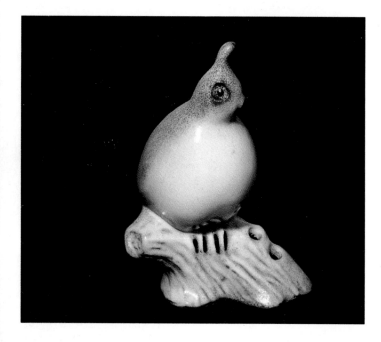

This lone quail is 6-1/2 inches high, is inkstamped "Howard / Pierce" on two lines. Estimated value: $35. *Carson Collection.*

A seal in matte black, 2-3/4 inches high. Its mark is shown below. Estimated value: $20. *Private Collection.*

HOWARD
PIERCE
PORCELAIN

Inkstamp of black seal above.

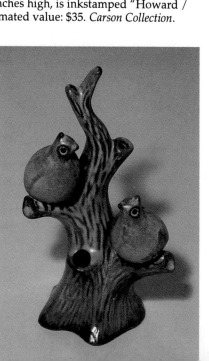

An owl set that was not measured, but the tree is approximately 10 inches high. Each of the birds are inkstamped "Howard / Pierce," on two lines. This set was made in 1986. Estimated value: $65. *Carson Collection.*

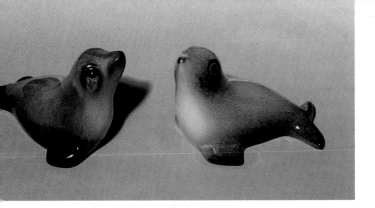

Different mold, different glazes. These seals are 3-1/4 inches high. Each is inkstamped "Howard / Pierce" on two lines. Estimated value: $25 each. *Oravitz Collection.*

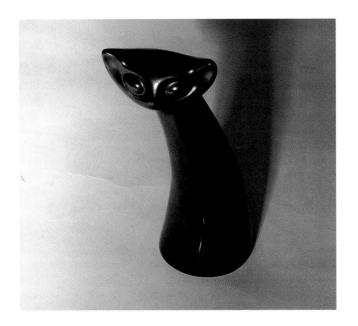

The black cat is 8 inches high with a "Howard / Pierce" inkstamp on two lines. Estimated value: $45. *Oravitz Collection.*

The little fellow on the left is 5-1/2 inches high, the one on the right 5-3/8 inches high. Neither is marked. The sign measures 3 x 6 inches. Estimated value: left $30, middle $40, right $30. *Carson Collection.*

Jane Callender

According to Chipman, this pottery was located in Los Angeles but that is all I have been able to find out.

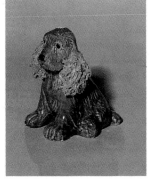

This Jane Callender cocker spaniel is 2-5/8 inches high. Its mark is shown. Estimated value: $30. *Carson Collection.*

Size of this Jane Callender poodle is 2-1/2 x 3-3/4 inches. The mark is the same as the brown cocker except that the poodle is no. "08". A close up of the tag is shown. Estimated value: $30. *Private Collection.*

Close up of the tag on the Jane Callender poodle.

Jean Manley

None of the figures shown are marked, but they are typical of what Chipman identifies as Jean Manley. According to Chipman, Jean Manley was located in Pasadena and was active in the late 1940s.

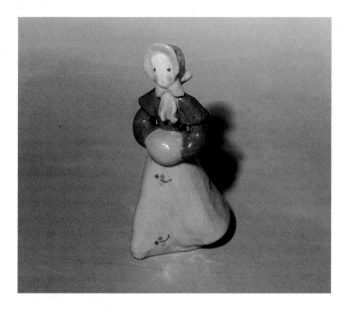

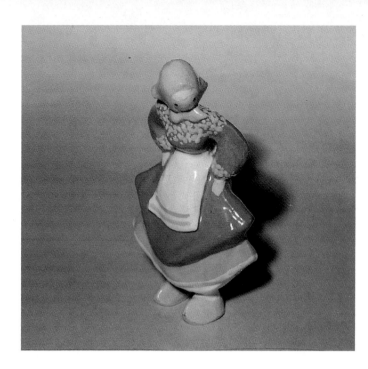

This figurine is 6-1/8 inches high. Estimated value: $18. *Oravitz Collection.*

Pink bisque on this one, too. It stands 7-1/2 inches high. Estimated value: $18. *Oravitz Collection.*

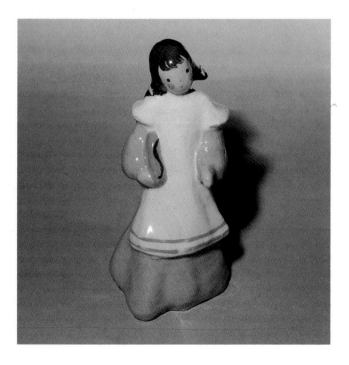

This girl is made of white bisque. She is 6-1/4 inches high. Estimated value: $18. *Oravitz Collection.*

Height here is 6-1/2 inches. This figure is made of pink bisque. Estimated value: $18. *Oravitz Collection.*

The boy and pony figure is 5-1/4 inches high. Estimated value: $22. *Oravitz Collection.*

The little girl on the left is 5-1/2 inches high. The mother and baby stand 7-1/4 inches. Their bottoms are shown. Estimated value: left $18, right $24. *Oravitz Collection.*

Bottoms of the girl and mother with baby, they are typical of Jean Manley figures.

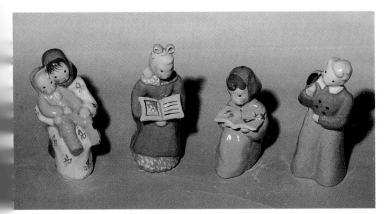

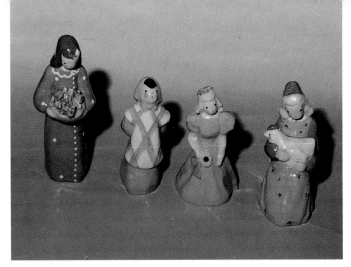

The figure at left stands 6 inches, the one next to it 4-1/2 inches. The two on the right are each 4-3/4 inches high. Estimated value: outside $24 each, inside $18 each. *Oravitz Collection.*

Jessie Grimes

Nothing at all is known here. The planter and figurines shown certainly identify Jessie Grimes' style, whoever she may have been. All three pieces are marked the same way. All three pieces were found in the midwest so the work of this pottery, which appears to have been a minor one, did travel to some extent.

The girl figurine stands 6-1/8 inches, the boy 5-3/4 inches. Both are marked, the mark of the girl being shown. Estimated value: $16 each. *Oravitz Collection.*

All four of these figures are made of flesh color bisque. Heights left to right are 4, 4-3/4, 3-1/2 and 4-1/2 inches. Estimated value: left to right $24, $20, $20, $18. *Oravitz Collection.*

Mark of Jessie Grimes girl figurine.

A Jessie Grimes planter, 7-3/4 inches high with the same mark as the two figurines. Estimated value: $14. *Oravitz Collection.*

These are figurines, the one on the left being 10 inches high, the one on the right 9-1/2 inches. Each is marked, the mark of the example on the right being shown below. Estimated value: $30 per pair. *Oravitz Collection.*

Johanna Ceramics

The only reference I have found to this company is in the June, 1952 issue of *The Gift and Art Buyer*, where an advertisment shows it located in Costa Mesa, and says it was represented by Blodgett & Company.

The ad, which emphazizes Christmas items, shows the mugs displayed here ($9 per dozen) and several other Christmas pieces. Included is a "large fat Santa" that appears to be 6 or 7 inches high, a "medium Santa" a bit shorter and much thinner, a "shelf sitter Santa" about 3 inches high, and two Santa candleholders, one standing the other lying on his stomach, perhaps about 4 inches and 3 inches high, respectively. All of these Santas have what appears to be extruded fur on their costumes, and were quite pricey for the times, $6.50 each wholesale for the large model, $4 each for the medium.

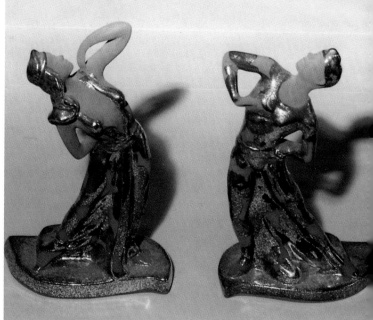

Mark of above Johanna Ceramics figurines.

A couple of Santa mugs much simpler than many of the Santas referred to in the text. Each is 3-1/2 inches high. Each is marked, "Johanna / Calif.," in ink on two lines under the glaze. Estimated value: $12 each. *Oravitz Collection.*

This figurine, *Penny*, is 4-1/2 inches high. Its mark is shown. Estimated value: $50. *Oravitz Collection.*

Josef Originals

Josef Originals was founded in a garage in Monrovia about 1946 by Muriel Joseph George and her husband Tom George. The J-o-s-e-f spelling of her name originated as a printer's error on the company's first label order, and due to time constraints could not be corrected.

Figures were made in California exclusively until 1959. At that time George went to Japan and contracted with a pottery there to execute her designs. Between then and 1962 the California figures were phased out while the Japanese were phased in.

Just prior to going to Japan, Murial and Tom George formed a partnership with George Good who at the time was a representative and distributor. The company was called George Imports. A full merger with George Good occurred in 1974 and the name was switched to George-Good Corporation, the hypen separating the two principals' last names. Muriel George sold out to George Good and retired in 1981. She died in 1992. George Good sold the business to Applause, Inc. in 1985. Today Josef Originals are manufactured in Japan, Korea and other Pacific-Asian countries.

The Josef Originals that were made in California nearly always have California as part of their impressed mark. The paper label will also say California.

For more on this popular California/Japan pottery I recommend *Josef Originals-Charming Figurines with Price Guide,* by Dee Harris and Jim and Kaye Whitaker (Schiffer, 1994).

Bottom of *Penny* with an inkstamp and her name impressed on the right.

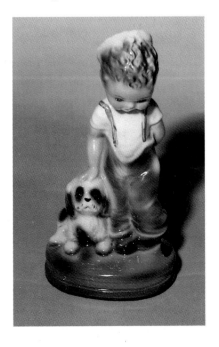

The bottom of this figurine was covered with felt so I do not know if it has any kind of permanent mark. However, there is a paper label that says, "Josef Originals / California," on two lines. Height of the figure is 7-1/4 inches. Estimated value: $50 *Oravitz Collection.*

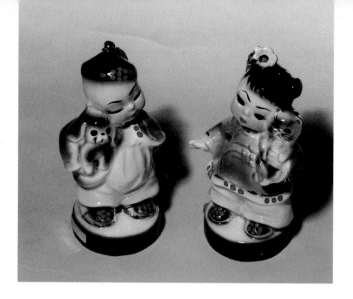

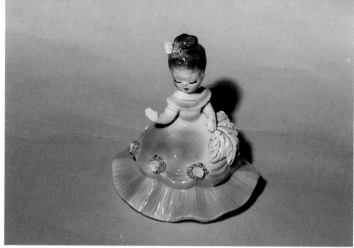

Wee Ching and *Wee Lin*, 5 and 4-7/8 inches high, respectively. *Wee Ching* has an impressed mark, "Josef Originals / ©52," on two lines along with a paper name label. *Wee Lin* also has a paper name label, and a slightly different impressed mark, "Josef / ©52," on two lines. Estimated value: $40 each. *Oravitz Collection.*

Height is 5-3/8 inches. "Josef Originals / ©" impressed on two lines. Estimated value: $45. *Oravitz Collection.*

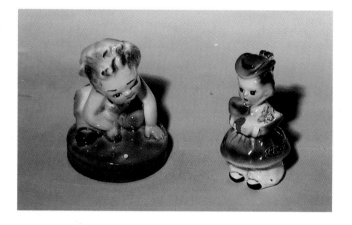

The little boy shooting marbles is 4-3/4 inches high. The figure has a "Josef Originals / California" paper label. You can see the "Josef Originals / California" paper label of the little girl. She also has a *Holiday* paper label. She was not measured. Estimated value: boy shooting marbles $75, *Holiday* $35. *Oravitz Collection.*

The boy is 6 inches high, the girl, *Charmaine*, 5-3/4 inches. Both have impressed marks, "Josef Originals / ©" on the bottom on two lines. Estimated value: boy $60, *Charmaine* $60. *Oravitz Collection.*

On the left is a bell, 3-3/8 inches high, and part of the *Belle* series. On the right a figurine 3-1/4 inches high. The bell has a paper label that reads *School Belle*, plus a remnant of a Josef Originals California paper label. The figurine has a "June" paper label and a Josef Originals California paper label, in addition to "Josef / ©" impressed on two lines. Estimated value: *Belle* $40, *June* $30. *Private Collection.*

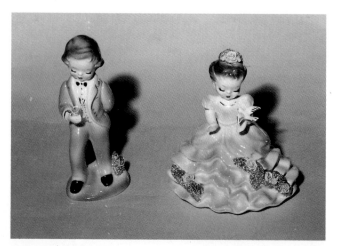

That's *Kandy* on the left, 4-1/4 inches high with a *Kandy* paper label. *Thursday*, 4 inches high, and also sporting a name paper label, is on the right. Additionally, *Thursday* has a "Josef Originals / California" paper label, and each figurine has two permanent marks, "Josef / Originals / ©," impressed and as an inkstamp. Estimated value: *Kandy* $40, *Thursday* $35. *Oravitz Collection.*

The figurines at left and right are the same, just different colors. The are 4-5/8 inches high. Both have "Josef Originals / ©" impressed on two lines. The one on the right has two paper labels, "Little Gift," and "Joseph Originals / California." The girl in the center carries the same impressed mark of the other two, plus a "Secret Pal" paper label. Estimated value: *Little Gift* $45 each, *Secret Pal* $40. *Oravitz Collection.*

This dog is 3-7/8 inches high. It has "Josef Originals / © 52" impressed, in addition to a "Josef Originals / California" paper label. Estimated value: $45. *Private Collection.*

Kaye of Hollywood

Derwich and Latos show Kaye of Hollywood being located in Hollywood, while Chipman lists North Hollywood. Pieces were signed "Kaye of Hollywood," or simply "Kaye," usually with a number. While its window of activity is unknown, the late 1940s through the early 1950s would seem to be a decent guess. It must have been a fairly large operation as Kaye pieces are seen quite often.

Glancing over the selection of Kaye of Hollywood figural pottery shown here, I get the impression that Kaye may have incorporated the creativity of several other potteries into its line. In one case I see De Lee

This is *Fluff* on the left, *Puff* on the right. Heights are 3-3/8 and 2-3/4 inches, respectively. Both have "Josef / Originals" impressed. *Fluff's* paper labels are shown. *Puff's* are the same except that the name is different. Estimated value: $45 each. *Private Collection.*

Paper labels of *Fluff*

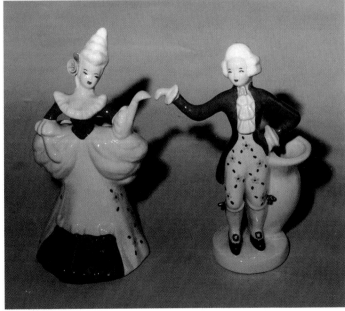

The lady is 9-1/4 inches high, marked "347-Kaye," in brown glaze on one line. The gentleman goes 9-3/4 inches, has the same mark except "348." Estimated value: $35 each. *Oravitz Collection.*

Art eyes, in a couple others the lace draping of California Dresden. In the Dutch girl with the baskets there is a form that at some distance could be Hedi Schoop, and several pieces are done in Kay Finch pastels.

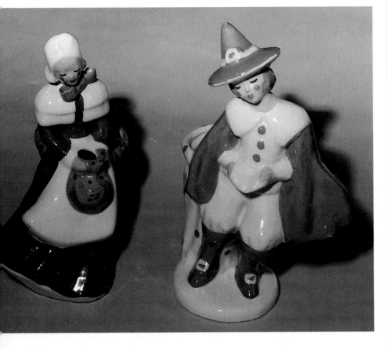

Pilgrims, 10-1/2 and 11-1/4 inches high, left to right. Their marks are shown. Estimated value: $30 each. *Oravitz Collection.*

Marks of the pilgrim couple.

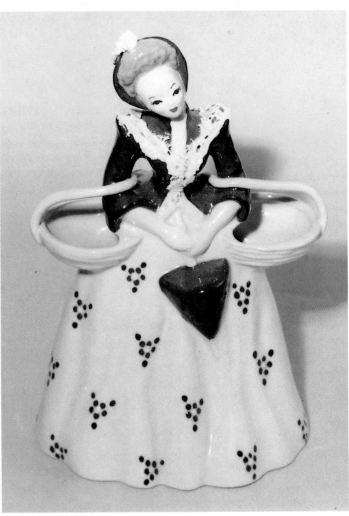

This basket lady stands 10-1/2 inches high. Her mark is shown below. Estimated value: $25. *Oravitz Collection.*

Mark of basket lady figure. The paper label reads "...orette Saltzman / Products / Los Angeles 5 / California," on four lines.

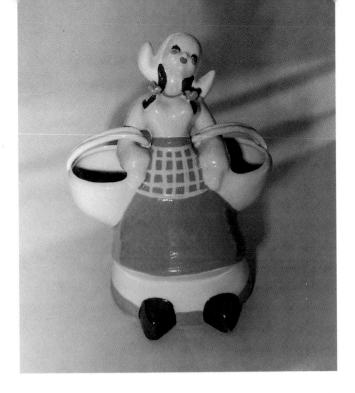

Another basket lady, 8-1/2 inches high and marked "3130 / Kaye" on two lines. Estimated value: $25. *Oravitz Collection.*

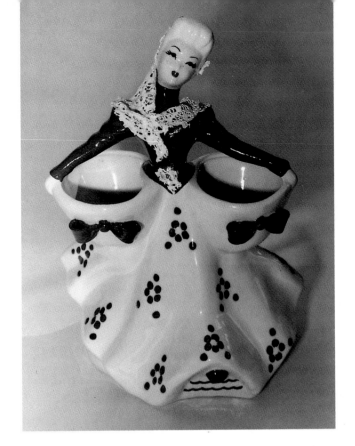

This one measures 13 inches in height. Its mark is shown below. Estimated value: $25. *Oravitz Collection.*

Mark of above basket lady.

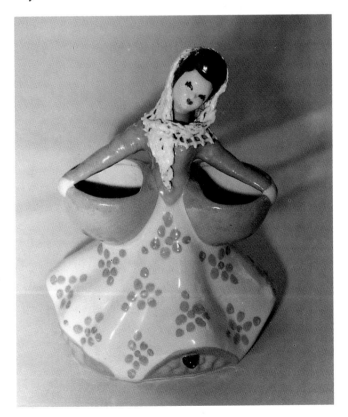

Kaye liked baskets, no doubt about that. This one is 9-3/4 inches high, marked "Kaye of Hollywood" and "301." Estimated value: $25. *Oravitz Collection.*

This girl is 9 inches high. She is marked, "2139 / Kaye" on two lines. Estimated value: $20. *Oravitz Collection.*

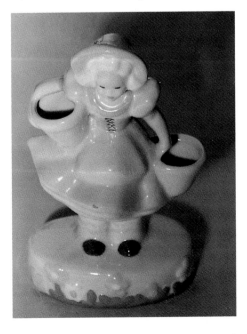

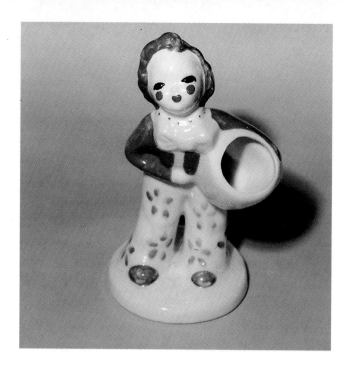

A boy, 9 inches high, marked "3116 / Kaye" on two lines. Estimated value: $20. *Oravitz Collection.*

Kay Finch

Kay Finch Ceramics started in 1938 when Kay and her husband, Braden Finch, bought a used kiln for $35 and installed it in a broken down converted milk shed behind their house in Santa Ana. From that humble beginning, Kay Finch Ceramics rose to become one of the foremost figural potteries in California, America and the world.

Kay Finch was born in 1903, began modelling in clay at a young age in her parents' backyard in El Paso, Texas, where stray animals quickly became her favorite subjects. Later she studied art at Ward Belmont College in Nashville, Tennessee, and at Scripps College, Claremont, California. At Scripps her instructor was William Manker, who at that time was the R. Guy Cowan of California potters. Howard Pierce was another of Manaker's understudies who did alright for himself.

At the outset of their pottery venture, Braden Finch, who had been a newspaper editor and publisher, resigned that post to work full-time at the ceramics business. Braden devoted his time to running the business, Kay devoted hers to creating its products. In 1939 they moved to Corona Del Mar, built a small studio within view of the ocean. They replaced the kiln in that studio twice, each time with a larger one, before they ran out of space in 1941 and were forced to build larger quarters that eventually employed more than sixty people. The new studio opened on December 7, 1941, a day destined to live in infamy and china cabinets. Throughout the war many of Kay Finch's decorators were military wives. At a time when numerous manufacturing plants, including potteries, operated on a piece-work basis, the Finches refused to go that route, fearing it would lower the quality of their product.

Braden Finch died in 1963, and shortly thereafter the company closed. Chipman alludes to the fact that Freeman-McFarlin ended up with the molds.

Along with all of its originality and creative splendor, Kay Finch pottery does have one flaw. It is very soft. Perfect pieces are the exception. Consequently, if you intend to build a decent size collection of it, you are probably going to have to accept small chips or run the risk of becoming a very frustrated collector. Another thing you see from time to time is figural pieces made from Kay Finch molds, sometimes even finished with her glazes, that are obviously not Kay Finch pieces. This is because the company sold unfinished figurals and glazes to home ceramists. Quoting from Kay Finch's 1961 catalog: "Courtesy is given to hobbyists who wish Kay Finch glazes or greenware."

While most Kay Finch pieces are small or average in size when compared to the ceramics of other companies, she also made some very large ones. According to company catalogs, the *Coach Dog*, a sitting dalmation, stood 17-1/2 inches high. Her *Big Santa Claus* measured 18" x 18", and the *Mermaid, Seahorses* and other fountain pieces ran up to two feet in height. An article in the October 13, 1944 issue of *Adventures in Business*, published by Knott's Berry Place (later Knott's Berry Farm), stated that her latest creations were "...exquisite Chinese figures three feet high...." All of these larger figures are extremely rare. If you are a Kay Finch collector who has one, consider it the find of a lifetime.

The *Peasant Boy* and *Peasant Girl* are each 7 inches high. He has a "Kay Finch / California" inkstamp on two lines, she is unmarked. Estimated value: $25 each. *Oravitz Collection.*

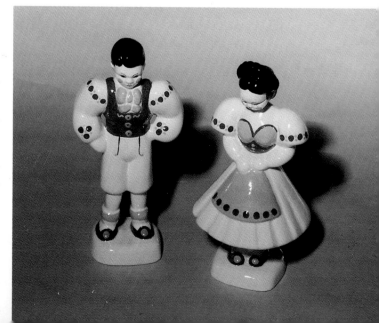

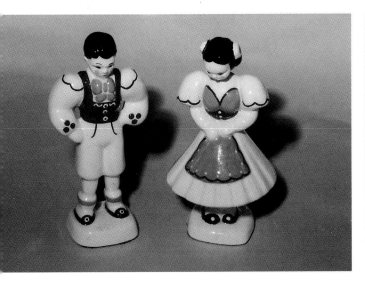

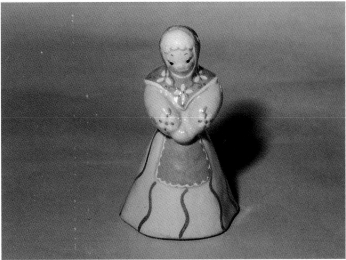

Peasant Boy and *Girl* in different colors. Estimated value: $25 each. *Oravitz Collection.*

A *Scandie Girl* with different decoration and a different mark, which is shown. Estimated value: $25. *Oravitz Collection.*

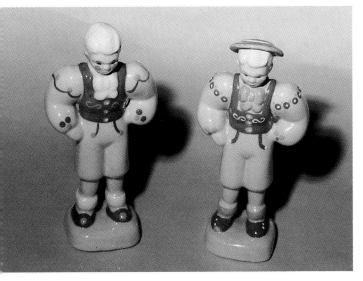

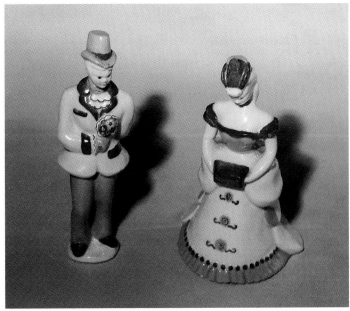

Two more Peasant Boys, one sporting a hat. The one with the hat is marked with an inkstamp, "Kay Finch / California" on two lines, the one without the hat is not marked. Estimated value: without hat $25, with hat $30. *Oravitz Collection.*

Mark of *Scandie Girl* with different decoration.

This is the *Scandie Boy* and *Girl*, 5-1/2 and 5-1/4 inches high, respectively. Both have inkstamp marks, "Kay Finch / California," on two lines. She also has "K. Finch" impressed. Estimated value: $25 each. *Oravitz Collection.*

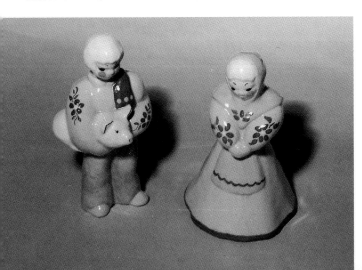

The *Godey Man* and *Lady*, according to the company's 1946 catalog. The man stands 7-3/4 inches high, the lady 7-1/4 inches. Estimated value: $45 each. *Oravitz Collection.*

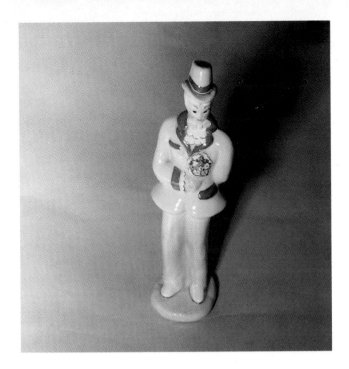

A *Godey Man*, this time marked with an inkstamp reading, "Kay Finch / Corona Del Mar," on three lines. Estimated value: $45. *Oravitz Collection*.

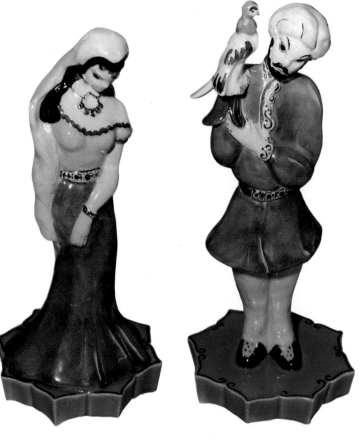

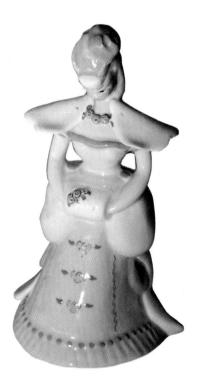

The *Godey Lady* in a different color. She is marked "K. Finch" by impression in addition to the incised initials, "VV." Estimated value: $45. *Oravitz Collection*.

I do not know what the company called this fine pair. The woman is 9-3/4 inches high, the man 10-1/2. Each is marked, "Kay Finch / California," being impressed in script on two lines. Estimated value: $95 each. *Oravitz Collection*.

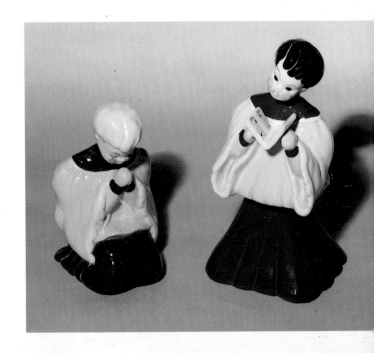

The *Choir Boy Kneeling* is 5-1/4 inches high, the *Choir Boy Standing* 7-5/8 inches. The kneeling model has a Kay Finch inkstamp, the standing one is unmarked. Both are made with pink bisque. Estimated value: $40 each. *Oravitz Collection*.

This figure is 6-1/2 inches high. It is unmarked. Estimated value: $50. *Oravitz Collection.*

And still another type of angel, this one measuring 1-5/8 x 5 inches. It is not marked. These were also made with blonde hair. Estimated value: $35. *Oravitz Collection.*

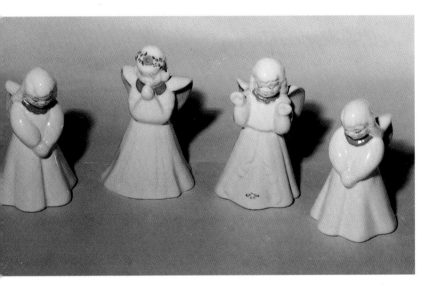

Four figures of three different *Angels*. The two on the ends are 4-1/4 inches high, the two in the middle 4-1/2 inches. The only one that is marked is the one on the far right, which has an inkstamp that says, "Kay Finch / California," on two lines. Estimated value: $40 each. *Oravitz Collection.*

Another type of angel. Height is 4-1/4 inches, mark is an inkstamp, "Kay / Finch," on two lines. Estimated value: $40. *Naylor Collection.*

This is *Ambrosia*, 10-3/4 inches high. *Ambrosia* is not marked. Estimated value: $210. *Oravitz Collection.*

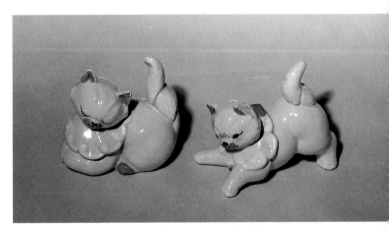

That's *Puff* on the left, *Muff* on the right. Each is 3-1/2 inches high. Neither is marked; *Puff* has initials "VV" incised. Estimated value: $25 each. *Oravitz Collection.*

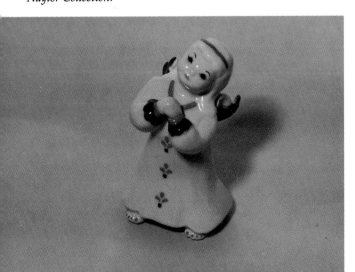

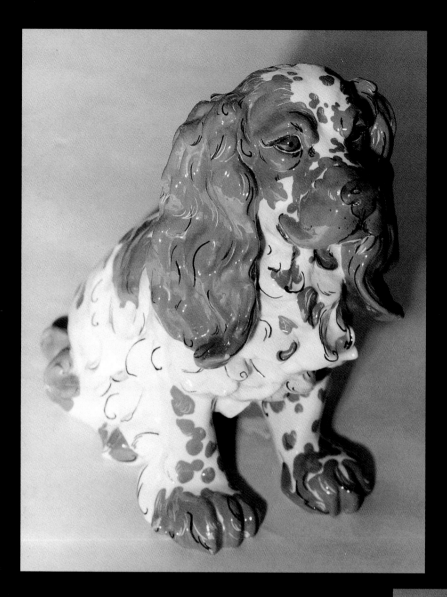

This is *Vicki*, an outstanding example of a Kay Finch dog figure, 11-1/2 inches high. It is not marked. Almost as interesting as the front is the back, which is shown. Estimated value: $325. *Oravitz Collection.*

Back of *Vicki*, complete with collar and heart.

Vicki in pink and white. This one is marked, "K. Finch / Calif.," impressed on two lines. Estimated value: $250. *Naylor Collection.*

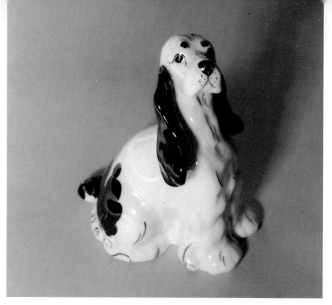

A black and white cocker, 5 inches high. It has "Kay Finch" impressed in the bottom. Estimated value: $55. *Carson Collection.*

This cocker spaniel is shorter, 8-3/4 inches high, but still large enough that you don't see it very often. Its mark is shown below. Estimated value: $140. *Oravitz Collection.*

Same dog as the black and white. Its mark is shown. Estimated value: $35. *Private Collection.*

Mark of 8-3/4 inch brown and white cocker.

Inkstamp mark of brown cocker. Note how light it is. That's the way many Kay Finch stamps were applied, so you sometimes must look very close to see them.

This Afghan measures 4-1/4 inches in height. It is marked with an inkstamp, "Kay Finch / California," on two lines. Estimated value: $50. *Oravitz Collection*.

The dog is 4 inches high, has a two line inkstamp, "Kay / Finch ©." The donkey's height is 4-1/8 inches. It also has a two line inkstamp mark, "Kay Finch / California." Estimated value: dog $25, donkey $35. *Oravitz Collection*.

The larger elephant here, whose name is *Peanuts*, is 8-7/8 inches high and unmarked. The smaller one, *Popcorn*, stands 6-7/8 inches, has a "Kay Finch / California" inkstamp. Estimated value: *Peanuts* $185, *Popcorn* $125. *Oravitz Collection*.

The elephant on the left is 5-1/8 inches high, has a "Kay Finch / California" inkstamp. The one in the center, 4-1/2 inches high, is unmarked. The one on the right, marked "Kay Finch / California," stands 4-1/4 inches high. Estimated value: left $75, center and right $45 each. *Oravitz Collection.*

Mark of *Grumpy.*

Draft horses, 4-1/4 inches high on the left, 3-3/4 inches high on the right. The taller example is unmarked, the smaller one has a smeared mark that is unreadable. Estimated value: $35 each. *Oravitz Collection.*

Here's *Winkie* (left) and *Sassy* (right). Each is 3-3/4 inches high, each has a "Kay Finch / California" inkstamp. Estimated value: $45 each. *Oravitz Collection.*

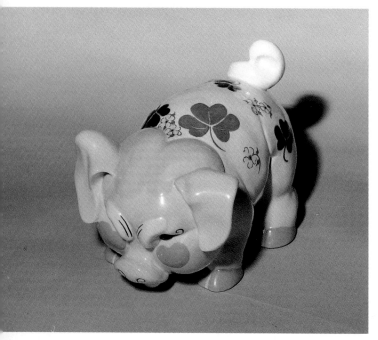

Sassy and *Winkie* again. Same size and marks. Estimated value: $45 each. *Oravitz Collection.*

This is *Grumpy,* a 6-3/8 inch high figurine that was also made as a bank, as was his partner, *Smiley,* who appears with another *Grumpy* on page 11. *Grumpy's* mark is shown. Estimated value: as shown $90, as a bank $130. *Oravitz Collection.*

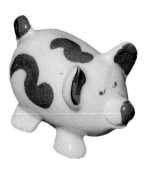

This little pig is only 1-5/8 inches high. It has an inkstamp mark, "Kay / Finch," on two lines. Estimated value: $25. *Graettinger Collection.*

Lamb figurine, 6 inches high, "Kay Finch / California" inkstamp. Estimated value: $35. *Carson Collection.*

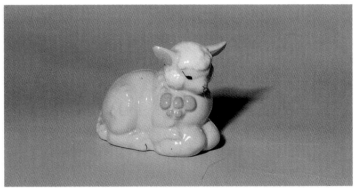

Rabbit figurine, 7-3/4 inches high. It is not marked. Estimated value: $130. *Oravitz Collection.*

The company called this *Kneeling Lamb*. It is 2-1/4 inches high and unmarked. Estimated value: $25. *Oravitz Collection.*

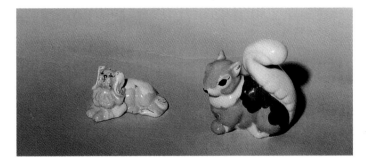

Small rabbit, 2-1/2 inches high, unmarked. Estimated value: $25. *Oravitz Collection.*

The little dog is 1-1/2 inches high, has a "Kay Finch / California" inkstamp. The squirrel, 3-1/2 inches high, is not marked. Estimated value: dog $20, squirrel $35. *Oravitz Collection.*

This little winged Afghan is 2-1/2 inches high. It has an unreadable Kay Finch inkstamp. Estimated value: $45. *Oravitz Collection.*

Fish figurine, 3-3/4 inches high, 7 inches long. It is marked "Kay Finch / California" by impression. Estimated value: $60. *Oravitz Collection.*

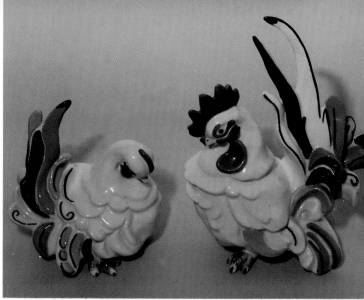

Butch and *Biddy* in still different colors. Estimated value: $75 each. *Naylor Collection.*

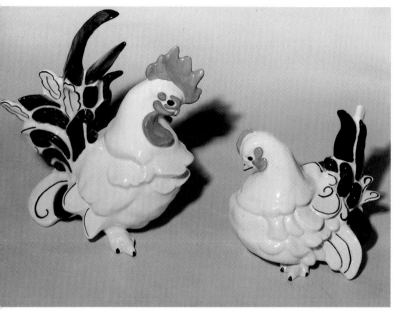

Butch and *Biddy*, 8-1/2 and 5-1/2 inches high, respectively. *Butch* is not marked. *Biddy* has "K. Finch" impressed. Estimated value: $75 each. *Oravitz Collection.*

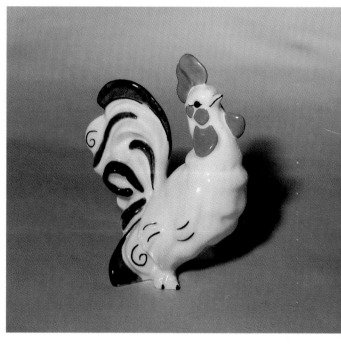

Unnamed and unmarked, this chicken figurine stands 5-3/4 inches high. Estimated value: $60. *Oravitz Collection.*

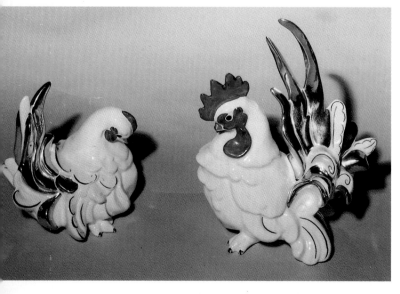

Biddy and *Butch* again, this time with gold decoration. Marks, or lack of them, same as above. Estimated value: $85 each. *Oravitz Collection.*

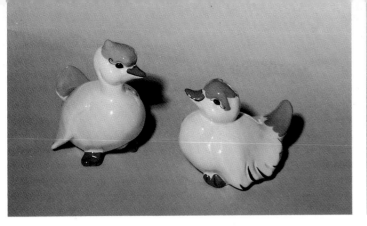

Peep and *Jeep*, according to the 1946 catalog, but it does not specifically state which is which. The one on the left is 4-1/4 inches high, the one on the right 3-1/4 inches. Neither is marked. Estimated value: $30 each. *Oravitz Collection.*

Polly is the name of this 4-3/4 inch high penguin that carries the inkstamp mark, "Kay / Finch," on two lines. Like the owls it is one of a set of three. The others are *Pee Wee* 3-1/4 inches high, and *Pete* 7-1/2 inches high. Estimated value: *Pete* $130, *Polly* $75, *Pee Wee* $35. *Oravitz Collection.*

This is *Toot*, 5-1/2 inches high, marked "Kay Finch / Calif." *Toot* is the middle size owl in a set of three that includes the smaller examples below called *Tootsie*, and an 8-3/4 inch high model named *Hoot* which is not shown. Estimated value: *Hoot* $120, *Toot* $70, *Tootsie* $30. *Oravitz Collection.*

The parakeet stands 5-1/2 inches high, is marked "Kay / Finch ©" on two lines. Estimated value: $75. *Oravitz Collection.*

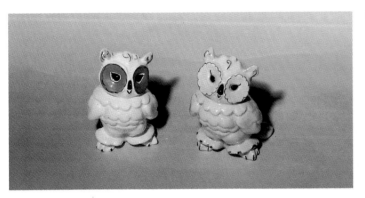

Two examples of *Tootsie*, each 3-7/8 inches high. The white one is inkstamped "Kay / Finch" on two lines. The pink one, "Kay Finch / California" on two lines. Estimated value: left $35, right $30. *Private Collection*

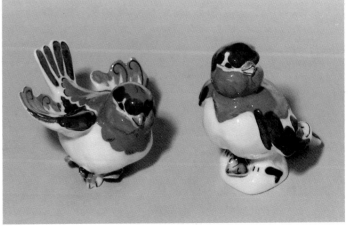

Mr. and *Mrs. Bird*. That's *Mrs.* on the left, 3 inches high. *Mr.*, on the right, is 4-1/4 inches. Neither is marked. Estimated value: $40 each. *Oravitz Collection.*

Mrs. Bird in lavender. Estimated value: $40. *Oravitz Collection.*

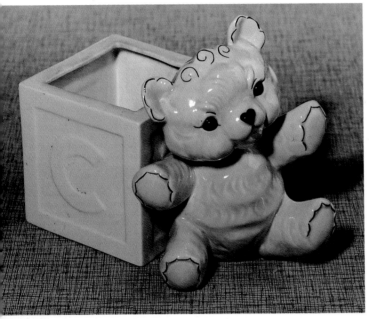

Block with Baby Planter, 5 inches high and marked the same as the *Block with Bear Planter*. Estimated value: $45. *Oravitz Collection.*

Book with Baby Planter, 6-3/4 inches high, same mark as the other two. Estimated value: $45. *Oravitz Collection.*

A *Block with Bear Planter*, 6 inches high. Its mark is shown. Estimated value: $35. *Oravitz Collection.*

Mark of *Block with Bear Planter.*

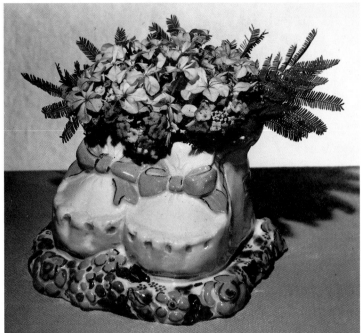

Booties Planter, height unknown. Estimated value: $25. *Courtesy of Frances Finch Webb.*

Archival photo of four planters, each 6-3/4 inches high. Estimated value: $30 each. *Courtesy of Frances Finch Webb.*

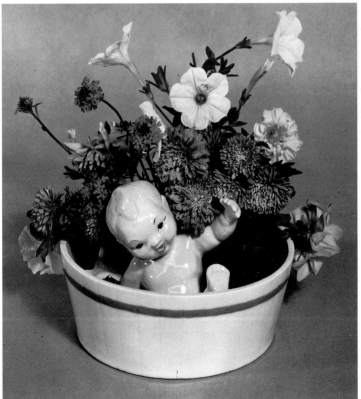

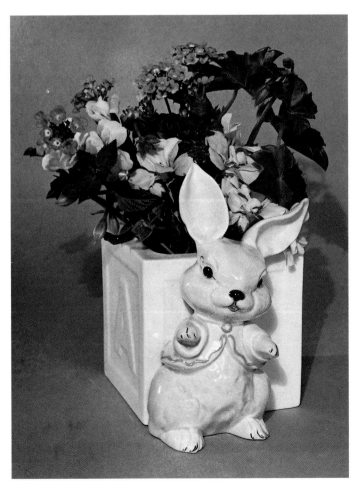

Tub with Baby Planter. Estimated value: $35. *Courtesy of Frances Finch Webb.*

Block with Bunny Planter. Estimated value: $30. *Courtesy of Frances Finch Webb.*

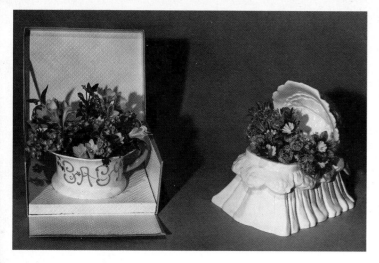

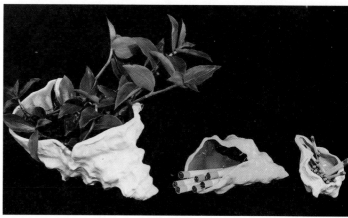

I am not aware of the name of the planter on the left. The one on the right was called the *Crib Planter* by the company. Estimated value: $30 each. *Courtesy of Frances Finch Webb.*

A Kay Finch shell set. Estimated value: *Shell Vase and Wallpocket* (4-1/2 inches high) $45, *Shell Ashtray* (2-3/4 inches high) $15, *Shell Match Holder* (2 inches high) $15. *Courtesy of Frances Finch Webb.*

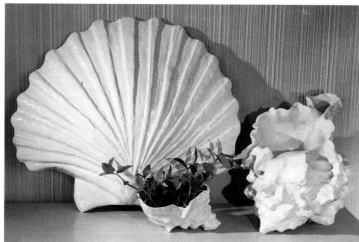

The *Donkey with Basket Planter* is about 3-7/8 inches high. The *Donkey*, figurine, 4-1/8 inches, is the same one shown above in color. Estimated value: planter $30, figurine $35. *Courtesy of Frances Finch Webb.*

Two different shells, one the same. Estimated value: Cockle Shell (23 inches across!) $150, Conch Shell (12 inches high) $100, Shell Vase and Wallpocket (as above) $45. *Courtesy of Frances Finch Webb.*

The heights and current prices of these wall plaques have not been determined. *Courtesy of Frances Finch Webb.*

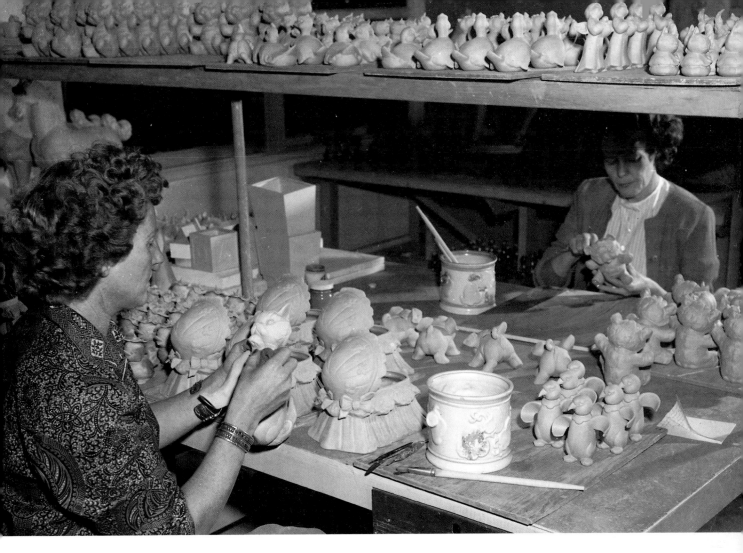

That's Kay Finch on the left, working with an employee to remove burrs and other imperfections after the pieces have been fired to bisque but before they are glazed. *Courtesy of Frances Finch Webb.*

Kim Ward

Kim Ward, according to its mark, was located in Hollywood. According to Chipman, Kim Ward was a pseudonym for Katherine Schueftan, a former Hedi Schoop employee whose work came so close to Schoop's that Schoop sued her and won. Be that as it may, Kim Ward, from today's vantage point, made some very nice California pottery. Perhaps not good enough to be included up on that pedestal with Kay Finch, Hedi Schoop, Brayton Laguna and a few others, but certainly nice enough to be included in anyone's collection without apology.

How long Schueftan was in business is unknown. Chipman gives the date of the lawsuit as 1942, so it may be reasonably assumed that she had to have started sometime before that but sometime after Schoop began her concern in 1938. Judging by the large number of Kim Ward pieces that are available today, losing the lawsuit may not have spelled the end of the company.

The boy planter, 5-1/4 inches high, is named *Petrov*. The girl, *Hilga*, measures 4-3/4 inches. Their marks are shown below. Estimated value: $15 each. *Oravitz Collection.*

Mark of Kim Ward *Petrov.*

Bottom of blue and pink girl planter.

Mark of Kim Ward *Hilga.* (I'm not sure which is more artistic, the figure or the mark.)

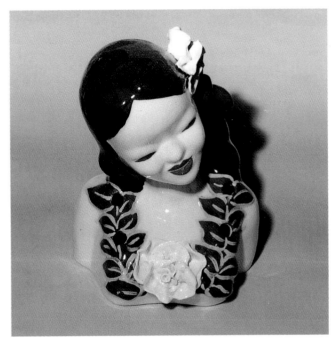

The opening in this planter is in the rear so you cannot see it in the picture. This is a large one, 10-1/2 inches high. Its mark is shown. Estimated value: $55. *Oravitz Collection.*

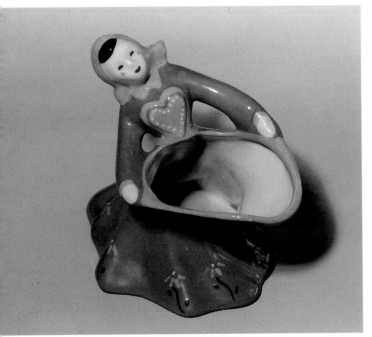

This planter is 5 inches high. Its mark is shown below. Estimated value: $15. *Oravitz Collection.*

Bottom of above girl head planter.

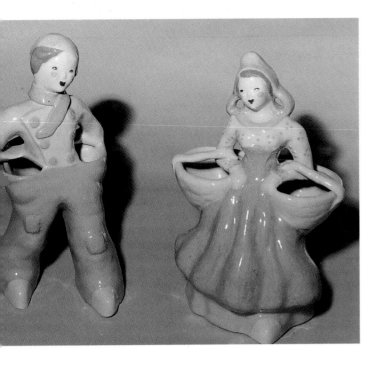

Bottom of above the boy figurine, which is also different than the planter.

The boy planter stands 9-1/4 inches high, the girl 8-1/2 inches. Their marks are shown. Estimated value: $20 each. *Oravitz Collection*.

Marks and bottoms of the boy and girl planters.

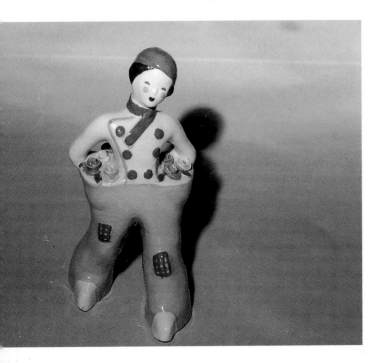

This is *Mimi*, 5-1/4 inches high. She is marked, "Kim Ward / Hollywood / Mimi," on three lines. Estimated value: $25. *Oravitz Collection*.

Same boy as above but a figurine. Estimated value: $20. *Oravitz Collection*.

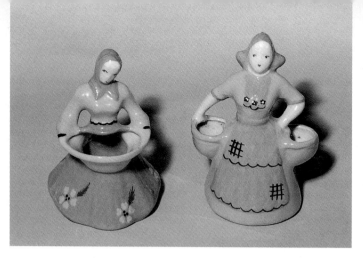

No absolute proof on these two as they are not marked. But, to me, the eyes and colors appear close enough to include them here. Each is 4-5/8 inches high. Estimated value: $15 each. *Oravitz Collection*.

Both planters are 5-1/2 inches high. the inkstamp mark of the one on the left reads, "US Patent 136478 / lamar," on two lines. The mark of *Little Red Riding Hood* is shown. Estimated value: left $10, right $20. *Oravitz Collection*.

L & F Ceramics

No information on this company except that the mark of the one piece shown says it was made in Hollywood.

Inkstamp mark of *Little Red Riding Hood*.

This planter measures 4-1/2 x 8 inches. Its impressed mark reads "L & F Ceramics / Hollywood Cal" on two lines. Estimated value: $10. *Oravitz Collection*.

Lamar

According to Derwich and Latos, the *1947 San Francisco Buyers Book and Directory*, showed Lamar as a manufacturer of nursery rhyme hand decorated flower holders. In the accompanying photograph, the planter on the left has a mark that includes a design patent number, no. 136478. Since this number corresponds to a date of 1943, we know of at least five calender years that the company was probably active. There may have been many more.

Lane & Company

The mark on one of the ship planters below shows Lane & Company located in Los Angeles in 1952. The mark of the swan (or is it a flamingo?) planter indicates it had moved to Van Nuys by 1959. According to Lehner, Lane went by the name Sunkist Creations for a time in the early 1960s, then reverted to the original name by 1965, at which time its street address was 14460 Arminta, Van Nuys. She states that they were in business until sometime after 1967. Lane's most prolific products were probably the numerous TV lamps, popular in the 1950s, that turn up at today's antique shows and never seem to sell. Their most expensive product today would be the Indian cookie jar, which at the beginning of 1995 was going for $1000 or more. It was also being reproduced.

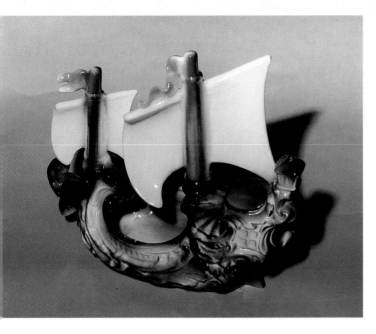

This ship is 9-1/4 inches high. Its impressed mark, which appears on the back, reads, "Lane & Co. LA Calif. © 1952." A picture of the bottom of this planter is shown. Estimated value: $25. *Naylor Collection*.

A swan planter, 10-3/4 inches high. Its impressed mark and paper label are shown below. Estimated value: $18. *Private Collection*.

Mark of the swan planter. It reads, "P-73 / Lane & Co. © 1959 / Van Nuys Cal. USA" on three lines.

Bottom of the Lane ship planter showing runners similar to those used by Royal Copley and other companies.

Same ship as above in a different color. This one is not marked. Estimated value: $25. *Naylor Collection*.

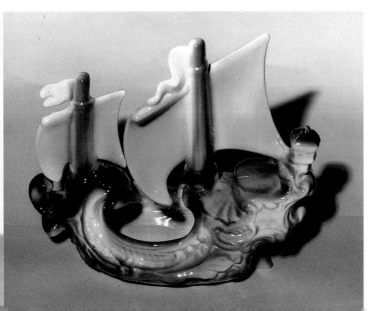

Los Angeles Pottery

This is probably the firm that is normally referred to as Los Angeles Potteries. Los Angeles Potteries was started in Lynwood in 1940 and called Best Potteries. Its address was 11700 Alameda Street. The original aim of the company was sanitary ware. When that didn't work out it turned to artware and figurines which were sold through N.S. Gustin of Los Angeles. Originally a brass plumbing accessory company, a split took place in 1942, metals going to one faction, ceramics to the other. At that time the name was changed to Los Angeles Potteries.

Over the years some of the partners in the company occasionally changed but the name was retained until December, 1970 when the firm closed. At closing it sold its molds to N.S. Gustin, which used them at Designcraft, a pottery in West Los Angeles in which it held part ownership. As a result, you may at times see Los Angeles Potteries items with marks other than Los Angeles Potteries, mainly N.S. Gustin.

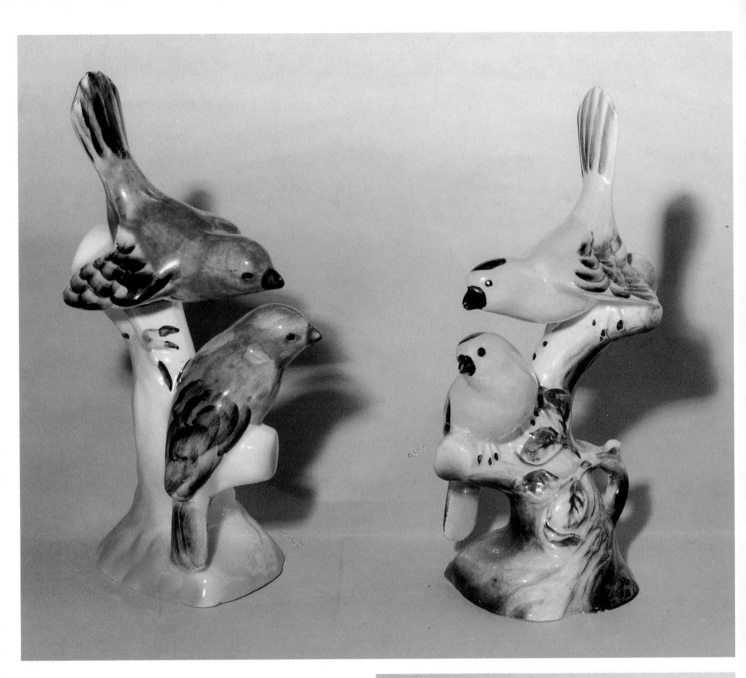

Two sets of birds shown from both the front and the back. Both figurines are 8-1/2 inches high, both have "Made in / California" impressed in script on two lines. Estimated value: $15 each. *Private Collection.*

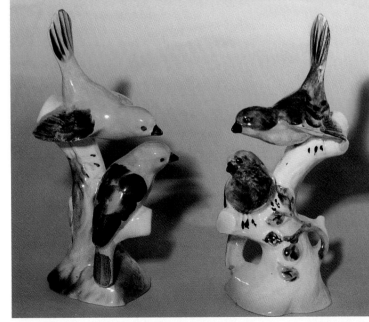

Same birds, same marks, different colors. Estimated value: $15 each. *Private Collection.*

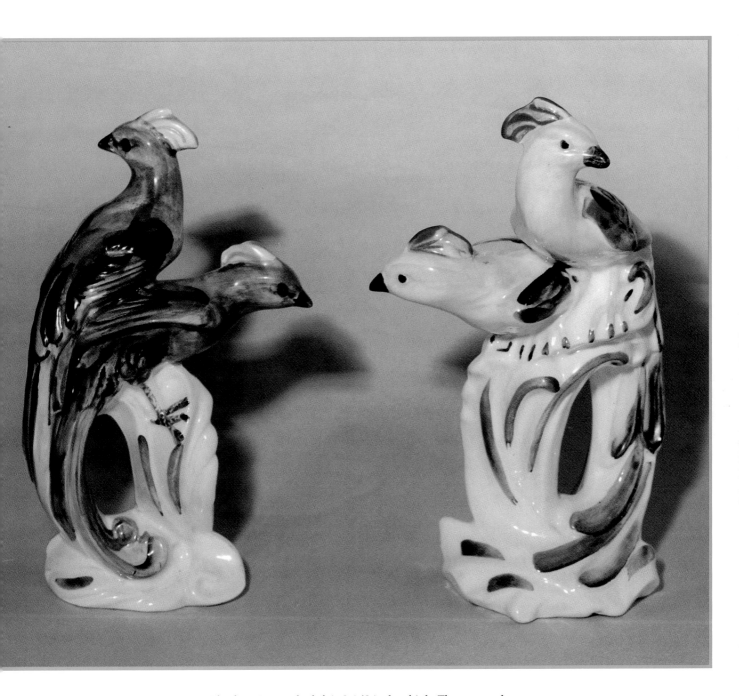

The figurine on the left is 8-1/2 inches high. The one on the right stands one inch taller at 9-1/2 inches. While the larger one is unmarked, the smaller one has "L.A. Pottery / Calif." impressed on two lines, and "#78" impressed in another part of the base. Estimated value: $15 each. *Private Collection.*

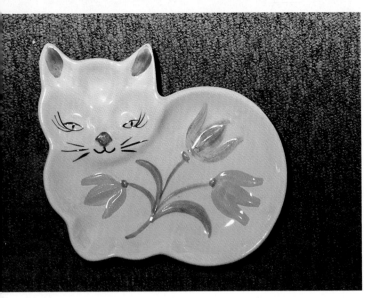

This cat plate is one inch high, 9 inches across at its widest point. It carries an impressed mark, "Hand Decorated / Los Angeles Potteries / Calif. U.S.A.," on three lines. Estimated value: $20. *Courtesy of Louise Lovick.*

Los Cali

Research into this pottery's background has yielded no reliable information.

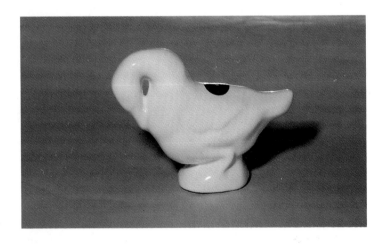

This goose measures 3-1/2 inches high, 4-3/4 inches long. The paper label is shown. Estimated value: $5. *Private Collection.*

Close-up of the paper label on the white goose.

Mackie's

Nothing known here except that it resided in California. Do not mistake this company with Macky's Hobby Molds, a Lincoln Park, Michigan, manufacturer of molds.

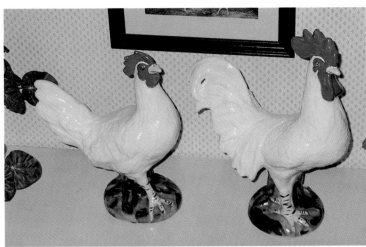

The rooster of this pair is 13 inches high. The hen was not measured. Each is marked, "Mackie's / Calif. ©" on two lines. Estimated value: rooster $60, hen $50. *Private Collection.*

Maddux of California

A lot of Maddux pottery is distinctive, very easy to recognize once you have been exposed to it. The company used more black than a lot of others did, relied mostly on airbrushing, and put quite a bit of deep mold detail into feathers, bark and wood grain.

The firm was founded by William Maddux in 1937 or 1938 in Los Angeles. Two early suppliers of the company, which may have been only a sales agency during its infancy, were Hollywood Ceramics and Valley Vista Pottery, both of which Maddux later acquired.

Sometime around 1949 Maddux was sold to Dave and Lou Warsaw. In 1956 Dave Warsaw sold his share to Morris D. Bogdanow. Lou followed suit some years later. Morris Bogdanow sold it to his son, Norman, in 1976, who in turn sold it to Carol Lee Tirre in 1977. The company went out of business in 1980.

According to most accounts, Maddux of California built a new manufacturing facility in 1959, which was sold in 1974. Between then and 1980 it functioned mainly as a design and sales organization, farming work out to other potteries as it apparently had done in the beginning. Look through old premium stamp catalogs, Top Value, S & H and others, and you will often see Maddux pieces offered as premiums.

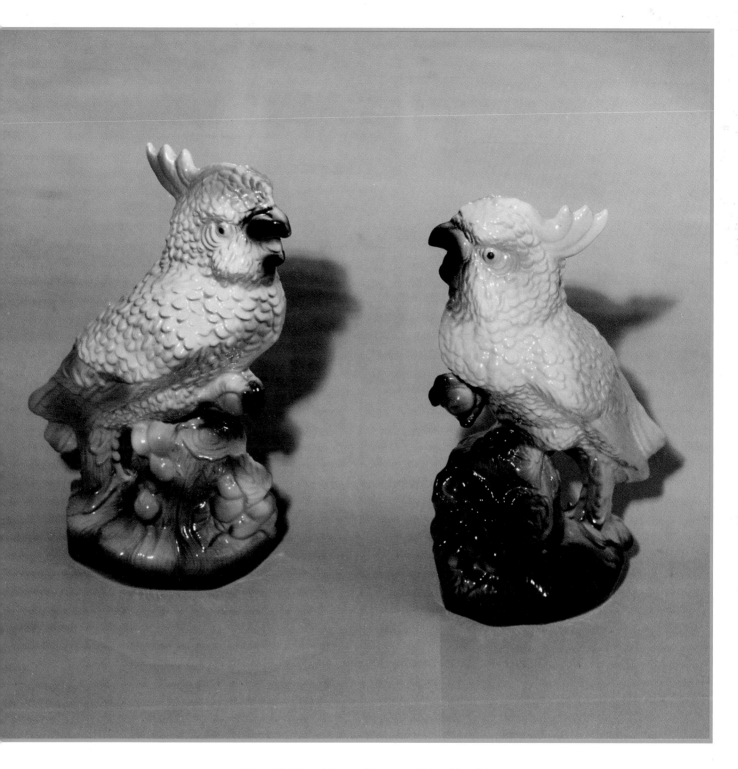

A pair of unmarked Maddux cockatoos, each 9-1/8 inches high. Estimated value: $20 each. *Private Collection.*

The bird on the left stands 6-7/8 inches high, the one on the right 6-1/4 inches. Neither is marked. Estimated value: $10 each. *Private Collection.*

Double cockatoos, 11-1/4 inches high and unmarked. Estimated value: $30. *Private Collection.*

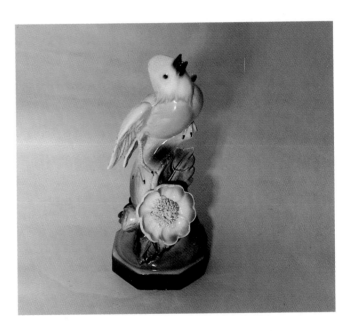

A pair of pheasants. The one on the left is 6-3/4 inches high, has "Maddux of Calif / (unreadable number) / Made in USA" impressed on three lines. The one the on the right stands 11-3/4 inches, is marked "Maddux of Calif / 943 ©1959 / Made in USA," impressed on three lines. Estimated value: $20 each. *Oravitz Collection.*

This bird is 10-3/8 inches high. It is not marked. Estimated value: $20. *Private Collection.*

This planter is 5-1/2 inches high. Its impressed mark reads, "Maddux of Calif / 446 ©'59 / Made in USA," with 446 and ©'59 widely separated. Estimated value: $10. *Private Collection.*

Height here is 8-1/2 inches. Like many Maddux pieces it is unmarked. Estimated value: $10. *Private Collection.*

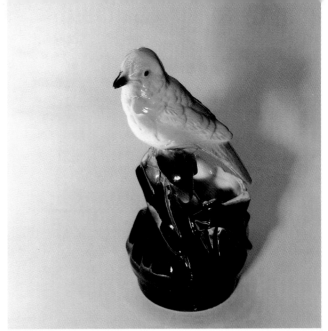

A 7-1/4 inch high planter that is impressed "Made in California" around the base. Estimated value: $10. *Private Collection.*

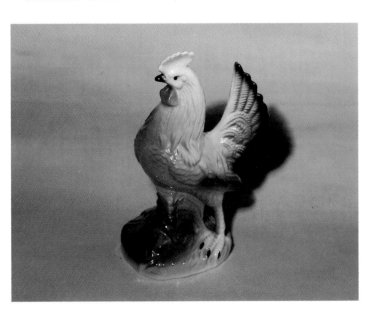

The chicken is 8-1/2 inches high. It is not marked. Estimated value: $15. *Private Collection.*

Height of this planter is 7-7/8 inches. It is impressed "#338" on one side of the base, "Made in / California" on the other. Estimated value: $20. *Private Collection.*

All of the Maddux birds I have seen have had open bottoms, and they were apparently always dipped in a clear glaze prior to firing. As a result, an open bottom with a glazed inside is a clue toward identification.

Height is 5-1/2 inches. Mark is "Maddux of California 508," impressed. Estimated value: $10. *Naylor Collection.*

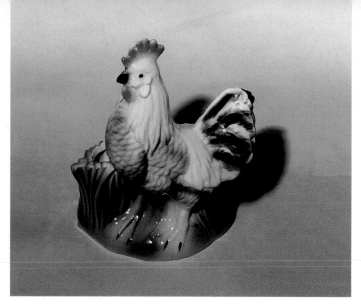

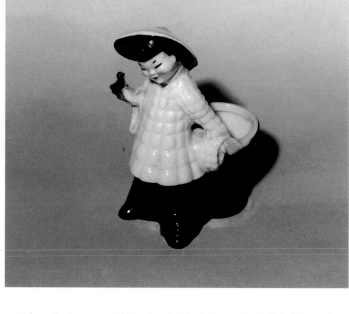

This planter is 7-1/2 inches high. It is unmarked. Estimated value: $15. *Naylor Collection.*

Oriental planter, 6-1/4 inches high. It is marked, "Maddux of California," by impression. Estimated value: $15. *Oravitz Collection.*

A 12-inch Art Deco style cat, "Maddux" impressed in the bottom. This is one of a pair, the other facing the opposite direction. In 1968, according to *Top Value Stamps Family Gift Catalog*, you could get the pair for 1-3/5 books. Estimated value: $35. *Carson Collection.*

Maurice Ceramics of California

According to the Roerigs, Maurice Ceramics is strictly a distributor. It is based in Los Angeles. Lehner found it listed in a 1967 directory; it may have been in business earlier. It is still operating today.

This peacock is quite large, 9-3/4 inches high, 16-1/2 inches long. Its impressed mark is shown below. Estimated value: $25. *Private Collection.*

Mark of the Maurice peacock.

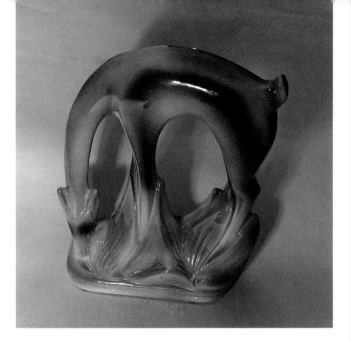

A feeding deer, 9-1/4 inches high. Its impressed mark reads "Maurice / Calif. USA / © / J-75" on four lines. Estimated value: $10. *Private Collection.*

Max Weil of California *See Weil of California, Inc.*

McCarty Brothers

Lee and Michael were the McCarty Brothers. Residents of Sierra Madre and graduates of Pasadena City College they started their pottery in Sierra Madre in 1941. It lasted until 1952.

Planters seem to have been their favorite product but figurines were also made, and the majority of their output was probably marked with the names of distributors instead of their own name. According to Lehner, from about 1943 to 1947 they were associated with distributor Walter Wilson, and after 1948 with Stewart B. McCulloch. Check those two listings and you will find pieces pictured that were obviously made by McCarty Brothers but bear the distributors' marks.

For as prolific as it was, the McCarty Brothers Pottery has remained a relative unknown among the California potteries of the 1940s. I think part of the reason is that the Japanese copied some of their oriental planters profusely, turning out many more than the McCarty Brothers themselves did. These shoddy imitations abound today, selling for very little if at all because people know they are of low quality. When collectors do see an original McCarty Brothers item they absently figure it's just another cheap Japanese planter and don't even look it over. But if you take the time to inspect and handle one of the originals, you will be pleasantly surprised by the design, workmanship, glazes, decoration, and other characteristics which set it apart from the cheap copies that eventually drove the pottery out of business.

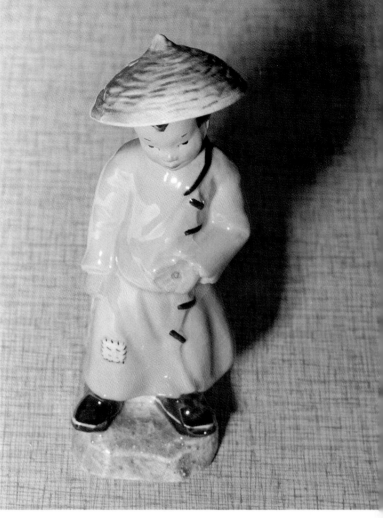

I failed to record whether this is a figurine or a planter. It is 8 inches high and its mark is shown below. Estimated value: $15. *Oravitz Collection.*

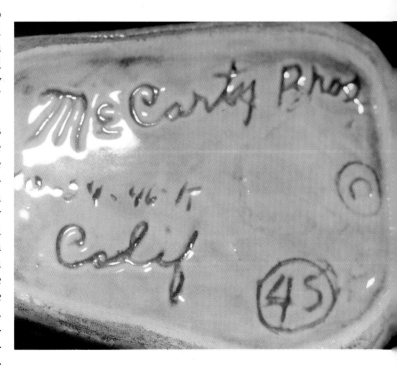

Mark of the oriental boy planter or figurine.

No guessing on this one. It is 7-1/2 inches high, has a mark similar to the one shown. Estimated value: $15. *Oravitz Collection.*

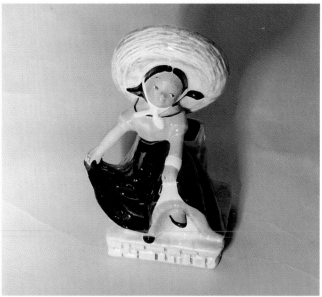

An unreadable but clearly recognizable McCarty Brothers mark identifies this 7-3/4 inch high planter. One part of the mark that is readable says "© 47." Estimated value: $15. *Oravitz Collection.*

McFarlin Potteries

According to Chipman, Gerald McFarlin was the owner/operator of McFarlin Potteries from 1927 until joining forces with Maynard Anthony Freeman to form Freeman-McFarlin in 1951. McFarlin Potteries was located in El Monte.

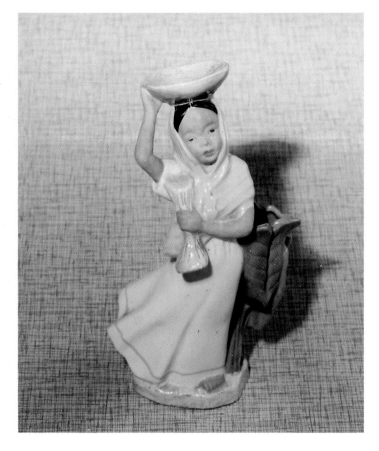

This peasant girl is also a planter. She stands 8-1/2 inches high, is marked "McCarty Bros. / 1-20-47:1 © 44 / California" on three lines. Estimated value: $15.

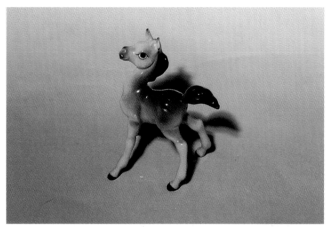

This 4-3/8 inch high colt is marked only by a paper label, which is shown. Estimated value: $12. *Oravitz Collection.*

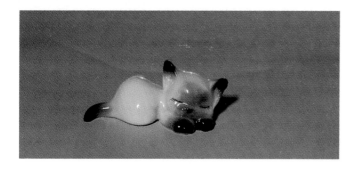

A sleeping cat, 1-1/4 x 3-1/8 inches, same paper label as the colt. Estimated value: $5. *Private Collection.*

Metlox

The word Metlox is an acronym for metal oxide, a material used in making neon signs. Ceramic signs with neon lighting were the focus of Metlox when T.C. and Willis O. Prouty, a father and son team, founded this Manhattan Beach pottery back in 1927. From 1922 to 1926 the Prouty's had owned Proutyline Products Company, a Hermosa Beach tile firm that, upon its sale in 1926, became part of American Encaustic Tiling Company's west coast adventure.

The beginning of the Depression in 1929, and the death of T.C. Prouty in 1931, dealt the sign business a double whammy, so Willis Prouty switched gears and began turning out dinnerware which was of high quality and sold well. Production of figural ware was delayed until the late 1930s when designer Carl Romanelli joined forces with Prouty. Then during World War II production of both dinnerware and figural ware was curtailed in favor of defense work.

Both lines were reinstituted after the war. Figural ware at Metlox probaby got its biggest boost though in 1946, and in a very strange form: the fire that destroyed Evan K. Shaw's American Pottery Company in Los Angeles. That's because Shaw promptly purchased Metlox from Prouty and continued to produce wonderful figuural pottery until his death in 1980, after which his family took over and ran the operation until closing it in 1989.

In case you haven't guessed, this means many of Shaw's Walt Disney figurals were actually made at Metlox in Manhattan Beach, not at American Pottery in Los Angeles as many people assume. The movie *Cinderella,* for example, was not released by Disney until 1950, four years after American Pottery burned, so the two *Cinderella* pieces shown in the section on American Pottery actually had to have been manufactured at Metlox.

Metlox used a variety of marks and paper labels, several of which are shown.

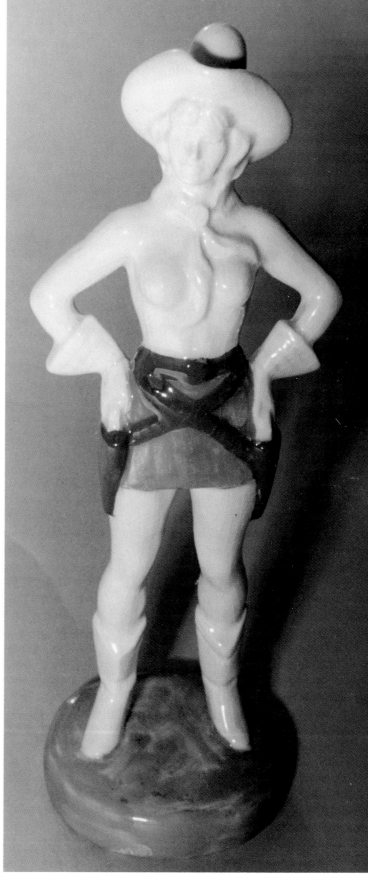

This figurine is 10 inches high. It has an impressed mark, "Poppy Trail / 1819 / Made in / California / USA," on five lines, with "C. Romanelli," impressed separately. Carl Romanelli was a designer Metlox used from the late 1930s until, presumably, the plant converted to defense work during World War II. Estimated value: $210. *Carson Collection.*

Metlox's Poppet line is one of its most collectible lines. This nun is 8-1/2 inches high. It is marked but I did not record the specifics. Estimated value: $45. *Teeters Collection.*

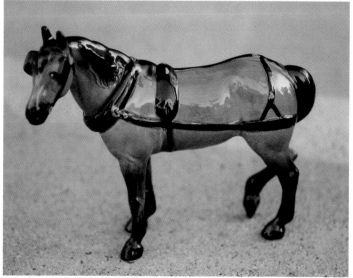

The man of this family is 5-1/4 inches high, the wife 5 inches, and the daughter 4-1/4 inches. The man and woman each have two Metlox paper labels, the daughter has one. The carriage has one, too. It measures 3-1/2 x 9 inches without the metal frame. Estimated value: man, woman and child $35 each, carriage $20. *Oravitz Collection.*

A monk to go with the nun. Height 6-3/4 inches. A round paper label states, "Poppets / by / Poppytrail / Metlox Potteries / Manhattan Beach, California / USA." Estimated value: $45. *Teeters Collection.*

A horse for the carriage, perhaps. Height is 8-1/8 inches. Length is 10 inches. It has a Metlox paper label. Estimated value: $65. *Private Collection.*

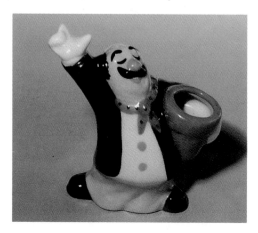

Planter, 4-1/2 inches high. It has a Metlox mark but which one was not recorded. Estimated value: $30. *Oravitz Collection.*

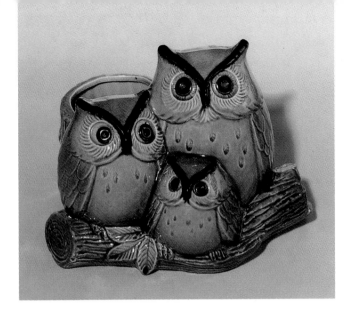

This planter matches the company's owl cookie jar. It is 6-1/4 inches high. Its mark is shown. Estimated value: $40. *Private Collection.*

Another typical paper label, also from the Currier & Ives horse.

Poppytrail mark of Metlox owl planter.

The penguin is 3-1/4 inches high. Its mark is shown. Estimated value: $15. *Private Collection.*

A typical Metlox paper label. This particular one was on the Currier & Ives horse on page 14.

Bottom and mark of penguin. A bit hard to read, it contains the words "USA," "Metlox," and the number, "580." Note that the bottom, and particularly the pour hole, look kind of rough. I find this to be the case with many of Metlox's smaller figurines.

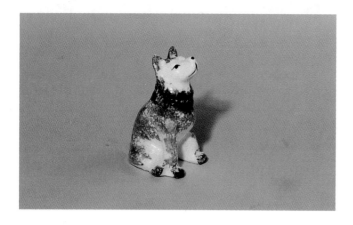

This dog is 2-7/8 inches high. Its mark is shown. Estimated value: $15. *Private Collection.*

Mark of stylized bird.

Mark of the Metlox dog. Although it does not say Metlox, note how the bottom compares favorably with that of the penguin, and the "Made in U.S.A." with that of the bird below.

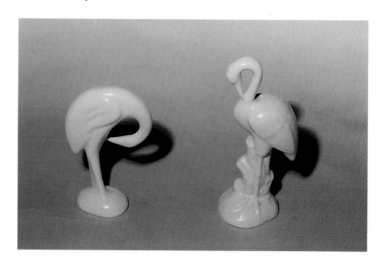

The bird on the left is 4-1/2 inches high, unmarked, and has a gloss glaze that does not show up very well in the picture. The bird on the right, 6 inches high, is inkstamped, "Metlox / Made in / U.S.A.," and has a matte glaze. Estimated value: $15 each. *Oravitz Collection.*

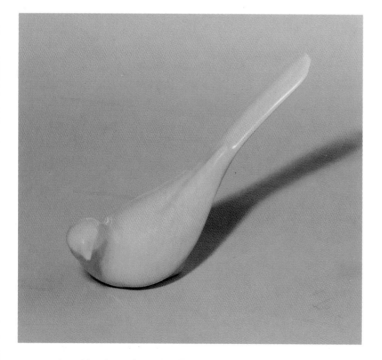

A stylized bird, 4-3/8 inches high. Its mark is shown. Estimated value: $15. *Private Collection.*

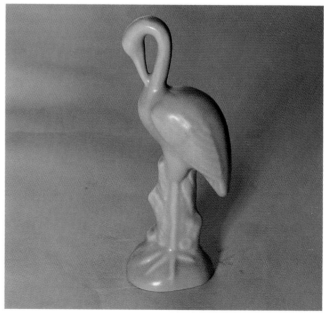

Same bird but a different color. The mark is shown. Estimated value: $15. *Private Collection.*

Mark of the pink shorebird.

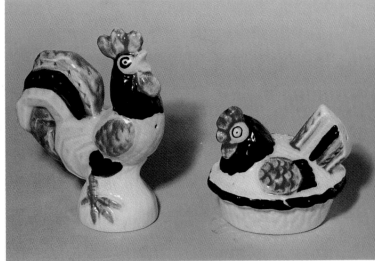

I have tried to stay away from kitchenware but feel these Red Rooster Provincial salt and pepper shakers could enhance most figurine collections. Heights are 4-5/8 and 2-7/8 inches. The shakers are not marked but the stoppers are, as shown. Estimated value: $40 per pair. *Private Collection.*

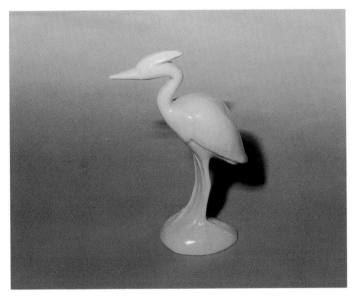

This bird stands 6-5/8 inches high. It is stamped, "Metlox / Made in/ U.S.A." Estimated value: $15. *Private Collection.*

Stopper of one of the above shakers.

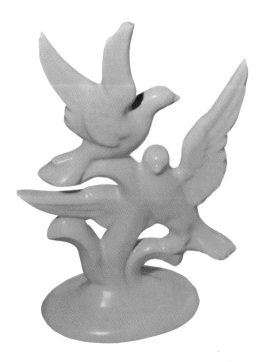

Double birds, perhaps the centerpiece of a console set. Height is 8 inches. The impressed mark reads, "Made in / California / USA." Estimated value: $20. *Private Collection.*

Same size, different colors. Estimated value: $20. *Private Collection.*

This piano is actually a small covered dish. It is 5 inches high, 8-5/8 inches wide, and 5 inches deep. It has a Metlox paper label. Estimated value: $22. *Courtesy of C.L. Miller.*

Modglin's

While Modglin's was a prolific pottery that did excellent work, little is known about it other than it was located in Los Angeles. Its style would seem to indicate 1940s and 1950s, possibly into the 1960s.

Most Modglin's pottery is marked. In many cases familiarity with marked pieces will allow you to easily identify the few unmarked pieces you may run across.

The Mettox bear on the left is 3-5/8 inches high, the one on the right measures 3 x 5-1/2 inches. One is inkstamped "U.S.A.," the other "Made in U.S.A." Estimated value: $25 each. *Oravitz Collection.*

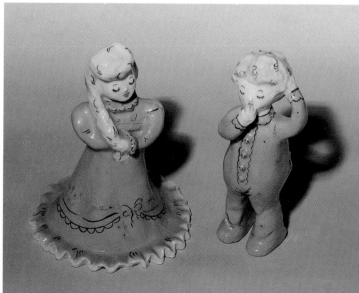

Janie and *Joey*, 7 and 6-5/8 inches high, respectively. Their marks are shown. Estimated value: $35 each. *Oravitz Collection.*

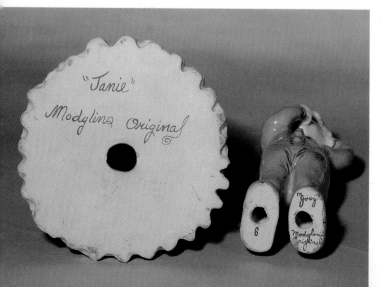

Marks of *Janie* and *Joey*.

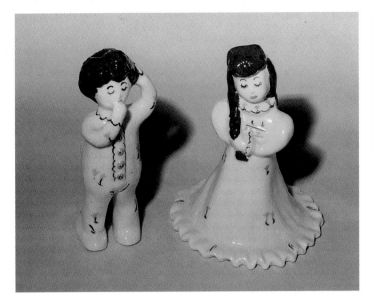

Mark on the right foot of the storybook girl.

Joey and *Janie* in a different color scheme. This pair is not marked. Estimated value: $35 each. *Oravitz Collection.*

This pair is commonly called the storybook girl and boy. The girl is 7-3/4 inches high, the boy 8 inches. The boy is not marked. The marks of the girl are shown. Estimated value: $45 each. *Oravitz Collection.*

Mark on the left foot of the storybook girl.

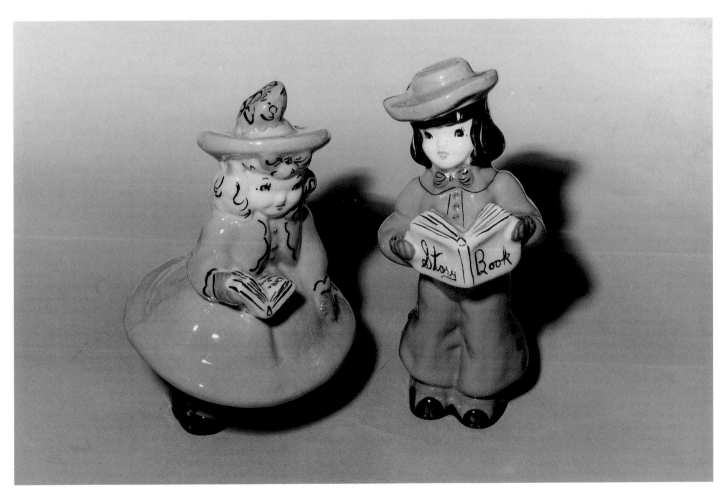

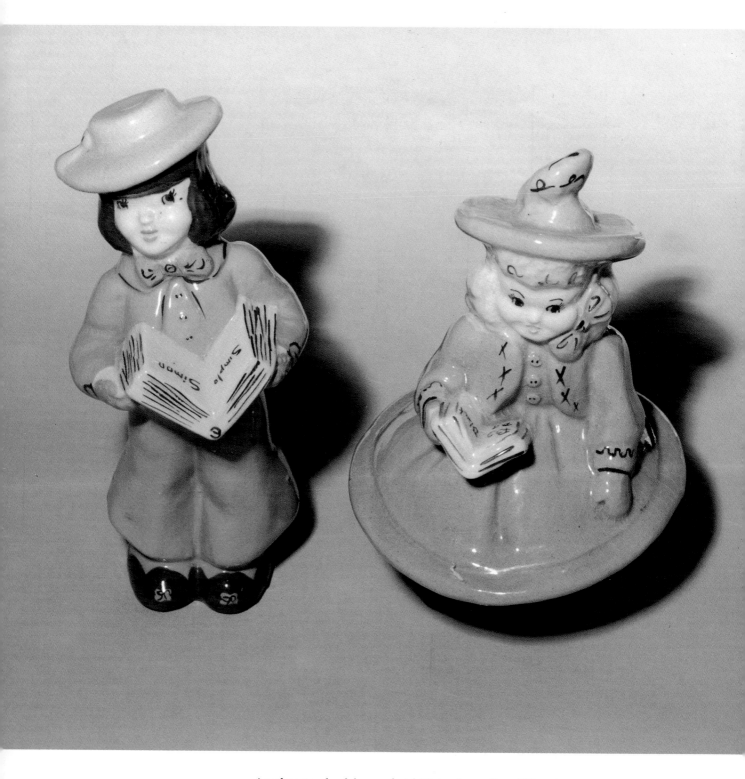

Another storybook boy and girl. Not only are they different
colors than the other couple, but look at the way the boy is
holding his book. Both of these figures are 8-1/4 inches high.
Neither is marked. Estimated value: $45 each. *Oravitz Collection*.

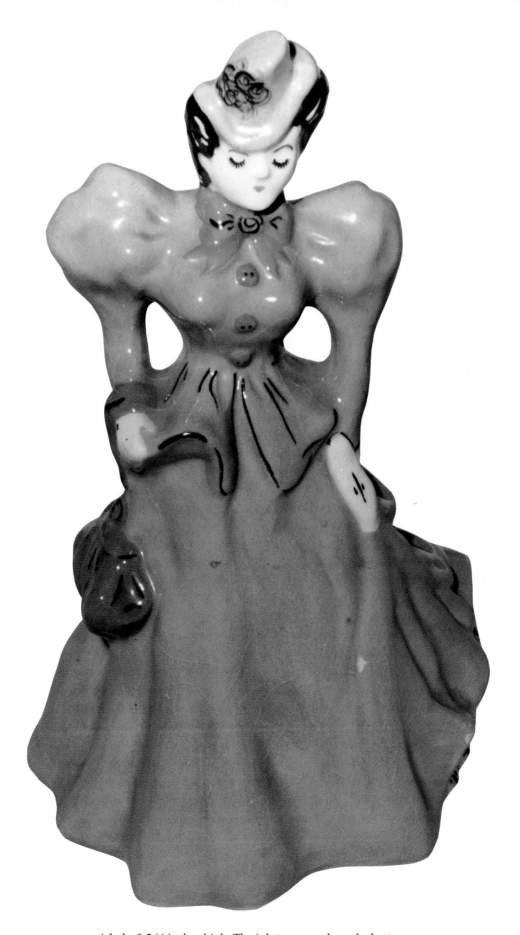

A lady, 9-3/4 inches high. The inkstamp mark on the bottom reads, "Modglin's / Los Angeles," on two lines. Estimated value: $40. *Oravitz Collection.*

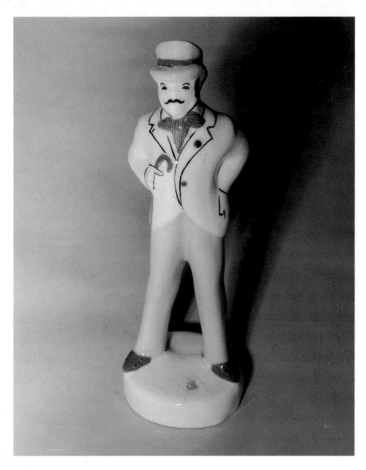

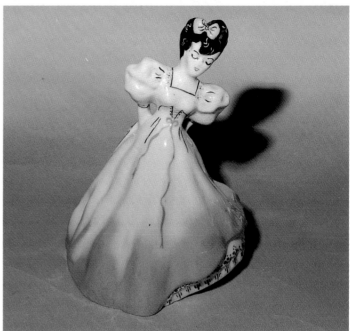

This lady stands 10-7/8 inches high. Her inkstamp is slightly different than some of those above, "Modglin's / California," on two lines. Estimated value: $40. *Oravitz Collection*.

This gentleman is tall, 11-1/2 inches. He has an inkstamp mark, "Modglin's / Los Angeles." Estimated value: $50. *Oravitz Collection*.

The horse on the left is 7 inches high. Its mark is shown below. *Popo*, as his saddle says, was not measured. *Popo* is marked "Modglin's / Los Angeles," on two lines. Estimated value: $30 each. *Oravitz Collection*.

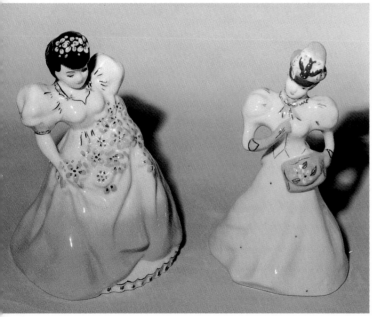

Heights are 9-3/8 and 9-1/2 inches left to right on this pair. Neither is marked. Estimated value: $40 each. *Oravitz Collection*.

Mark of the horse with *Popo*.

An unmarked Modglin's tiger measuring 4-1/2 x 9 inches. Estimated value: $40. *Oravitz Collection.*

This pair of lambs, each 3-3/4 inches high, present a mystery of sorts. Modglin's four-legged animals, such as the tiger, horses and these and other lambs, generally have three closed feet and one open foot that was used to drain the slip when the piece was poured. As you can see below, the white and black lamb is different. Estimated value: $20 each. *Oravitz Collection.*

A Modglin's bear, 4 inches high with no mark. Estimated value: $25. *Oravitz Collection.*

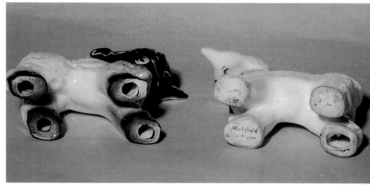

Bottoms of both lambs showing the four open feet of the white and black lamb. The airbrushing is different, too, but not totally as the green bird shown was also airbrushed.

Modglin's chicks, 5-1/4 inches high. The one on the left has a "Modglin's / Original" inkstamp. The one on the right has "15" in ink, a letter that looks something like a "K" impressed, and "original" in ink. Estimated value: $20 each. *Oravitz Collection.*

The bunny is 6-3/4 inches high. It has the same K-type letter incised as the one chick does. Estimated value: $35. *Oravitz Collection.*

A blue bunny. This one has a "4" incised with no other mark. Estimated value: $35. *Oravitz Collection.*

This Modglin's cat stands 7-1/4 inches high. It has "3" written in ink, a "P" incised and nothing else. However, another photographed had a "Modglin's / Original / Los Angeles" inkstamp. This cat was also made in brown, and possibly other colors. Estimated value: $45. *Oravitz Collection.*

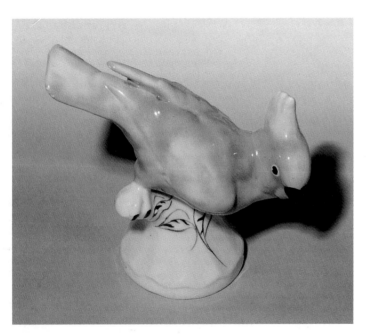

This bird is 8 inches high. Its mark is shown below. Estimated value: $40. *Oravitz Collection.*

In case this photo comes out hard to read, the mark is "Modglin's," in raised letters.

Orville Kirby Pottery *See Sleepy Hollow Pottery*

Phantasy Ceramics

All I have been able to find out about this company is what the mark says, that it was located somewhere in California.

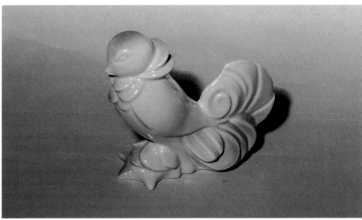

This 5-1/8 inch high bird is the only piece of Phantasy Ceramics I ran into in the course of photographing the book. Its mark is shown. Estimated value: $10. *Oravitz Collection.*

Mark of above bird, "Phantasy / Ceramics / California," on three lines.

Pixie Potters

The planter/wallpockets shown are both marked Pixie Potteries in raised letters.

According to Lehner, a John T. Hughes, no address given, filed for registration of a Pixie Pottery mark in September, 1945, claiming he had used it that year for ornamental flower containers, salt and pepper shakers, and dinnerware. Then in 1946 a lady named Mildred H. Andrews, of Los Angeles, filed a "Pixie" mark, saying she had used it for ceramic figurines since 1939.

Throw in the paper label shown that says Laguna Beach and I am not really sure where that leaves us, other than to say that's all I have been able to find out.

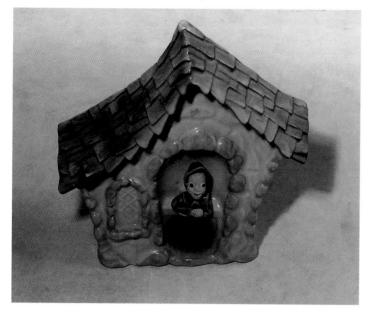

As best as I recall, this paper label was on a pixie figurine but I have been unable to find the picture. Nevertheless, it does give a location for the Pixie Potters, assuming that is the same company as the Pixie Potteries.

Poinsettia Studio

This company is best known for its salt and pepper shakers. I have been unable to determine where it was located. My guess on its period of activity would be the 1950s. As shown, Poinsettia Studio's forte appears to have been useful things of figural form.

This is a wallpocket, 8-1/2 inches high. It is marked, "© Pixie Potteries," in raised letters. Estimated value: $10. *Oravitz Collection.*

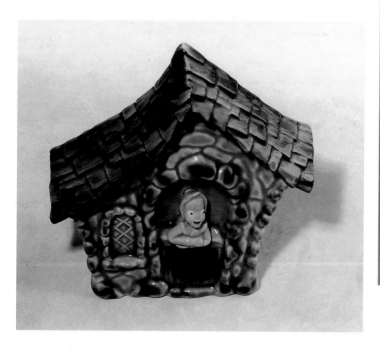

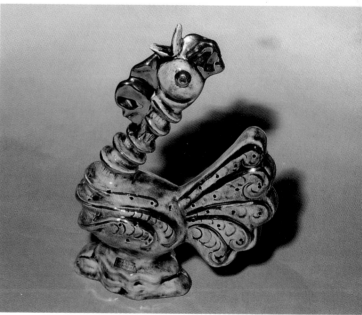

A rooster hors d'oeuvres, 9-3/4 inches high. It has the same paper label that is shown below. Estimated value: $25. *Oravitz Collection.*

Same height, same mark. Estimated value: $10. *Oravitz Collection.*

Both of these are bells. The chick is 1-5/8 inches high, the horse 2-3/4. Each has a paper label, the horse's being shown. Estimated value: $10 each. *Private Collection.*

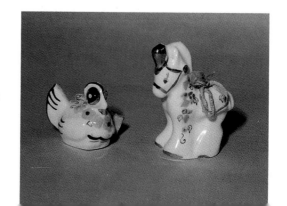

The paper label of the horse. The same paper label was used on the other pieces shown.

Poppytrail *See Metlox*

Poxon China Company *See Vernon Kilns*

Pryde & Joy *See Brad Keeler*

RaArt Pottery *See Royal Hickman*

Reba Rookwood of California
 No information on this pottery at this time.

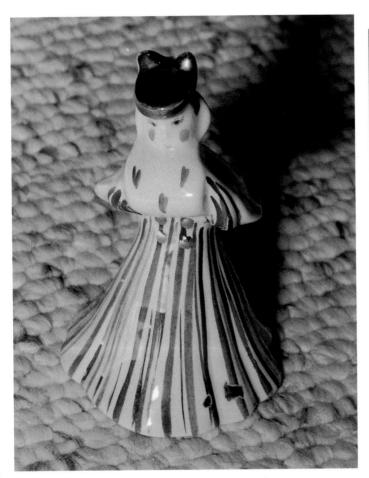

This figure is 5 inches high, has a remnant of a Poinsettia Studios paper label. Estimated value: $15. *Oravitz Collection.*

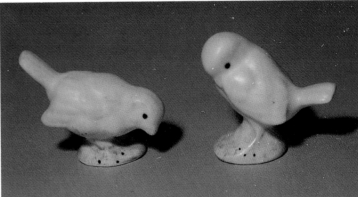

The bird on the left is 2-1/8 inches long, while the one on the right is 2-1/2 inches high. The mark of one of them is shown. Estimated value: $8 each. *Carson Collection.*

Mark of the Reba Rookwood of California birds.

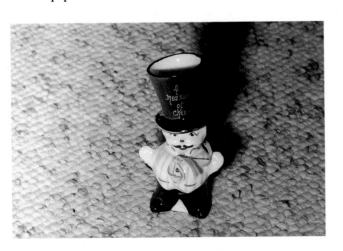

The top half of this figural is a shot glass, the bottom a bell. It has a Poinsettia Studios paper label. Estimated value: $15. *Oravitz Collection.*

Regal of California

This is yet another pottery about which nothing has surfaced.

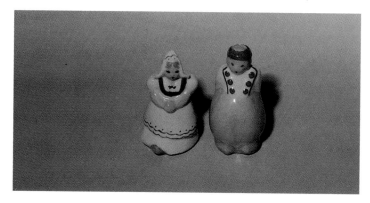

Dutch girl and boy salt and pepper shakers, 3 and 3-1/4 inches high, respectively. Her mark is shown. He is not marked. Estimated value: $20 per pair. *Oravitz Collection.*

Bottom of Dutch girl shaker. The mark appears to me to say, "Regal Calif. by Georgia."

Rio Hondo Potteries

Walk into any antique shop in the Zanesville, Ohio area and you will find unmarked little Rio Hondo animal figurals represented as local Chic Pottery pieces. That's because the two had similar styles, along with a dozen or so other potteries that operated in various locations in the 1940s and 1950s.

The paper label tells us the pottery was located in El Monte. After that it gets a little complicated. According to Lehner, Rio Hondo was started sometime before 1945, a year in which Gerald H. McParlin (later of Freeman-McFarlin) was listed as general manager. In 1951 three people named Waters and one

named Hiffner were listed as the owners. Lehner found a listing for Rio Hondo in 1952 but not in 1955.

So far, so good. But then we flip over to Derwich and Latos to find William Reinhold, son of Sierra Vista owner Leonard R. Lenaburg, founding a pottery in El Monte in 1946 called Hondo Ceramics, which he apparently ran until the early 1970s. The two may be one in the same, or not connected at all.

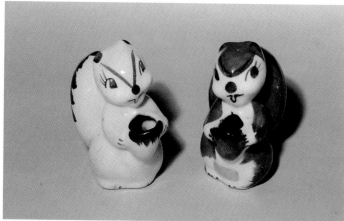

Rio Hondo squirrel planters, each 3-3/4 inches high. Neither is marked except for the paper label of the green one. Estimated value: $5 each. *Oravitz Collection.*

The rabbit and chick planters are each 2-3/4 inches high. The pig planter is 1-7/8 inches. All have Rio Hondo paper labels, a close up of which is shown. Estimated value: $5 each. *Oravitz Collection.*

Rio Hondo paper label of the rabbit and cart planter above.

All figurines. The turtle in front is 1-3/8 inches high while the back row, left to right, measures 1-3/8, 3-3/4, 3-1/2, and 2-1/2 inches. The turtle and penguin are positively identified by their paper labels. The grasshopper, bunny and calves are "probablies." Estimated value: $5 each. *Oravitz Collection.*

No definite proof this butterfly is Rio Hondo, but when you look at it you almost have to ask yourself how it couldn't be. The piece is 2-1/2 inches high, unmarked. Estimated value: $5. *Oravitz Collection.*

Compare the pink on the chick planter and the eyes of the rabbit planter with this 2-1/4 inch high unmarked elephant figurine, and perhaps you will come to the same conclusion I did about its origin. Estimated value: $5. *Private Collection.*

Robert Simmons

Robert Simmons was located in Los Angeles. We know from the Eberling & Reuss Company catalog that it was active in 1950. A reasonable guess would be that it started up sometime in the 1940s or late 1930s, and probably lasted until sometime in the 1950s.

In any case, it was much more prolific than many California pottery collectors realize. Numerous figurines were marketed. Once you know how to spot them, you will be surprised at how many you see.

Pieces without paper labels can be identified by several different characteristics. One is the grayish green used on many pieces. I have seen it on very few items by other potteries, but Simmons used it profusely. Comma-shaped eyes are another indicator. So are the fringe-like edges on much of the painting on the birds and animals. Silver name labels, like those used by DeLee Art, are prevalent on many items, and some pieces have an inkstamped number on the bottom that will always match the number on the silver name label when both are present. Also, most Robert Simmons pieces have a spot of glaze on the bottom, and also an incised, not impressed, single or double digit number.

One of the interesting aspects of Robert Simmons is that the company apparently used several Royal Doulton designs. If you look on pages 138 and 139 of *The Charlton Standard Catalogue of Royal Doulton Animals,* by Jean Dale (The Charlton Press, 1994), you will see all four of the white, black and tan dogs shown here. I am not talking similar designs. They are exact copies! What's the story? Was Robert Simmons a former Doulton employee who designed the original pieces and owned the rights to them or thought he did? Was he a common ripoff artist? I don't know. According to Dale, Doulton began making these dogs in 1934, so it seems likely the Doulton versions would have predated the Robert Simmons versions. And Doulton continued making some of them as late as 1985, which makes it unlikely the company would have sold the rights to the designs. Lots of potential ramifications. Lots of potential theories. No answers.

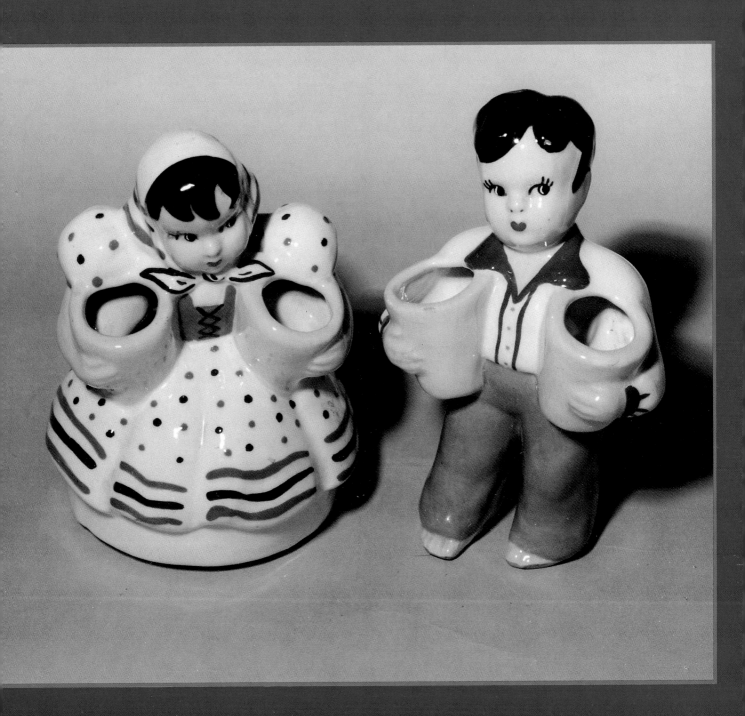

Take a good look at the green in this pair of planters because
Robert Simmons was the only pottery of which I am aware that
used it extensively. Its presence will often provide the confirm-
ing evidence on unmarked examples. The girl is 6-1/4 inches
high, the boy 6-3/4 inches. In addition to the Robert Simmons
green, this pair has two other identifying features: comma eyes
and Simmons-type inkstamp numbers, 2004 for her, 2009 for
him. Estimated value: $15 each. *Oravitz Collection.*

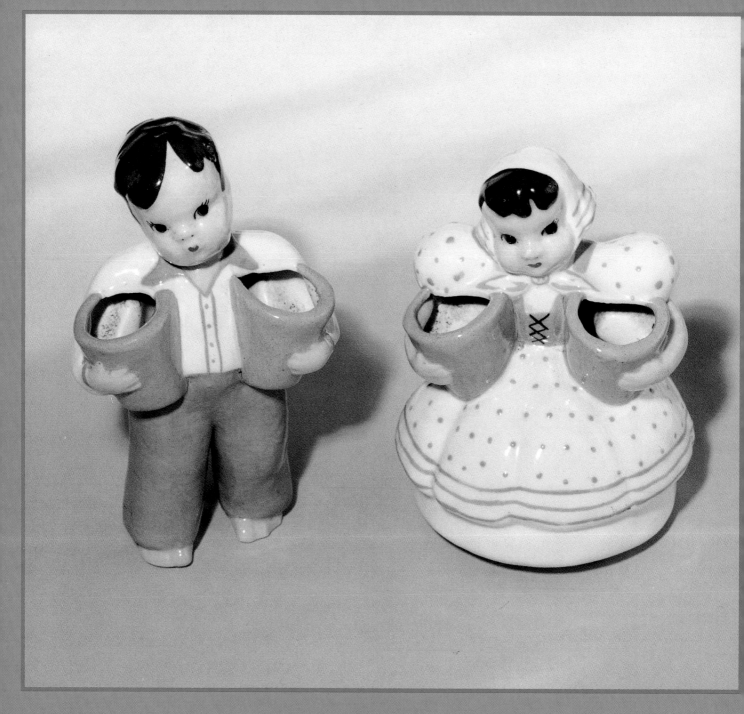

My notes show him being 6-3/8 inches, her 6 inches. Perhaps I read my tape wrong, or perhaps these are actually slightly different heights than the other pair, a rather common circumstance due to any number of reasons including mold growth, redesigning, different slip mixture or firing temperature, etc. Each has a different inkstamp number than the green pair, too. His is "2800," hers "2802." Estimated value: $15 each. *Oravitz Collection.*

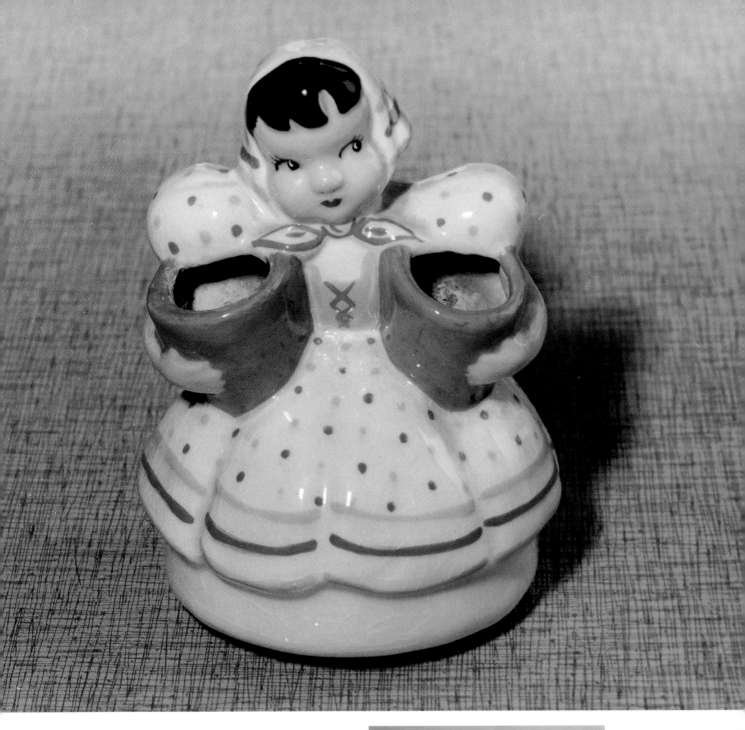

And yet another color change. This one measured 6-1/2 inches, had a "2084" inkstamp. Estimated value: $15. *Oravitz Collection.*

This dog stands 3-3/4 inches high. It is unmarked except for the telltale spot of paint on one of its hind feet, which is shown. Estimated value: $18. *Private Collection.*

Measurements left to right are 4-1/2 inches high, 2-3/4 x 5-1/4 inches, and 3-1/4 x 5-1/4 inches. Each of these dogs has a spot of paint on the bottom of one foot as shown. Estimated value: $18 each. *Private Collection.*

Bottoms of the four dogs. Note the spot of paint on each one. Additionally, the three on the right have an incised number-9, 7, and 16 left to right-another identifying feature of Robert Simmons.

The collie stands 4-3/4 inches high, has the silver paper label which reads, "Laddie / 112," on two lines, a spot of brown paint and the incised number, "1," on the bottom of its front right foot. The terrier is *Barky*, 4-7/8 inches high. *Barky* has a spot of brown paint on its front right foot but lacks an incised number. Estimated value: $20 each. *Private Collection.*

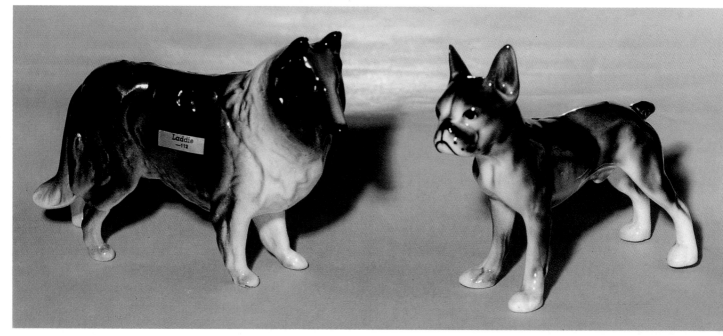

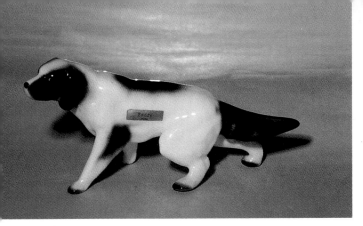

This dog measures 3-1/4 x 7-3/4 inches. Its paper label says, "Buddy / 2044," on two lines. Also, it carries an identifying spot of light yellow paint on the bottom of its left rear foot. Estimated value: $10. *Private Collection.*

This cute little guy is called *Pals.* He is 4-3/4 inches high. Check the catalog pages and you will see his partner, also *Pals,* looking to his right instead of his left. Estimated value: $15. *Private Collection.*

This 4-5/8 inch high dog is *Mac,* which the company called a Scotty. The dog has a "1" incised on the bottom. Note the Simmons brushing technique on the black patches on this dog and compare it with the four white, black and tan dogs. Also, if you happen to run into one only half as tall, that would be *Maggie.* Estimated value: $18. *Private Collection.*

Silver and black paper label of *Pals.*

Mugsy is 5 inches high with a "1" impressed on the bottom along with a spot of Simmons green paint. Estimated value: $18. *Private Collection.*

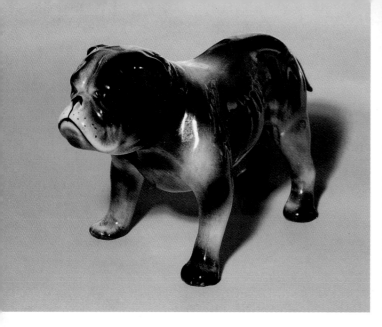

The bulldog's name is *Major*. He measures 4-3/4 x 7-3/8 inches. A "13" is incised in his right rear foot. Estimated value: $22. *Private Collection*.

This is a typical Robert Simmons paper label, the exact kind that appears on *Countess*. This particular label, however, was photographed on *King*, the German shepherd on page 16.

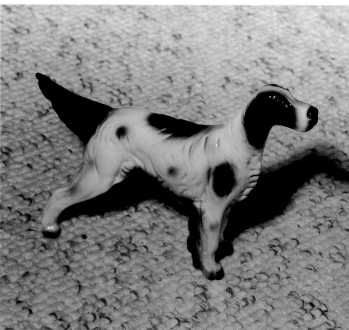

A pointer named *Ace*, 7-1/4 x 9-1/2 inches. *Ace* carries a Robert Simmons paper label, has a "1" incised on one of its feet, and also has a black paint spot on another foot. Estimated value: $25. *Oravitz Collection*.

According to the catalog pages, this is *Countess*. She is 9 inches high and carries a Robert Simmons paper label. Estimated value: $32. *Oravitz Collection*.

The larger cat, *Kat*, is 5-1/4 inches high with a "16" incised on the bottom. It also has a paper label which is shown. The smaller one, *Empress*, stands 4-3/4 inches high. Its silver and black paper label reads, "Empress / -153." Estimated value: $15 each. *Oravitz Collection.*

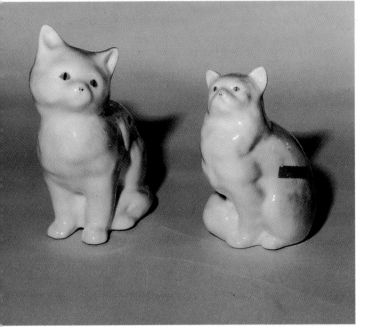

Height of the skunk is 2-5/8 inches. Its name is *Pewey*. It has an inkstamp reading, "2020," an incised "5," and a sister named *Pewette*, who can be seen in the catalog pages with the parents, *Wiff* and *Poff*. The duck is *Meg*, 4 inches high. It has an "8" incised. Its paper label reads, "Meg / 2011" on two lines. Estimated value: *Pewey*, $10, *Meg* $15. *Private Collection.*

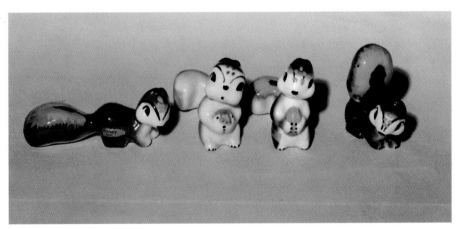

Silver and black paper label of *Kat*.

That's *Whisky* at far left, 2-1/8 x 4-5/8 inches with a paper label, "Whisky / 2031," on two lines. Next to him is an unmarked *Nutsy*, 2-3/4 inches high. Then we come to another *Nutsy* this time with a paper label, ("Nutsy / 2031"). This example is 3 inches high. The unmarked critter at far right, *Frisky*, is 3-1/8 inches high. Notice the difference between the two *Nutsys*. Not only is the height different, but the *Nutsy* with the paper name label is slighter and leaner all the way around. Estimated value: $8 each. *Oravitz Collection.*

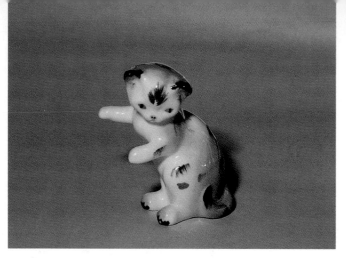

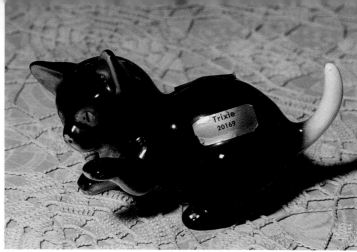

This is *Putsy*, 3-3/4 inches high, and one of a set of three. The other two are *Tutsy*, and *Wutsy*, who are shown below. *Putsy* is unmarked except for the remnant of the silver and black paper label. Estimated value: $10.

Trixie measures 2-3/4 x 3-1/2 inches. There are no marks except for the paper label you see. Estimated value: $12. *Private Collection*.

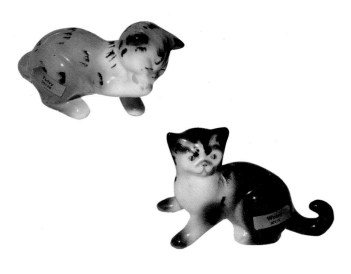

Here is *Tutsy* and *Wutsy*, who measure 2-3/4 x 5 inches, and 2-1/4 x 4 inches, respectively. Their paper labels read "Tutsy / 20138," and "Wutsy / 20138." Estimated value: $10 each. *Private Collection*.

The tiger measures 5-1/4 x 9-1/2 inches. Marks on its feet are shown. This mold was also used for a panther named *Congo*. Estimated value: $35. *Private Collection*.

Wutsy in tan and white. Estimated value: $10. *Private Collection*.

Bottom of the tiger.

The button buck is named *Nimbi*, the doe, *Deer Me*. They stand 9-1/4 and 9 inches high, respectively. The only mark of identification on either is a "1" (one) incised on *Nimbi's* front left foot. Estimated value: $22 each. *Private Collection.*

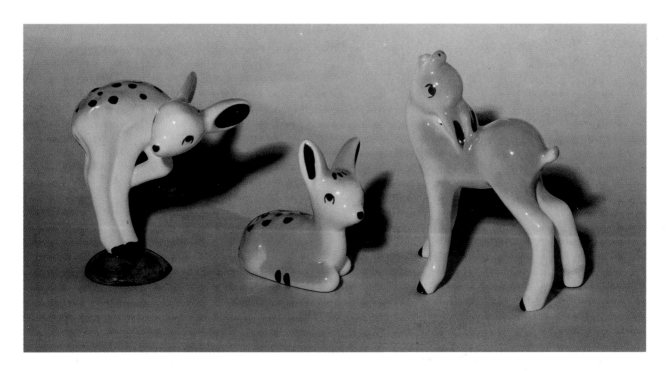

The fawn on the left stands 5-1/4 inches high, sports an incised "8" on its bottom. I do not know its name. The fawn in the center, *Miss Innocent*, is 3-3/4 inches high, has an "X" incised on the bottom. The yearling at right is called *Cry Baby*. It measures 6 inches in height, and has a "17" incised on its back left foot. Estimated value: $18 each. *Oravitz Collection.*

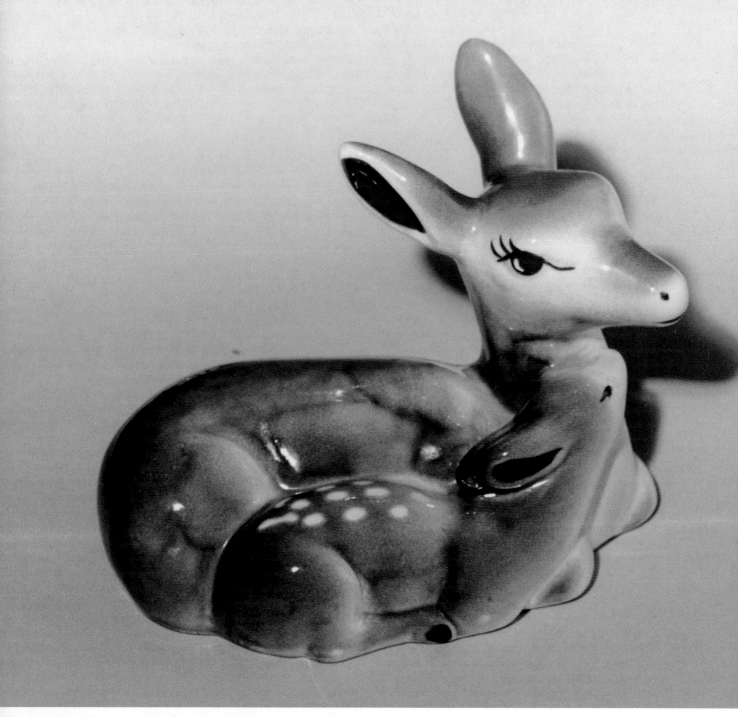

The catalog calls this figurine *Guardian*. It measures 5-1/4 x 7 inches. Its bottom is shown below. Estimated value: $22. *Oravitz Collection*.

The bottom of *Guardian*. Note the inkstamp number and spot of paint, two features often seen on Robert Simmons pieces.

Tex measures 4-1/2 x 6 inches. This particular example carries a Robert Simmons paper label. Estimated value: $15. *Oravitz Collection.*

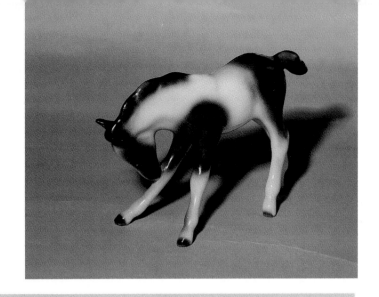

An oriole named *Sir Echo*, 8 inches high. In addition to the familiar Robert Simmons green and an unreadable silver and black paper label, it also has an "11" incised on its bottom along with a spot of paint. Estimated value: $22. *Private Collection.*

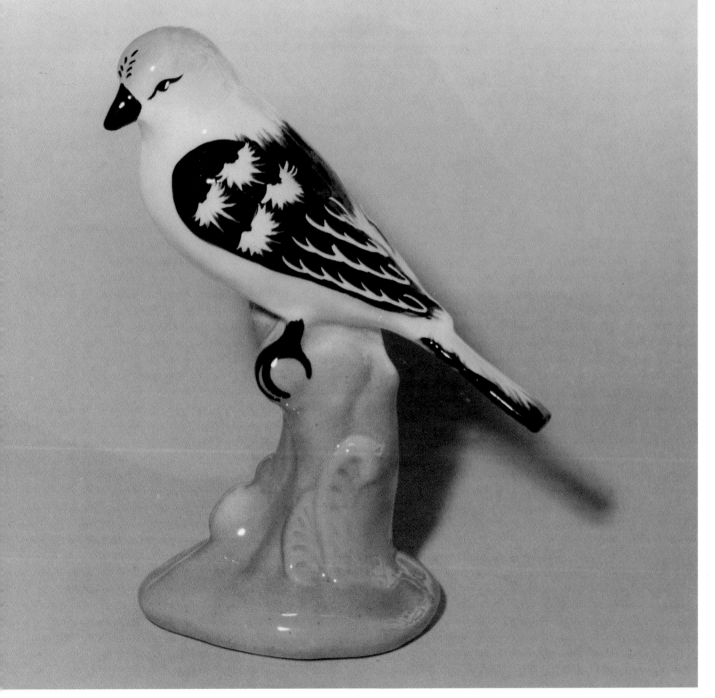

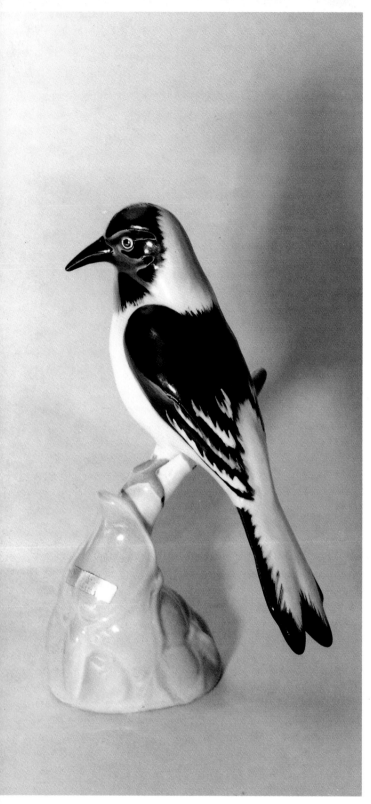

Chirpo is 7-1/8 inches high, unmarked except for the green feet and blue body. Estimated value: $22. *Oravitz Collection.*

Honk left, *Tonk* right. *Honk* measures 4-3/4 x 7-1/2 inches while *Tonk* stands 6 inches high. Their bottoms are shown. Estimated value: $25 each. *Private Collection.*

Another bird, more of that same green. This one is 6 inches high, has a spot of paint on the bottom. The company called this one a tanager, and named it *Cheerio*. Estimated value: $18. *Private Collection.*

Bottoms of the ducks. Interesting situation here because the bottom of *Honk* (left) is glazed while the bottom of *Tonk* (right) is not. Also, note the spot of paint on each, and the Robert Simmons paper label on the *Tonk.*

These pictures are from the 1950 catalog of the Philadelphia firm of Eberling & Ruess, formerly known as Erphila.

Robert Simmons Ceramics—continued

f.o.b. Los Angeles, Calif.

Send Orders to Ebeling & Reuss Co., Phila. 6, Pa.

		Price per		
FIRST ROW		Size	Dozen	Packed
111	Bull Dog, l/s. "Major"	7½"	$21.00	1/6 doz.
196	Pointer, "Ace"	9½"	21.00	1/6 doz.
125	Bird, "Chirpee," yellow and blue	6¼"	21.00	1/6 doz.
122	Oriole, "Sir Echo," yellow with black	8"	21.00	1/6 doz.
126	Bird, "Chirps," blue	7½"	21.00	1/6 doz.
123	Blue Bird, "Melody"	7"	21.00	1/6 doz.
	SECOND ROW			
165	Horse Group, "Santa Anita," and "Hialeah"	7"	24.00	1/6 doz.
166	Horse, "Pacer"	7"	24.00	¼ doz.
114	Police Dog, "King"	10½"	30.00	1/6 doz.
	THIRD ROW			
148	Boxer, "Baron"	10"	30.00	1/6 doz.
90	Zebras, "Zip," and "Zog," asstd.	9"	30.00	1/3 doz.
177	Modern Horse, "Zara"	12"	30.00	1/6 doz.
	Black w/ green or green w/ black, specify which.			

CONTINUED ON THE NEXT THREE PAGES

29

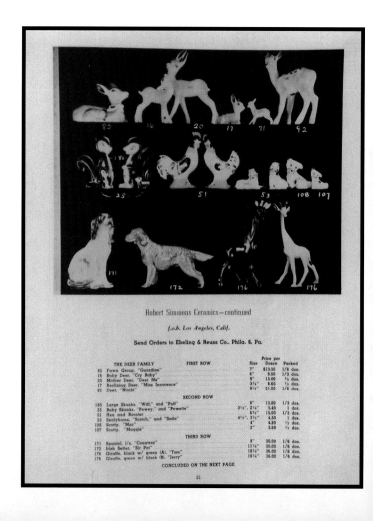

Robert Simmons Ceramics—continued

f.o.b. Los Angeles, Calif.

Send Orders to Ebeling & Reuss Co., Phila. 6, Pa.

			Price per		
THE DEER FAMILY	**FIRST ROW**		Size	Dozen	Packed
82	Fawn Group, "Guardian"		7"	$13.50	1/6 doz.
16	Baby Deer, "Cry Baby"		6"	9.00	1/3 doz.
20	Mother Deer, "Deer Me"		9"	15.00	¼ doz.
17	Reclining Deer, "Miss Innocence"		3¾"	6.60	½ doz.
92	Deer, "Nimbi"		9½"	21.00	1/6 doz.
	SECOND ROW				
180	Large Skunks, "Wiff," and "Paff"		5"	15.00	1/3 doz.
25	Baby Skunks, "Pewey," and "Pewette"		3¼", 2¼"	5.40	1 doz.
51	Hen and Rooster		6½"	15.00	1/3 doz.
53	Sealyhams, "Scotch," and "Soda"		4½", 3½"	4.50	1 doz.
108	Scotty, "Mac"		4"	4.80	½ doz.
107	Scotty, "Maggie"		2"	3.60	½ doz.
	THIRD ROW				
171	Spaniel, l/s. "Countess"		9"	30.00	1/6 doz.
172	Irish Setter, "Sir Pat"		11¼"	30.00	1/6 doz.
176	Giraffe, black w/ green (A), "Tom"		10¼"	36.00	1/6 doz.
176	Giraffe, green w/ black (B), "Jerry"		10¼"	36.00	1/6 doz.

CONCLUDED ON THE NEXT PAGE

31

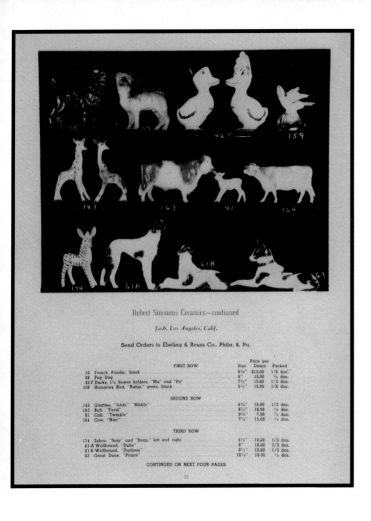

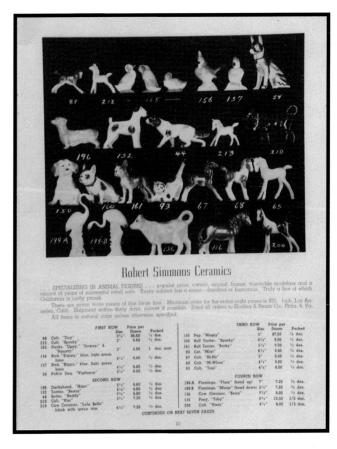

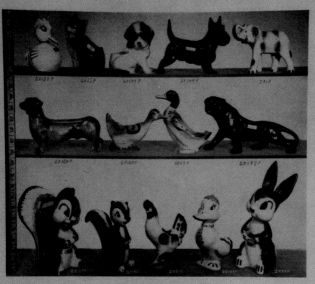

Robert Simmons Ceramics—concluded

An Intriguing Group of Planters!

While every item shown is a flower-holder or planter, the same subject is obtainable as a decorative ornament—that is, without the opening. The "F" after the number indicates "flower-holder" but the same number without the "F" would indicate that the subject is desired as ornament only. Price and packing are the same in either case. Every subject has a name which appears on sticker attached. Size indicated by inch tape at left. Shipment within thirty days, f.o.b. Los Angeles, Calif. Send orders to Ebeling & Reuss Co., Phila 6, Pa.

No.		Item	Name	Price	Minimum Packing
		TOP ROW			
20137	F	Chicken Flower Holder	"Chickee"	$ 5.40 doz.	1/2 doz.
2035	F	Cat Flower Holder	"Kat"	7.20 doz.	1/2 doz.
20148	F	St. Bernard Flower Holder	"Bernie"	7.20 doz.	1/4 doz.
20144	F	Scotty Flower Holder	"Chauncy"	15.00 doz.	1/4 doz.
2001	F	Elephant Flower Holder	"Peanuts"	9.00 doz.	1/2 doz.
		MIDDLE ROW			
20152	F	Dachshund Flower Holder	"Fritz"	12.00 doz.	1/3 doz.
20120	F	Mallard Duck Flower Holder	"Honk"	15.00 doz.	1/4 doz.
20119	F	Mallard Duck Flower Holder	"Tonk"	15.00 doz.	1/4 doz.
20187	F	Black Panther Flower Holder	"Congo"	18.00 doz.	1/6 doz.
		BOTTOM ROW			
2037	F	Squirrel Flower Holder	"Nippy"	36.00 doz.	1/12 doz.
20180	F	Skunks 2 asst. Flower Holder	"Wiff Puff"	15.00 doz.	1/2 doz.
2051	F	Hen and Rooster Flower Holder	"Strut"	15.00 doz.	1/3 doz.
20192	F	Duck Flower Holder only	"Oscar"	12.00 doz.	1/3 doz.
2036	F	Rabbit Flower Holder	"Cheeky"	30.00 doz.	1/12 doz.

32

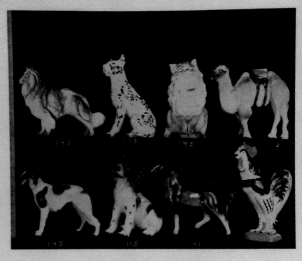

Robert Simmons Ceramics—continued

f.o.b. Los Angeles, Calif.

Send Orders to Ebeling & Reuss Co., Phila. 6, Pa.

			Size	Price per Dozen	Packed
		TOP ROW			
147	Collie. l/s. "Queenie"		10½"	$36.00	1/6 doz.
173	Great Dane. "Colonel"		9¾"	36.00	1/6 doz.
195	Large Chinchilla Cat. "Punch." white or gray		9½"	36.00	1/12 doz.
12	Camel. large. "Chesterfield"		10"	36.00	1/6 doz.
		SECOND ROW			
145	Wolfhound. "Apollo"		10"	42.00	1/6 doz.
115	Sitting Pup. "Patsy"		9½"	45.00	1/12 doz.
146	Horse. large size. "Mercury"		11"	42.00	1/6 doz.
08	Rooster. discontinued				

CONTINUED ON THE NEXT TWO PAGES

30

Roselane

Roselane was owned by William ("Doc") and Georgia Fields, a husband and wife who founded the pottery in their Pasadena home in 1938. In 1940 the company moved to a factory environment in Pasadena where it remained until 1968. At that time the building was torn down to make room for a freeway and the company moved to Baldwin Park.

"Doc" Fields died August 15, 1973. Three months later, according to Derwich and Latos, Georgia Fields sold the business to Rod and Audrey Prathos. According to Chipman, however, the purchaser was Prather Engineering (probably one in the same), which moved the company to Long Beach and ceased operations in 1977.

From 1965 through 1967 Hagen-Renaker distributed the Roselane line, which accounts for Roselane pieces often being found with Hagen-Renaker paper labels, as on two of the owls here.

Roselane's Sparkler line, which is probably the company's best known and most recognized product, was started about 1952. Be leary of unmarked sparklers as copies were made in Japan and sold by American importers. A pair of Napco sparklers are shown. The majority of Roselane marks include the name of the company. Some, however, simply state Made in California or Made in U.S.A.

Mark of the tan bisque Scotty.

Sparklers are probably Roselane's best known product. Most were tan with a bisque surface. The black one here is a rare exception. The Scotty on the left is 4-1/8 inches high. Its impressed mark, "Roselane / © / U.S.A.," is shown below. The Scotty on the right is 4-1/2 inches high, has the same mark. Estimated value: tan $15, black $20. *Private Collection.*

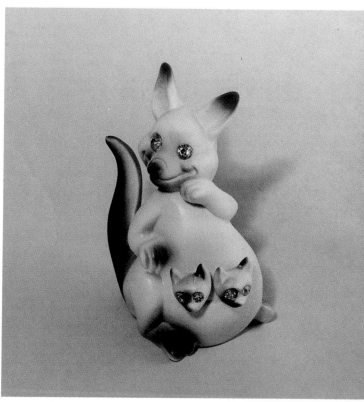

A kangaroo with two joeys, 4-1/4 inches high, marked with an impressed, "Roselane / © / U.S.A." on three lines. Estimated value: $20. *Private Collection.*

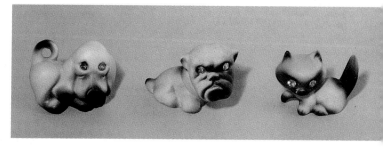

Three little ones here, 1-1/2, 1-3/4 and 1-1/2 inches high, left to right. All three are marked with an impressed "© / U.S.A." on two lines. Estimated value: $5 each. *Private Collection.*

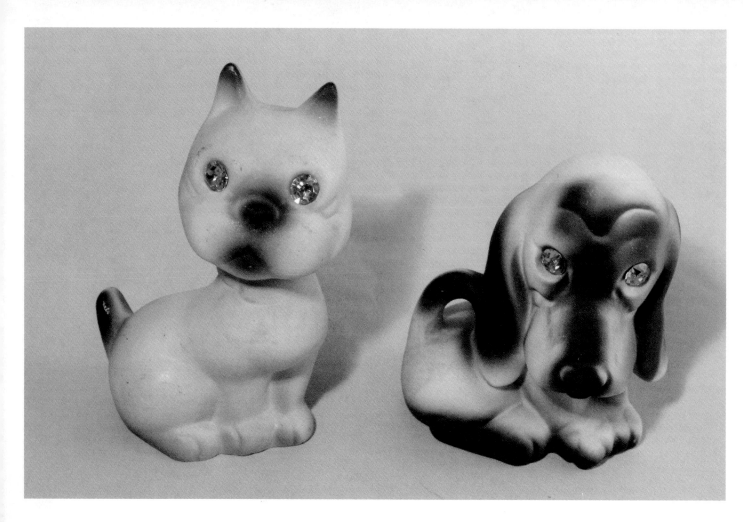

The dog on the left is 4-3/8 inches high, has "U.S.A. / © / 100" impressed on three lines. The dog on the right is 3-3/4 inches high with a different three line impressed mark, "Roselane / © / U.S.A." Estimated value: $10 each. *Private Collection.*

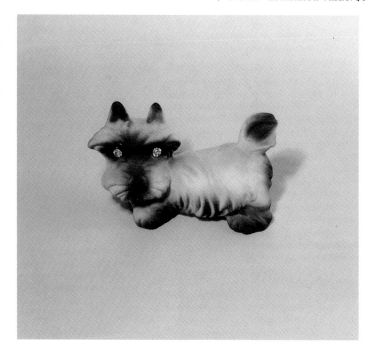

This guy is 2-7/8 inches high with "Roselane / ©" impressed on two lines. Estimated value: $10. *Private Collection.*

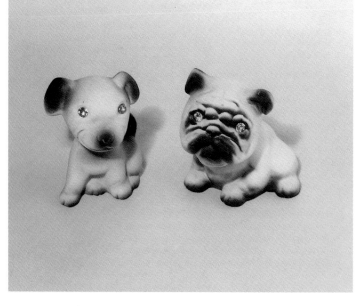

Two more pooches, with an average height of 3-1/4 inches. The one on the left is marked, "U.S.A. / © / 106" impressed on three lines, while the other is marked, "Roselane / © / U.S.A." impressed on three lines. Estimated value: $8 each. *Private Collection.*

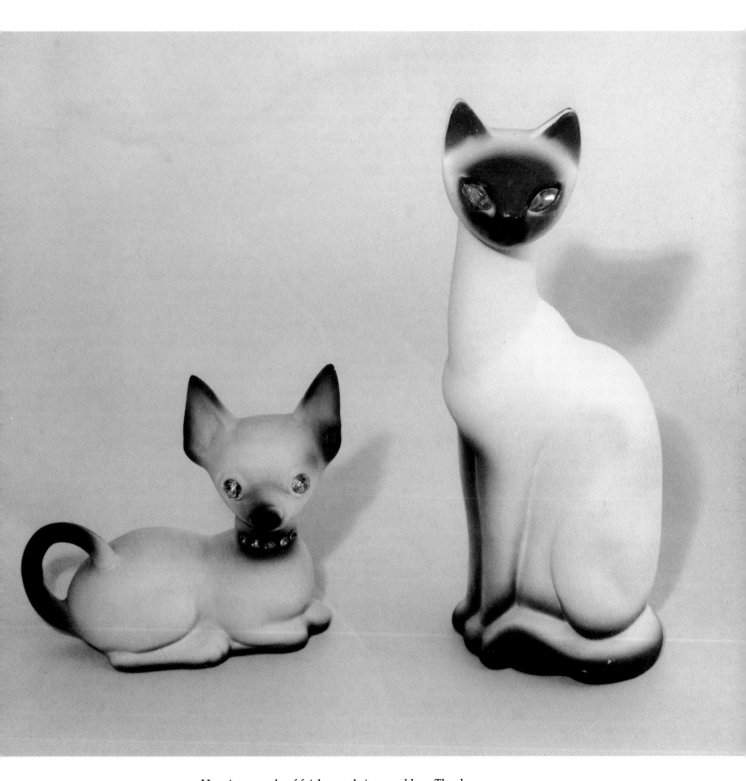

Here is a couple of fairly good size sparklers. The dog, complete with a jewelled collar, is 4-7/8 inches high while the cat towers at 10-1/8 inches. Both are marked: "© / Calif. U.S.A." is impressed in the canine on two lines, "Calif. / U.S.A. / ©" is impressed in the feline on three lines. Estimated value: dog $18, cat $25. *Private Collection.*

BEWARE OF IMPOSTERS

Basically the same as above, 2-1/4 and 2-3/4 inches high, but with a green gloss glaze. The smaller owl is marked with an impressed "U.S.A. / ©" on two lines. The larger one is not marked. Estimated value: small $5, large $8. *Private Collection.*

While these two sparklers look just like Roselane they are actually Japanese products imported by National Potteries Company, also known as Napco. The dog is 3-1/4 inches high, has a "K2950" inkstamp and a Napco paper label. The owl is 4 inches high with a "K2953" inkstamp and a remnant of a Napco paper label. Both inkstamps are very light, almost unnoticeable. Estimated value: dog $5, owl $5. *Private Collection.*

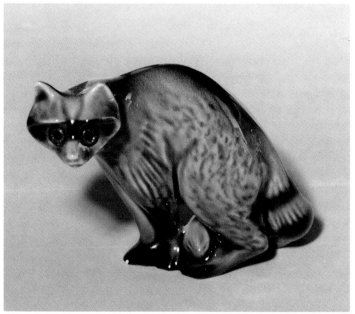

The owls on the outside are 2-1/4 inches high, the one in the middle is 2-3/4 inches. The difference looks greater due to the angle from which the picture was shot. The left and middle pieces are unmarked, the right piece has "U.S.A. / ©" impressed on two lines. The larger owl in the middle has a Hagen-Renaker paper label, which is shown below. Estimated value: left and right $5 each, middle $8. *Private Collection.*

Raccoon, ringtail or coati? Whatever it is, it has a height of 3-3/8 inches. "U.S.A." is impressed in its bottom. Estimated value: $12. *Private Collection.*

Hagen-Renaker paper label of the owl in the middle. This indicates only that Hagen-Renaker distributed the product, not that it manufactured it. If you have any Roselane piece with a Hagen-Renaker paper label, that means it was made between 1965 and 1967, the years the two companies were associated.

The owl on the left is 3-1/2 inches high, has "Roselane" impressed. The owl on the right comes in at 7-1/4 inches, has the Hagen-Renaker paper label shown below. Estimated value: left $10, right $18. *Private Collection.*

Height of this one is 7-3/8 inches. "Roselane / U.S.A." is very lightly impressed on two lines. Estimated value: $15. *Private Collection.*

Hagen-Renaker paper label of Roselane owl above.

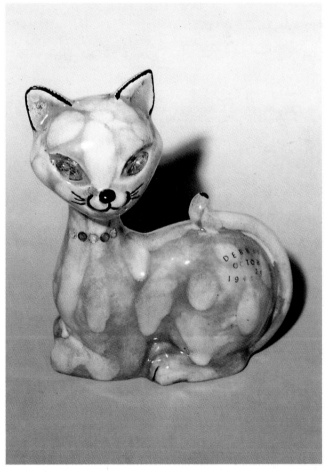

This Roselane owl measures 7 inches in height. It is not marked. Estimated value: $18. *Private Collection.*

Interesting piece here, apparently made for a girl's birthday, perhaps the daughter of a Roselane employee. The 6-1/8 inch high cat, marked with an impressed "Calif. / © / U.S.A.," has an unusual glaze and fired on decal. The decal says, "Debbie / October / 25 / 1946 1960," on four lines. Estimated value: $30. *Private Collection.*

This dog is 3-3/4 inches high. It has an impressed mark, "Roselane / ©." The initials "na," and the letter "G," are incised. Estimated value: $8. *Oravitz Collection.*

Impressed mark of gray cockatoo.

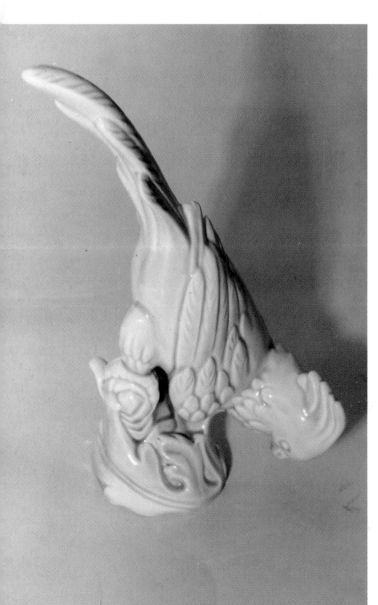

A cockatoo, 9-1/2 inches high. Its mark is shown below. Estimated value: $18. *Private Collection.*

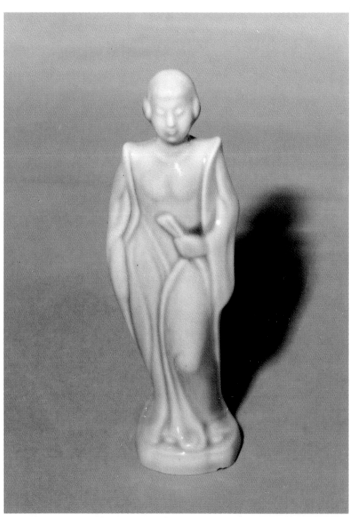

This figure stands 6-1/8 inches high. It is marked, "Roselane (impressed) / 125" (raised), on two lines. Estimated value: $15. *Private Collection.*

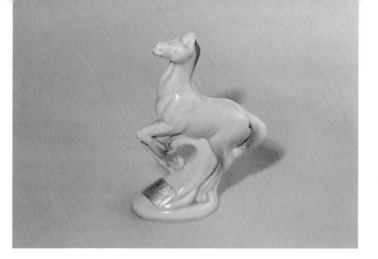

This horse is 5 inches high. It is marked only by a paper label, which is shown below. Estimated value: $12. *Private Collection.*

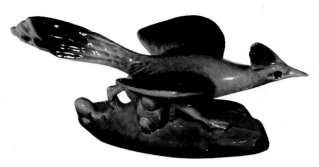

The roadrunner measures 4-1/4 x 8-3/4 inches. It is marked by impression, "Roselane 135." Estimated value: $25. *Oravitz Collection.*

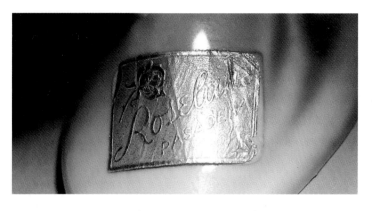

Roselane paper label of above horse.

Ross Ceramics

The Ross Ceramics, according to the partial paper label shown below, was located on Kornblum Avenue, in a California city that ended with ...thorne. Hawthorne, the same city where Sascha Brastoff originally landed in California, sounds good to me. Ross may have been a short-lived operation as all the the pieces shown were copyrighted in a single year, 1945.

Ross Originals *See Ross Ceramics*

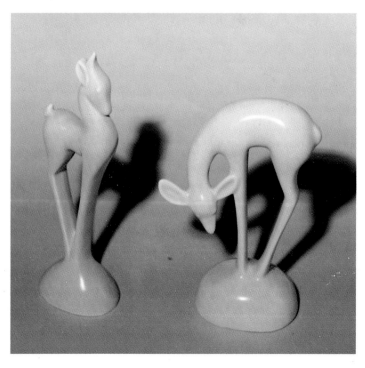

A pair of stylized deer, 7-1/2 and 6-1/2 inches high. The taller one, on the left, has "Roselane / 99 / Pasadena" impressed. The shorter one is unmarked. Estimated value: $12 each. *Oravitz Collection.*

The donkey is 4-1/4 inches high. It is impressed, "Ross 45 / Originals," on two lines with the 45 in a circle. Estimated value: $22. *Private Collection.*

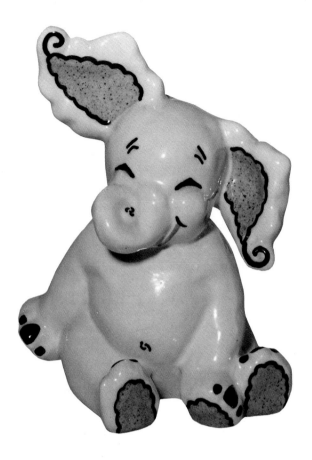

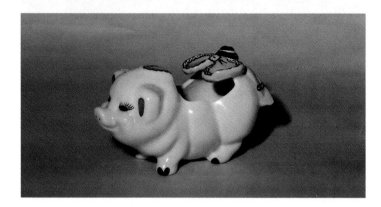

Pig planter, 3-1/2 x 5-1/4 inches. It has a Ross Originals paper label. Estimated value: $18. *Oravitz Collection.*

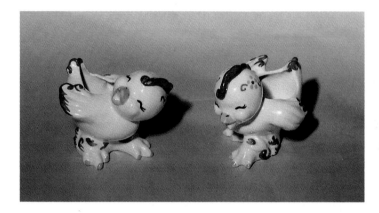

This elephant is a bank, the slot being in the back. It is 5-3/4 inches high. It is marked, "Ross / Originals / 45," on three lines with the 45 in a circle. It also has a paper label which is shown. Estimated value: $45. *Private Collection.*

The chick planter on the left, 3-1/2 inches high, is not marked. The one on the right, 3-7/8 inches high, has an impressed mark which is shown. Estimated value: $15 each. *Oravitz Collection.*

Ross Originals paper label of the elephant bank.

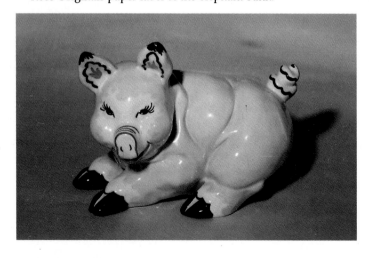

Impressed mark of one of the chick planters.

Pig figurine, 5-1/8 inches high, impressed, "A5 / Ross / Originals," on three lines. My guess is that this was probably also made as a bank. Estimated value: figurine $28, bank (if made) $45. *Oravitz Collection.*

Royal Hickman

Royal Arden Hickman was a designer who is probably best known for his work with Haeger Potteries of Dundee, Illinois, and with the Heisey Glass Company of Newark, Ohio, where he modeled many of that glass house's animal figures. He was born in Oregon in 1893, died in Mexico in 1969,

Sometime during the early part of the Depression he started a company, RaArt Pottery, apparently in or near San Francisco. This followed a short stint at a relative's pottery in San Jose. How long RaArt was in business is unknown. It is known, however, that Hickman spent some time overseas doing design work in Europe, and had returned by 1938, at which time he became chief designer for Haeger. With that in mind, it seems probable that the giraffes may have been made sometime in the mid-1930s.

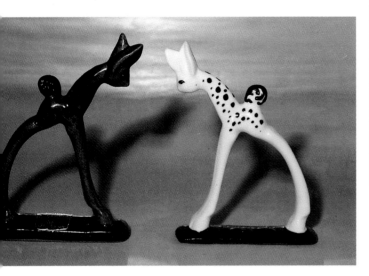

The brown giraffe is 6-1/4 inches high, the white one 6-1/8 inches, the difference being in the thickness of the base. The paper label of the brown one is shown. The white one is unmarked. Recently I saw a much larger white giraffe that did have a paper label; its height was in the 10 to 12 inch range. Estimated value: $25 each. *Private Collection.*

Paper label of the brown giraffe.

Sara Hume

I have been unable to find this pottery listed anywhere. Perhaps a reader knows something about it.

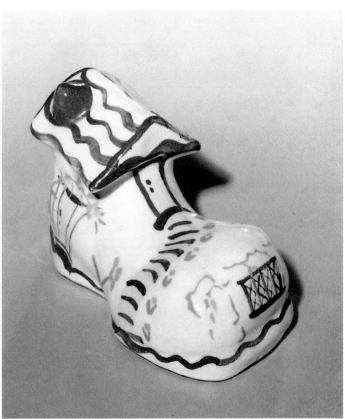

This shoe bank measures 3-3/8 x 5-1/4 inches. It has a Sara Hume paper label, which is shown. Estimated value: $25. *Oravitz Collection.*

Paper label of the Sara Hume shoe bank.

Bottom of the Sierra Vista clown head bank.

Lamb figurine, 6-1/4 inches high. Unmarked but carrying a recognizable remnant of a paper label similar to the shoe bank. It says, "...d a little lamb / / Kiln of / ...ume / ...ornia," on five lines. Estimated value: $20. *Oravitz Collection.*

S.B.M. *See Stewart B. McCulloch*

Sierra Vista Ceramics

According to all sources checked, this pottery was started in Sierra Vista in 1942 by Reinhold and Leonard R. Lenaburg, a father and son. The elder Lenaburg retired in 1951, at which time younger one moved the business to Phoenix. Be that as it may, marks of several cookie jars made by this company show it located in Pasadena, so it seems rather obvious that some of its California tenure must have been spent there. The company is mainly known for its cookie jars but also made giftware and other kitchen artware.

Sleepy Hollow Pottery

As the mark indicates, Sleepy Hollow Pottery was located in Laguna Beach. For a time at least. According to Derwich and Latos, Sleepy Hollow was started in 1940 by persons unnamed, then purchased in 1947 by Orville Kirby. Kirby was a potter who had been doing business in Los Angeles under the names California Pottery and Orville Kirby Pottery since at least 1941. He began dabbling in ceramics in 1934. In 1954 Kirby moved the pottery to Monroe, Utah, where he continued to use the Sleepy Hollow name.

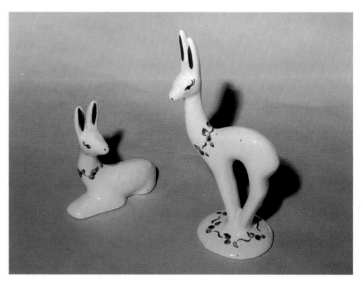

Two deer, one marked, one not. The figurine on the left is the unmarked one. It is 4-3/4 inches high. The standing deer measures 7-5/8 inches in height. Its mark is shown. Estimated value: left $5, right $8. *Oravitz Collection.*

Mark of the standing deer.

A 5-1/2 inch high bank to match a Sierra Vista cookie jar. It is unmarked but has a distinctive bottom, which is shown. Estimated value: $35. *Private Collection.*

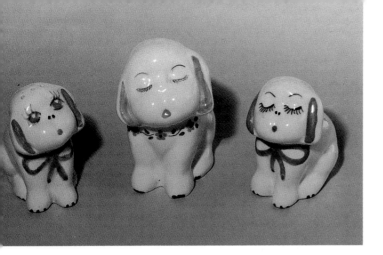

That's a salt and pepper set on the outside with a figurine in the middle. The salt and pepper are each 3-1/2 inches high. One has a paper label that is shown. The figurine is 4-1/4 inches high. It is not marked. Estimated value: salt and pepper $16 pair, figurine $7. *Oravitz Collection.*

Paper label of the shaker.

Marks of the boy (left) and girl (right) figurines.

Squire Ceramics

Squire Ceramics, whose trademark was S-Quire, was located at 2818 Benedict Street, Los Angeles, according to James R. Lafferty Sr. in *The Forties Revisited Vol. II.* Lehner found them listed in various trade journals from 1948 through 1952. Derwich and Latos, who say the pottery was razed for a freeway right of way and never rebuilt, found them listed as early as 1947.

All of the figurines I have seen incorporate the phrase, "Figurine by Zaida," into the mark.

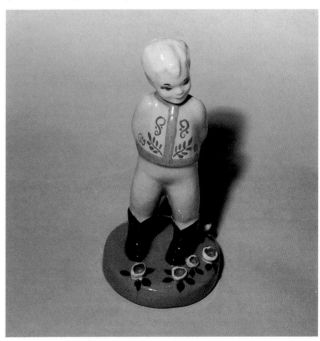

This boy figurine stands 6-7/8 inches high. Its mark is shown. Estimated value: $25. *Oravitz Collection.*

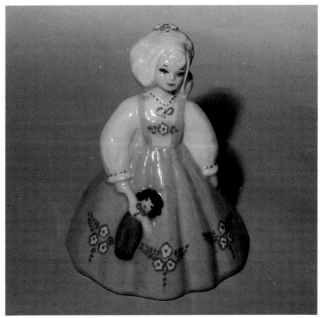

A girl and a doll. This figurine is 6 inches high. Its mark is shown. Estimated value: $30. *Oravitz Collection.*

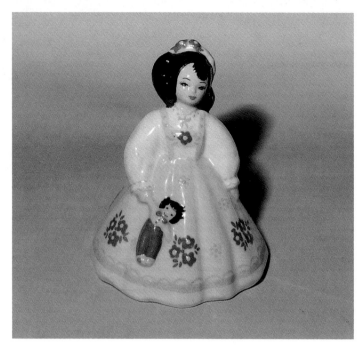

A second girl with doll figurine, this time in a different color and also one-half inch taller at 6-1/2 inches. The mark is shown. Estimated value: $30. *Oravitz Collection.*

Mark of the yellow girl with doll figurine. It is styled a bit differently than the previous one.

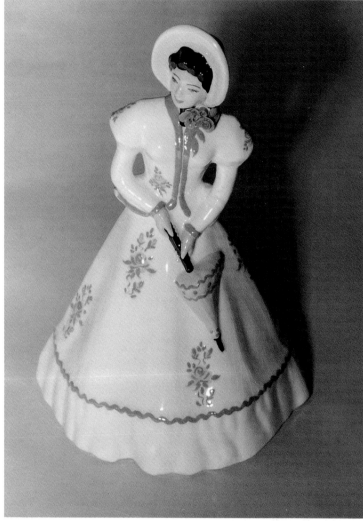

This figurine is 11 inches high. Its mark is shown. Estimated value: $40. *Oravitz Collection.*

Mark of the lady with umbrella figurine.

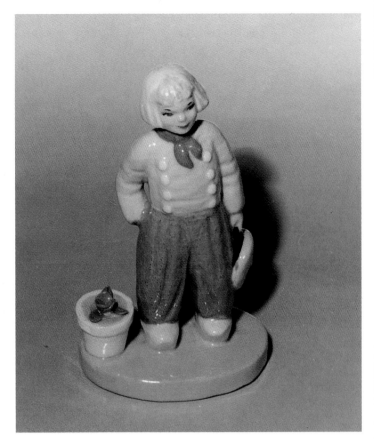

Stewart B. McColloch

This was a distributing firm, not a pottery. I am not sure of the exact location, but it was somewhere in southern California. In many if not all cases, the Stewart B. McColloch name was stamped on the pieces by the pottery that made them. For example, the Chinese boy and girl planters shown were obviously made by the McCarty Brothers, who used McColloch for a distributor during the last few years of their run beginning about 1949.

A Dutch boy figurine; there must be a Dutch girl somewhere out there to go with it. Height is 7 inches. It is marked in a fashion similar to the three marks shown. Estimated value: $28. *Oravitz Collection.*

Starlet Ceramics

Information about this pottery, other than it was located in Pasadena as its mark shows, has eluded me.

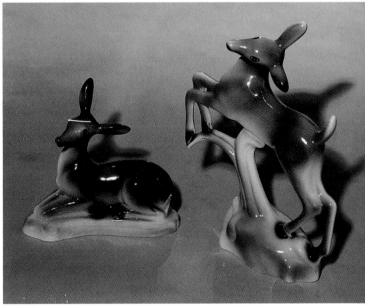

The resting deer measures 5-5/8 x 6-1/8 inches. The leaping deer is 9-1/4 inches high. Both are figurines. Both have identical inkstamps, one of which is shown. Estimated value: left $10, right $15. *Private Collection.*

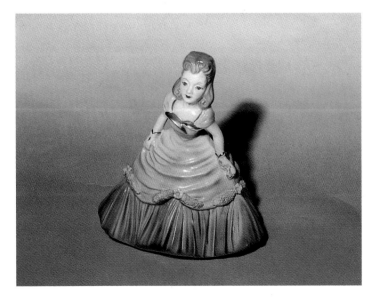

This is a planter, 6-7/8 inches high. Its inkstamp mark is shown. Estimated value: $15. *Private Collection.*

Inkstamp of resting deer. As far as I know, this inkstamp and the S.B.M. of the oriental boy planter are the only ones used by Stewart B. McCulloch.

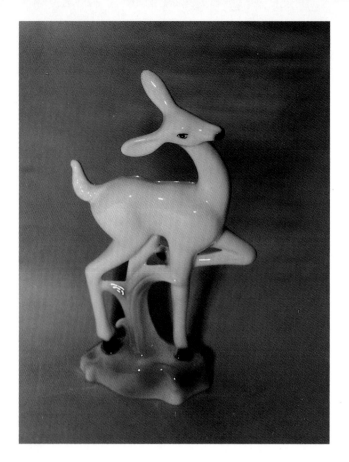

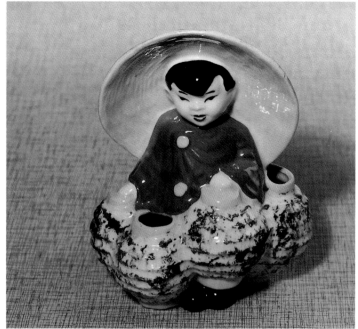

Maybe you would call this a strutting deer. It is 11-1/2 inches high, has the half round McCulloch inkstamp. I have seen this same deer in brown, and have also seen a McCulloch horse in very similar pose. Estimated value: $18. *Private Collection.*

Check page 167 and see if there is any doubt in your mind about who made this planter for Stewart B. McCulloch. The piece is 6-3/4 inches high. Its mark is shown. Estimated value: $18. *Oravitz Collection.*

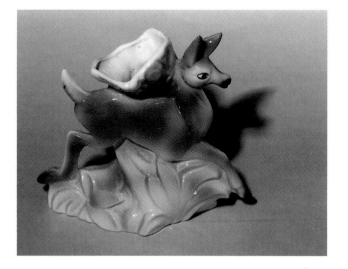

Round Stewart B. McCulloch mark of the Oriental planter.

This deer planter is 5-1/2 inches high. It has a McCulloch half round inkstamp. Estimated value: $10. *Naylor Collection.*

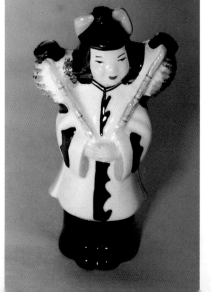

Another planter with a round McCulloch inkstamp, this one stands 6-7/8 inches high. Estimated value: $20. *Oravitz Collection.*

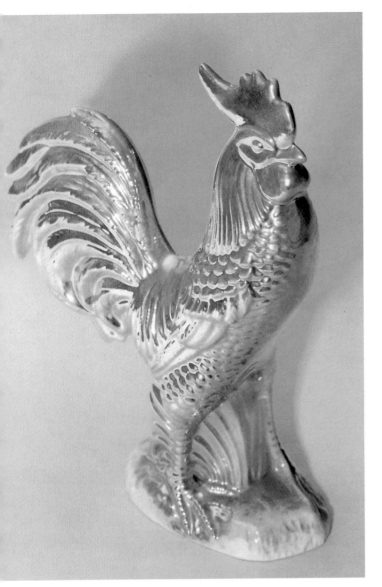

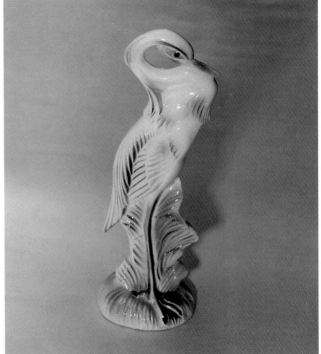

Shorebird, 12-1/4 inches high with a half round McCulloch inkstamp. Note that it has painted toenails and deep relief similar to woodcarving. Both characteristics are typical of Maddux of California. Could there be a connection? Estimated value: $15. *Private Collection.*

Ten inches high and a half round inkstamp. Estimated value: $22.

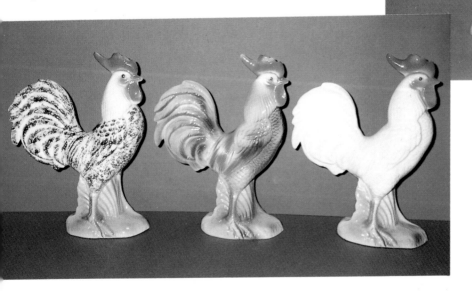

A peacock, 6-1/2 inches high, 9-1/2 inches long. It has a McCulloch half round inkstamp. Estimated value: $20. *Private Collection.*

Three more roosters with the same story. I have never seen a hen. Estimated value: $22 each. *Private Collection.*

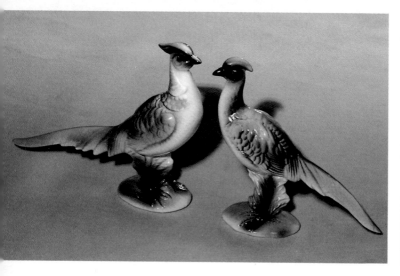

The exotic bird on the left measures 7 x 9 inches, has a McCulloch half round inkstamp. The one on the right, 6-3/4 x 6-1/2, is not marked. Estimated value: $12 each. *Oravitz Collection.*

Six and one-half inches high with a McCulloch half round inkstamp. Estimated value: $12. *Private Collection.*

A planter with gold decoration, 5-3/4 inches high. It has a McCulloch half round inkstamp. Estimated value: $12. *Naylor Collection.*

As above but a different color. I have also seen these birds with red as the basic color. Green is most common. Estimated value: $15. *Private Collection.*

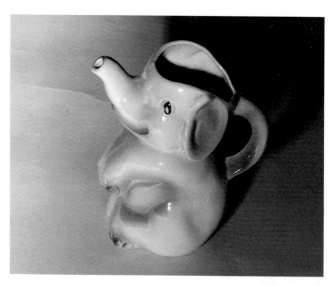

Probably a pheasant, this flying bird measures 4-3/8 x 11-1/2 inches. It has a McCulloch half round inkstamp. Estimated value: $22. *Private Collection.*

This elephant pitcher is 6 inches high. It carries the McCulloch half round inkstamp. Estimated value: $28. *Oravitz Collection.*

Stewart of California

No information was found on this pottery. The pig shown looks very much like a Modglin's piece.

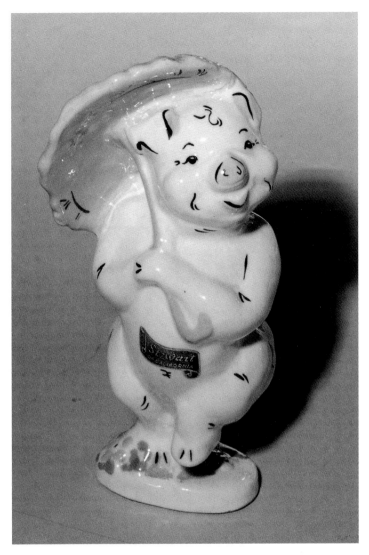

With all the little squigglies this pig figurine sure is reminiscent of Modglin's, but it has a Stewart label. It is 6-5/8 inches high, and a close up of the paper label is shown. Estimated value: $22. *Oravitz Collection.*

Close up of the paper label on the pig.

Treasure Craft

Treasure Craft is one of the few California potteries from the 1940s that is still in business today. It is currently owned by Pfaltzgraff Pottery, of York, Pennsylvania.

The company was founded in Gardena by Alfred A. Levin in 1945. Over the years it has grown from a single car garage with only the owner on the payroll to a 250,000 square foot complex with about 500 employees. The site changed from Gardena to Compton years ago. In the mid-1970s Treasure Craft bought the molds of its chief competitor, Twin Winton.

Treasure Craft, unlike most of the California potteries featured in this book, for many years relied on earth tones, lots of brown and green, instead of the more popular brilliant solids and soft pastels. As a result the company's pieces lingered in a collector's purgatory for years as enthusiasts scrambled to secure things made by the more traditional California potteries. In the past few years, however, collectors have discovered Treasure Craft (and Twin Winton), apparently recognizing their outstanding mold work, and coming to appreciate their fine stains and glazes which were once passed off as boring.

A pixie planter/wallpocket, 5 inches high. A close up of its Treasure Craft paper label is shown. Estimated value: $7. *Oravitz Collection.*

Paper label of above pixie planter.

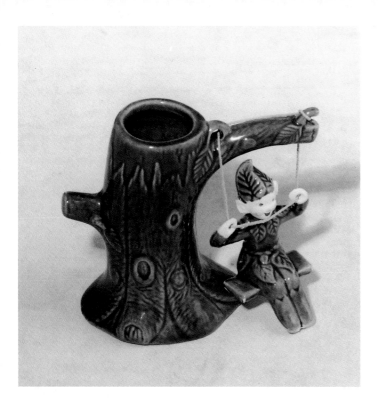

This one is 4 inches high, has the same paper label as above. Estimated value: $5. *Private Collection.*

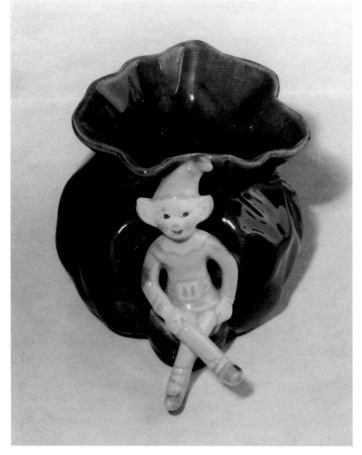

Might Treasure Craft have bought out Pixie Potters? It seems like a possibility. Height here is 3-3/4 inches, paper label is the same as above. Estimated value: $5. *Oravitz Collection.*

Twin Winton

Twin Winton was named for the twins who founded it, Don and Ross Winton, who began dabbling in a ceramics business while still in their teens.

The pottery began in 1936 in a rented building in Pasadena. At that time it was known as Burke-Winton as the Wintons were in a partnership with a lady named Helen Burke. Don did the modelling, Ross made the molds and Helen Burke did the decorating. The chief product was animal figurines. This arrangement lasted until sometime in 1939 when the Winton twins struck out on their own, setting up a small pottery in nearby Tujunga. Three years later they moved to larger quarters in Pasadena. Then in 1943 they enlisted in the service and operations ceased for the duration of the war.

In 1946, with the war behind them, the Wintons jumped back into the pottery business, this time setting up shop in South Pasadena, and taking in their older brother, Bruce, and several other people as partners. Another move to larger quarters was required by 1950 and the business landed back in Pasadena.

Then in 1952 Don and Ross sold out to Bruce, each of the twins embarking on a freelance designing career. Much of their work, of course, was for Twin Winton, which Bruce moved to El Monte.

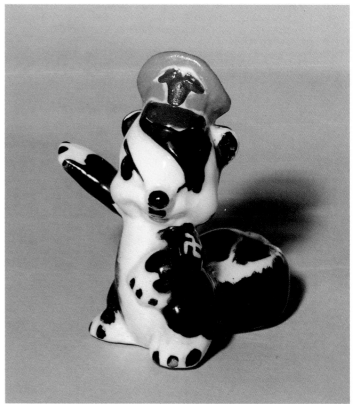

Of all the pieces we photographed for this book, I think I got the biggest kick out of this Adolph Hitler caricature. It has the hat, the salute, the swastika, and if you look close, even the squirrely little mustache. Height is 4 inches. Its mark is pictured. Estimated value: $75. *Oravitz Collection.*

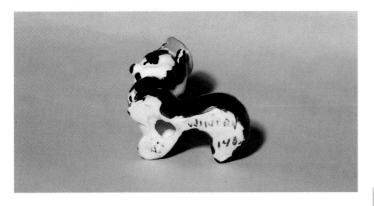

Mark of Hitler skunk.

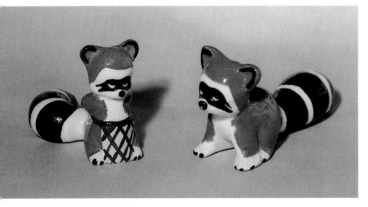

A much less evil skunk, this one being 2-3/4 inches high. It is marked "Winton / 12," in thick black characters on two lines. Estimated value: $15. *Private Collection.*

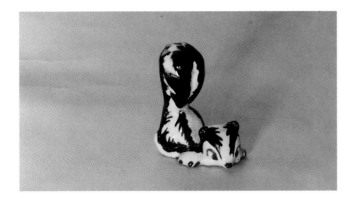

The raccoon on the left measures 3 x 3-1/2 inches. The one on the right, 3 x 5-1/4 inches. Both marks are shown. Estimated value: $18 each. *Private Collection.*

Bottoms of the Twin Winton raccoons.

In 1964 the pottery underwent a final move to the San Juan Capistrano plant Brad Keeler was building when he suddenly died 12 years earlier. Twin Winton was sold in 1975.

The earliest Winton figurals are marked Burke-Winton. In some cases simply B-W. Most of the animal and people figurines I have seen have had the hand printed mark shown while cookie jars generally have an inkstamp or impressed mark.

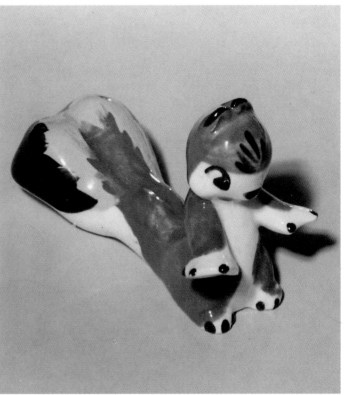

A squirrel figurine, 3-1/2 x 5-1/4 inches. His outstretched paws make it look like a cartoon squirrel trying to stop fast. The mark of this piece is shown. A larger Twin Winton squirrel appears on page 16. Estimated value: $30. *Carson Collection.*

Mark of the squirrel.

An ice skating girl who has fallen down. She is 3-1/2 inches high. Her marks are shown. Estimated value: $45. *Carson Collection.*

Marks of the ice skating girl.

Van Meter

I have been unable to find out anything about Van Meter with the exception of what the paper label says, that it hailed from Santa Barbara. My assumption is that it was a pottery, not a retail outlet, but even this may not be correct.

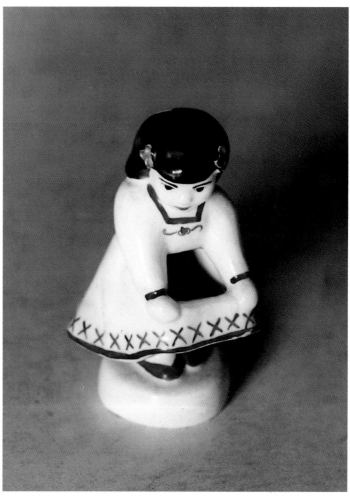

This is a small planter, 3-1/2 inches high. It has a gold paper label with black lettering that reads, "Van Meter/ Santa Barbara" on two lines. Estimated value: $8. *Oravitz Collection.*

Van Meter paper label of girl planter.

Vera La Fountain Dunn

As the paper label states, this firm was located in Hollywood. Lehner found them listed in a 1945 trade publication, which said they made figurines.

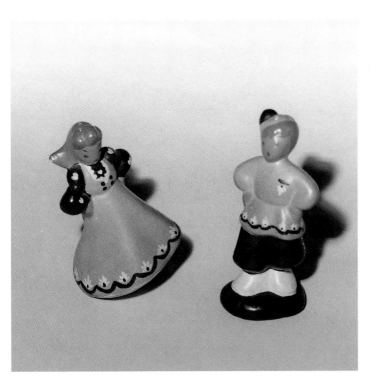

Hansel and *Gretel*. She is 3-3/4 inches high, unmarked. He is 4-1/4 inches, and his paper label is shown. Estimated value: $35 per pair. *Oravitz Collection.*

Mark of *Hansel.*

Vernon Kilns

Vernon Kilns was one of the older California Potteries, beginning life in 1916 as the Poxon China Company. Faye Bennison purchased Poxon China in 1930 and renamed the company for the city in which it was located. For a time Vernon Pottery was used as the name, then Vernon Kilns.

The main concern of figural California pottery collectors in Vernon Kilns is its line of *Fantasia* figurines, made under license from Walt Disney for a very short time, 1940 to 1942. Vernon Kilns was mainly a dinnerware and decorated plate pottery, and due to the expenses involved in making the figurines, it signed its Disney license over to Evan K. Shaw, then of American Pottery, later Metlox, in 1942. Metlox, under Shaw's ownership, purchased Vernon Kilns outright in 1958.

The *Fantasia* figurines, and the bowls and vases that went with them, are extremely rare, hence I found only a few to photograph for the book. To get a better lock on what you are looking for in this field, I suggest *Tomart's Illustrated Disneyana Catalog and Price Guide Vol. III* which shows some of the line in color, and *Vol. IV* which shows more of it in black and white.

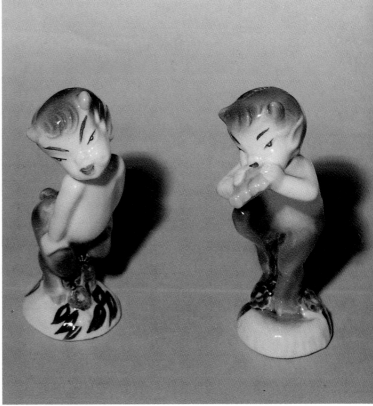

From *Fantasia,* two of the six *satyrs* Vernon made. That's *no. 2* on left, 4-1/2 inches high, and *no. 3* on the right, 4-3/4 inches. Each has its number impressed, each has two inkstamps. They are, "Disney / copyright 1940," on two lines, and, "Vernon Kilns / U.S.A.," on two lines. Estimated value: $350 each. *Oravitz Collection.*

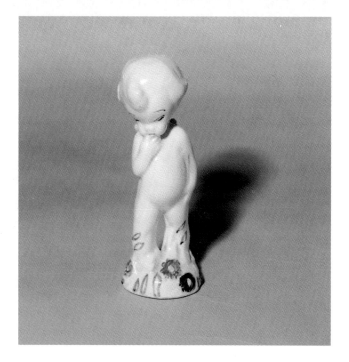

Also from *Fantasia, no. 9 sprite,* one of six. It stands 4-5/8 inches high, is not marked. Estimated value: $300. *Oravitz Collection.*

Bottom of the *Bacchus* bank. Hoodwink is a registered trademark used by Vohann of California, not by Disney.

Vernon Pottery *See Vernon Kilns*

Vohann of California

E.R. von Helmolt and Charles Kauffman started this pottery in Laguna Beach in 1950. They moved it to Capistrano Beach in 1953. Charles Chaney designed many items for Vohann. The firm is still in business today.

Walker Potteries

Walker Potteries, Monrovia, was owned by Joseph Walker. Exact years are unknown. However, it had to have been operating prior to 1946, the year Hagen-Renaker was founded because John Renaker worked at Walker Potteries prior to going into business with his wife and father-in-law. While the ending date for Walker Potteries is a mystery, it seems to have lasted at least into the 1950s, as Chipman states that Walker-Renaker, which started in 1952, was located across the street from Walker Potteries.

Another *Fantasia* character, *Bacchus,* as a 6-3/4 inch high bank. Its Vohann mark is shown. Estimated value: $150. *Oravitz Collection.*

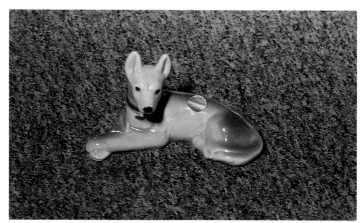

This dog measures 3 x 4-3/4 inches. It has the same paper label as the horse, which is shown close up. Estimated value: $10. *Private Collection.*

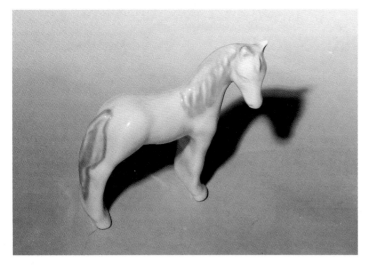

Six inches is the height of this horse. Its paper label is shown. Estimated value: $12. *Oravitz Collection.*

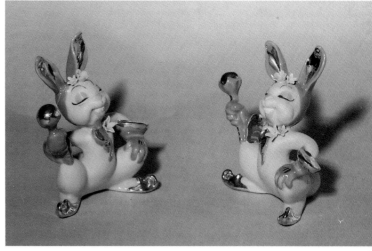

These rabbits are both the same, just set at different angles. Height of each is 4 inches. They are inkstamped, "© WR." Estimated value: $25 each. *Private Collection.*

Paper label of the Walker horse. The same label is on the dog.

Walker-Renaker

Joseph Walker and John Renaker formed Walker-Renaker in 1952. According to Roller, Rose and Berkwitz, Moss Renaker, John Renaker's mother, was the creative force behind it. Each of the pink bisque animals for which the pottery is known came with a card with a poem on it that related to the animal. Susi Singer is said to have done some designing for Walker-Renaker.

The operation lasted until 1959. It was most likely driven out of business by cheaper Japanese imitations, if the number available on today's market gives a reliable indication. The imported pieces are near exact copies except they have less gold and less intricate applied decoration. While I have never taken a survey, I would guess that I see 10 to 15 of the imports for every one of the actual Walker-Renaker pieces.

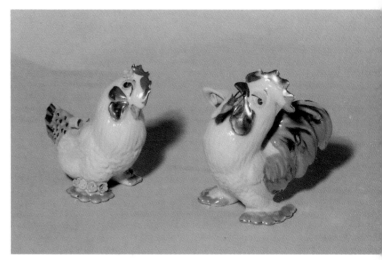

Don't they both look a bit unsure? She is 2-7/8 inches high, he is 3-1/8 inches. His flower is separate. Neither of these figures is marked. Estimated value: $30 per pair if perfect (the bow in front of her tail is broken). *Private Collection.*

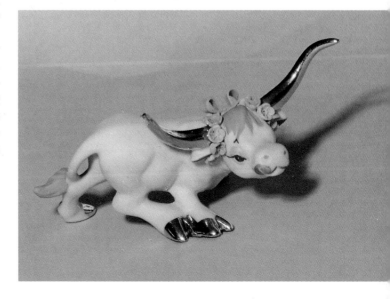

Size of this longhorn is 2 x 4-1/2 inches. It is inkstamped, "Walker / Renaker" on two lines. Estimated value: $20. *Private Collection.*

Height of the horse is 3 inches. Its inkstamp mark reads, "Walker / Renaker" on two lines. Estimated value: $20. *Private Collection.*

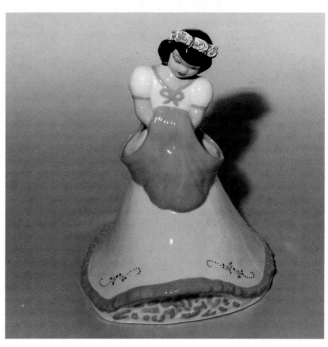

A dark haired *Nancy* planter as opposed to the blonde *Nancy* shown on the title page. Height is 9 inches, the mark appears below. Estimated value: $22. *Oravitz Collection.*

Mark of the *Nancy* planter.

Another *Nancy*, same size but with a different mark, "Nancy / by / Walter Wilson," very lightly incised on three lines. Estimated value: $22. *Oravitz Collection.*

The goose that laid the golden egg is 4 inches high and marked with a "©WR" inkstamp. Estimated value: $25. *Private Collection.*

Walter Wilson

Walter Wilson was a distributor who was located in Pasadena. According to Lehner, the company was active from sometime prior to 1943 until sometime after 1954. From 1943 to 1947 Walter Wilson distributed the McCarty Brothers line.

The Walter Wilson piece seen most often is the *Nancy* figurine, which is marked Nancy / By / Walter Wilson, sometimes in ink, sometimes incised. Price stickers still in existence on some pieces generally indicate the company's wares were sold in better quality department stores.

Marked in ink, "Toy Ming / by / Walter Wilson," on three lines, this planter stands 9 inches high. Estimated value: $18. *Private Collection.*

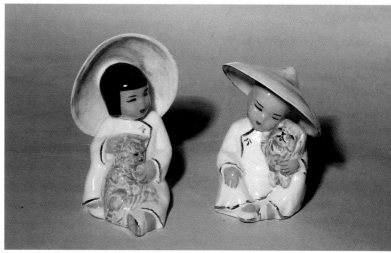

The figure on the left is 4-1/2 inches high. Its mark is shown. The figure on the right is 3-3/4 inches. It is marked the same except the number is "294." Estimated value: $15 each. *Oravitz Collection.*

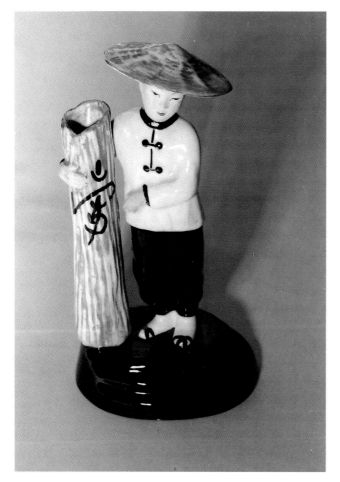

This planter is 9 inches high. It is simply marked, "Walter Wilson," on the bottom. Estimated value: $18. *Oravitz Collection.*

Mark of Walter Wilson Oriental girl with cat planter.

Weil of California, Inc.

Different information from different sources on this one. According to Derwich and Latos, owner/founder Max Weil emigrated to the United States and settled in Los Angeles immediately after World War II, or about 1946. According to Lehner, the company was founded in the late 1930s. Either way, the most active period for this pottery appears to have been from the end of the war until Max Weil's death in 1954.

Lafferty shows the firm located at 3160 San Fernando Road, Los Angeles. During the early days it was apparently called California Figurine Company. A company name change to Max Weil of California, and a mark change to *Weil Ware*, likely took place when the pottery expanded its lines to include dinner ware. This was sometime before 1950 as Lehner cites an article from that year that calls it one of the six biggest dinnerware makers in California.

After Weil died in 1954 the operation was taken over by Frederic Grant, former art director of Glad-dening, McBean, former president of Weller. Two years later it was liquidated, the facilities being sold to companies with no interests in pottery.

Paper label of the lady in the green hat.

Two planters the same but with different decoration. Each is 9-1/2 inches high. The one on the left has an inkstamp and paper label, both of which are shown. The one on the right is unmarked. Estimated value: $22 each. *Oravitz Collection.*

Inkstamp of the lady in the green hat.

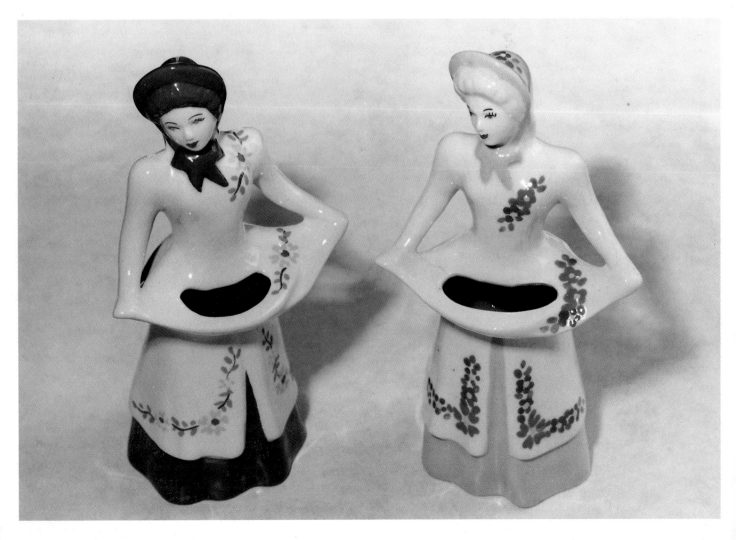

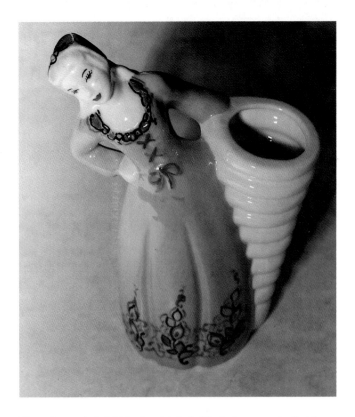

Height is 7-3/4 inches, mark is the Weilware burro inkstamp. Estimated value: $45. *Oravitz Collection.*

This planter is 9-3/4 inches high. It likely has a mate that leans the opposite direction. Its paper label is shown. Estimated value: $32. *Oravitz Collection.*

Paper label of the leaning lady planter. Note the M W for *Max Weil.*

The boy planter is 11 inches high, the girl 10 inches. The boy has an M W inkstamp similar to the paper label of the leaning lady planter. The girl is unmarked. Estimated value: $28 each. *Oravitz Collection.*

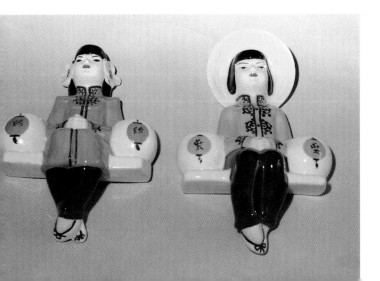

The wallpocket on the left, 9 inches high, has "4045" impressed. The one on the right, 10 inches high, has "4046" impressed. They both have a Weilware burro inkstamp. Estimated value: $35 each. *Oravitz Collection.*

This planter is 9-3/4 inches high. Note the applied flowers at the waist and under the hat. In addition to the Weilware burro mark, it has "4059" under the glaze in something that looks similar to crayon. Estimated value: $32. *Oravitz Collection.*

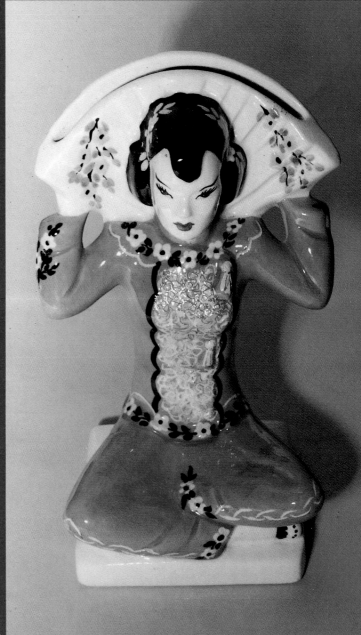

Height is 7-1/4 inches. The number on the bottom is "4041." There is also an unreadable scratched in mark. Estimated value: $42. *Oravitz Collection.*

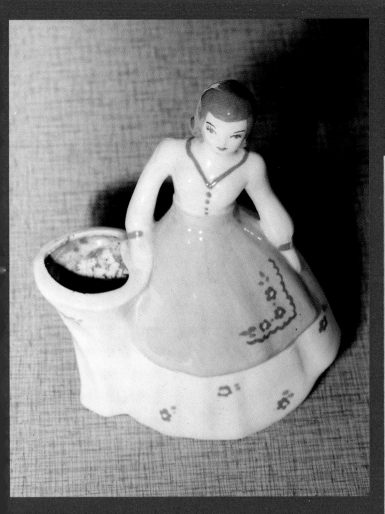

This one is 8 inches high, "1665" appears under the glaze. Estimated value: $24. *Oravitz Collection.*

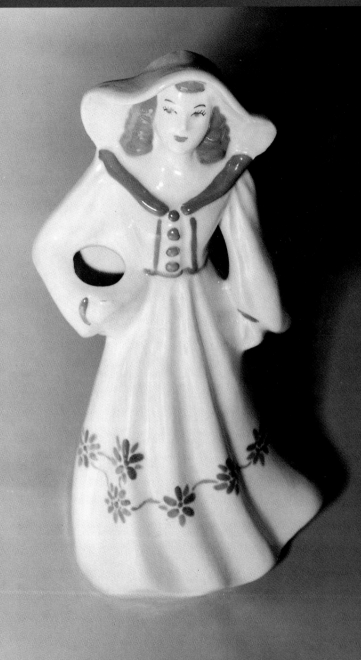

Height of this lady is 11-1/4 inches. Under the glaze is "3056." Estimated value: $24. *Oravitz Collection.*

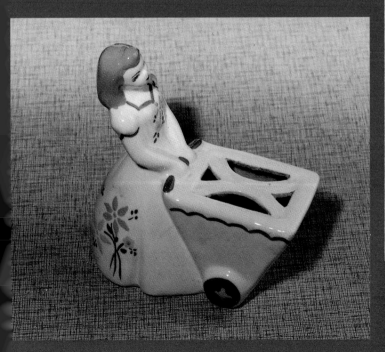

"BB" impressed, "4001" under the glaze, and 8-1/4 inches high. Estimated value: $18. *Oravitz Collection.*

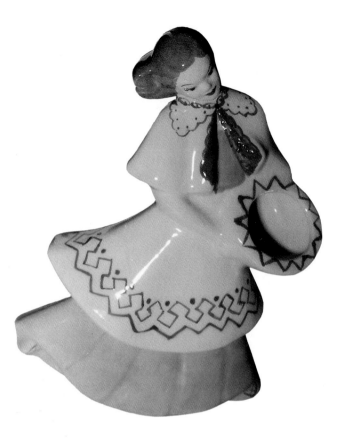

A 9-1/4 inch planter, "3055" under the glaze. Estimated value: $28. *Oravitz Collection.*

This planter is 6-3/4 inches high, has "4000" under the glaze and "DC" scratched into the bisque. Estimated value: $20. *Oravitz Collection.*

West Coast Pottery

A largely unheralded pottery that did lovely work, West Coast was located at 725 Lake Street, Burbank. The company's name appeared in trade journals as early as 1940, as late as 1948, possibly later.

As you can see from the limited selection here, some of the company's figures employed a style and workmanship on a par with the best of the California potteries.

A lamb figurine, 3 inches high. The mark on its bottom is shown, and so is its paper label. Estimated value: $20. *Private Collection.*

Bottom of lamb figurine.

Paper label of lamb figurine.

This pony figurine is 3-1/8 inches high. It does not have a paper label, but its bottom, and the markings on it, is similar to the lamb's. Estimated value: $20. *Oravitz Collection.*

Bottom of the pony, "Dandy" printed, "1006" impressed.

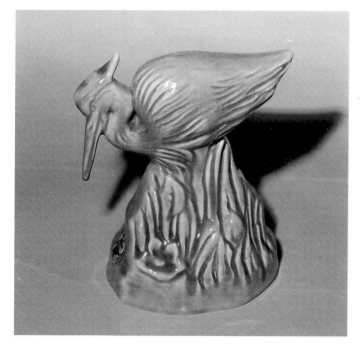

This bird figurine is 8 inches high. Note the paper label at the left. The mark on the bottom of this piece is shown. Estimated value: $15. *Oravitz Collection.*

Bottom of shorebird figurine.

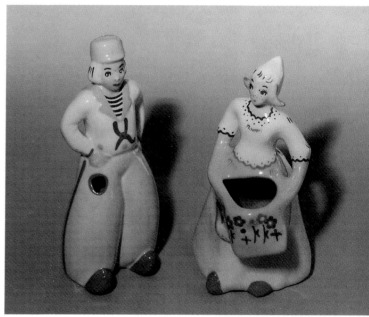

Hans and *Gretchen* planters, 7-1/2 and 7-1/4 inches high, respectively. "West Coast Pottery" is impressed in both, and their bottoms are shown. Estimated value: $22 each. *Oravitz Collection.*

Bottoms of *Hans* and *Gretchen.*

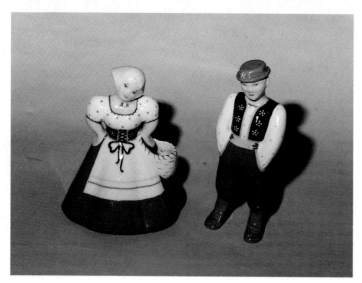

Strange case here. This is obviously a pair, but the girl is a planter, the boy is a figurine. Perhaps each one was made both ways, and this pair was married sometime after they left the factory. She is 6 inches high, has "West Coast Pottery" impressed, and "1040-DK" (sounds like and IRS form) in ink. He is 7 inches high, and not marked. Estimated value: she $25, he $30. *Oravitz Collection.*

Weston Ware *See Brayton Laguna*

Will-George

Like Twin Winton, the Will-George Pottery was named for the two brothers who founded it, Will and George Climes. The business began in the Los Angeles garage of Will Climes in 1934 when the brothers were in their mid- to late-twenties. Prior to that Will had studied at the Chicago Art Institute, and both men had worked at Catalina Pottery on Catalina Island. George worked at Catalina longer than Will. There, as an understudy of Virgil K. Haldeman, George gained much of the knowledge and skill that would later make his own pottery an outstanding example of the best California's ceramics industry had to offer.

In 1938 Edgar Bergan (probably much to the dismay of Charlie McCarthy) became a partner in the business. With Bergan's money and celebrity the firm prospered to the point that, within two years, it had to move to a larger facility in Pasadena. Sometime after World War II Bergan and the Climes went their separate ways, at which point the brothers moved the business to San Gabriel where they operated under the name Claysmiths. The individual pieces, however, were still marked Will-George. Lehner found Claysmiths listed in trade journals as early as 1948.

Claysmiths closed in 1958 due to increased competition from foreign imports during the postwar period. Interestingly, though, according to Chipman,

it was not the flood of pottery from Japan that forced the company out of business. Rather, the products imported from Italy sounded its death knell. That makes sense, as much of the Will-George line is very similar to the later Italian wares that are just now beginning to draw collector interest.

After liquidating their business, both brothers remained in the pottery game. Will, who died in 1960, became a designer for Hagen-Renaker. George worked first at Redondo Tile Company, then at Gladdening-McBean. He passed away in 1966.

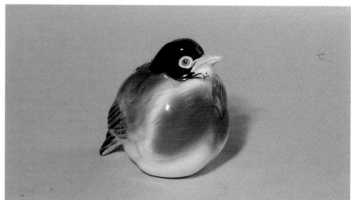

If you think you have seen this robin before, it is because a very similar model appears under Hagen-Renaker on page 116. The most likely explanation would be that Will Climes may have sold the design to Hagen-Renaker, as he worked for that pottery from sometime after Will-George closed in 1956, until his death in 1960. The robin is 3 inches high. Its paper label is shown. Estimated value: $25. *Private Collection.*

Paper label of Will-George robin.

This cardinal is 3-3/4 inches high. As you can see, this same model was sometimes finished as a bluejay. Its mark is shown. Estimated value: $35. *Private Collection.*

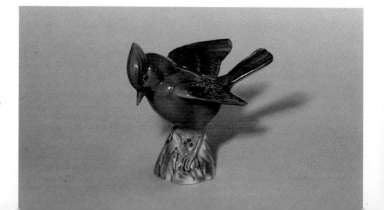

Mark of the cardinal.

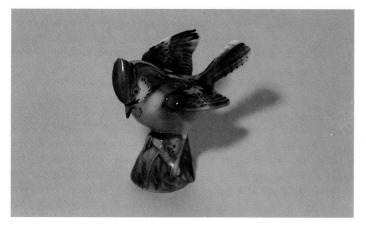

Here's the bluejay; look closely and you will see his top knot has been chipped. Height and mark is same as the cardinal. Estimated value: $35 (if perfect.) *Private Collection.*

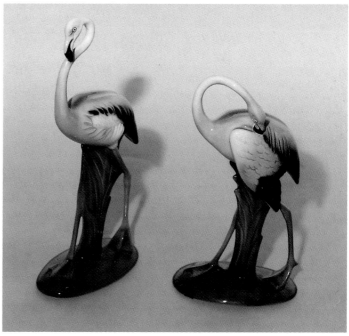

Will-George flamingoes are so wonderfully light and delicate that when handling them you can almost appreciate them as much with your eyes closed as with your eyes open. The one on the left is 11-1/2 inches high, the one on the right 9-5/8 inches. Each is marked with a Will-George inkstamp. Estimated value: $85 each. *Private Collection.*

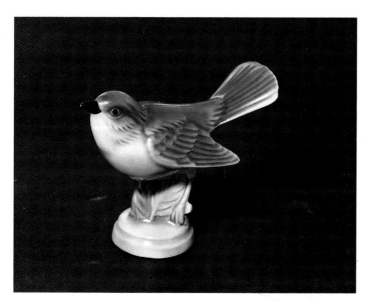

This 3-1/4 inches high bluebird had a Will-George mark, but I didn't record specifically what it was. Estimated value: $35. *Carson Collection.*

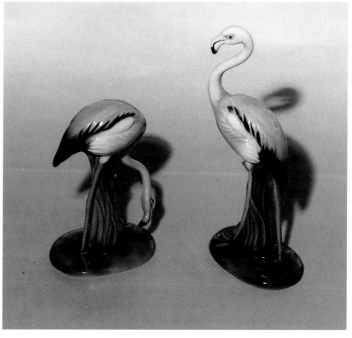

A smaller pair here, 6-1/2 and 9-1/2 inches high, with a "Will-George" inkstamp. Estimated value: $60 each. *Private Collection.*

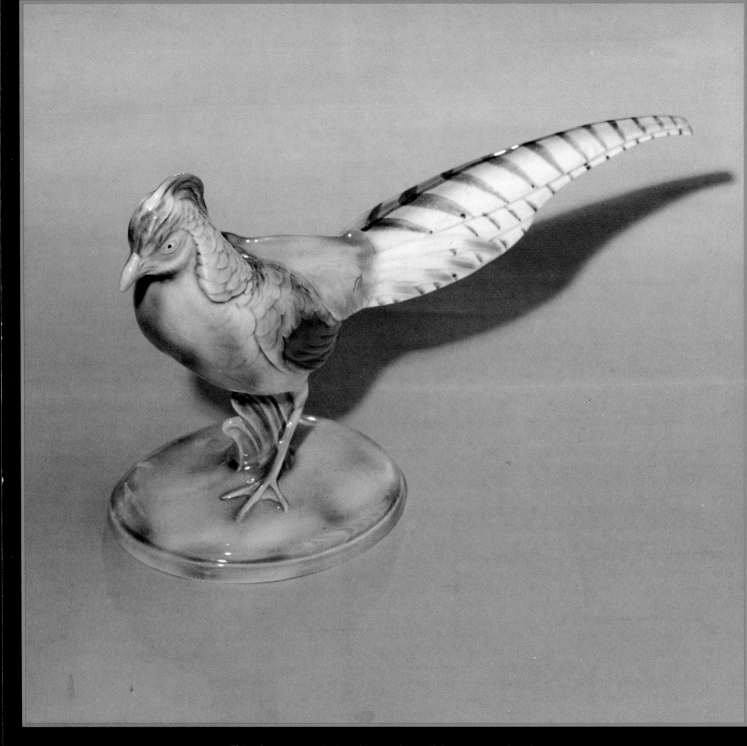

This pheasant is missing the tip of its tail, but you get the idea. As is it measures 7-3/8 x 15 inches. It is marked with an inkstamp, "Will-George / Pasadena," on two lines. Estimated value: $95 (if perfect.) *Courtesy of Louise Lovick.*

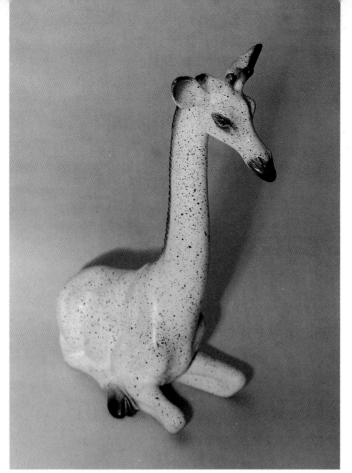

A highly stylized piece for Will-George, this giraffe is 11-1/8 inches high. It is marked with a paper label, "Will-George / California," on two lines. Estimated value: $45. *Private Collection.*

This planter is 8-1/2 inches high. It has a "Will-George" inkstamp. Estimated value: $30. *Courtesy of Dan Borgis.*

Winton *See Twin Winton*

Ynez

Ynez was located in Inglewood. According to Lehner, it began prior to 1948, remained in business until around 1953. This was a fairly prolific pottery. The fact that only three pieces are shown is a result of logistics, not rarity.

Many Ynez figures were named, such as the *Abigail* shown here. Derwich and Latos reported seeing *Caroline, Edward, Eloise, Kathy Lou* and *Penelope.* Chipman shows a *Jennifer.* There were probably many others.

Mark of Ynez *Abagail.*

This is *Abagail,* 7 inches high. Her mark is shown. Estimated value: $30. *Oravitz Collection.*

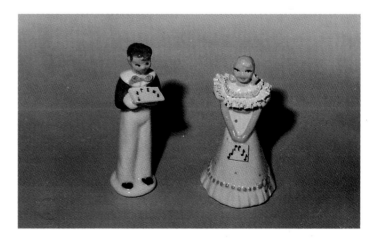

Height on the left is 5-3/8 inches. The figurine is marked, "Curlie / by Ynez," in the same manner as *Abagail.* Height on the right is 5-1/8 inches. She has the same type of mark, which says, "Carla / by Ynez." Estimated value: $25 each. *Oravitz Collection.*

Yona Ceramics

This business was owned by Max and Yona Lippin, former employees of Hedi Schoop which should come as no surprise when you look at the pictures. According to Derwich and Latos, Yona Ceramics was located at 5320 North Adams Boulevard, Los Angeles. Years are not known, except that the firm was obviously started sometime after 1939 or 1940, the time at which Schoop's work began gaining momentum. Derwich and Latos found Yona listed in trade journals as late as 1950.

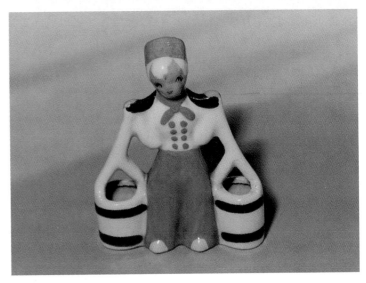

A boy with buckets but certainly not a mate for the girl as it is only 5-3/8 inches high. It is marked, "Yona 29." Estimated value: $20. *Oravitz Collection.*

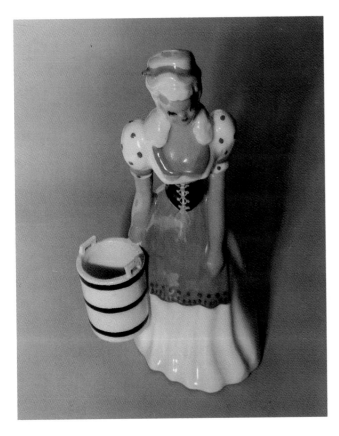

This planter stands 8-3/4 inches high. Its mark is shown. Estimated value: $30. *Oravitz Collection.*

Mark of girl with bucket planter.

This planter stands 8-3/8 inches high. It is marked "Yona / #10" under the glaze on two lines. Estimated value: $25. *Oravitz Collection.*

Nine inches is the height of this planter. It is marked "Yona / #19" on two lines. Estimated value: $30. *Oravitz Collection.*

This planter stands 7-3/8 inches high, is marked "Yona / 48." Estimated value: $40. *Oravitz Collection.*

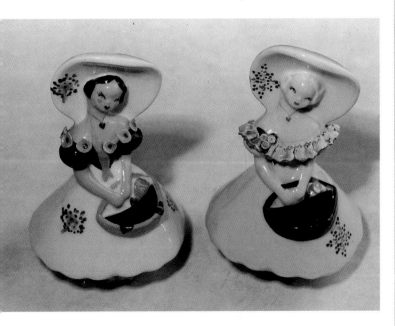

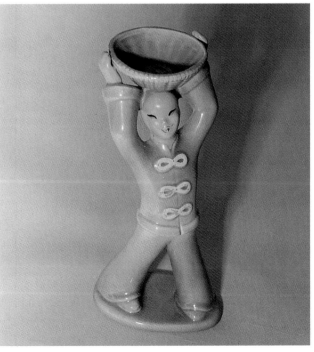

Left: "22 / Yona" on two lines under the glaze, 7-3/4 inches; right: "Yona" under the glaze, 7-1/2 inches. Estimated value: $35 each. *Oravitz Collection.*

A figurine for a change. Height is 8-5/8 inches. It is marked, "Yona." Estimated value: $25. *Oravitz Collection.*

Another figurine. This one is 7-1/2 inches high, marked in gold, "Yona / 321," on two lines. Estimated value: $35. *Oravitz Collection.*

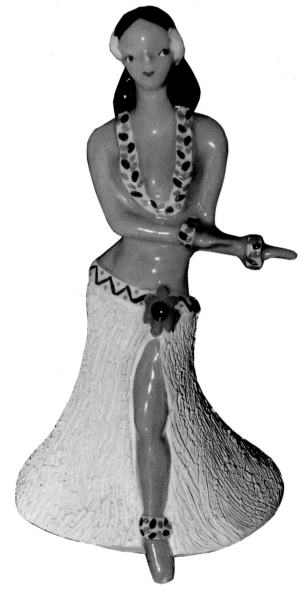

A hula girl, 10-7/8 inches high, and marked "Yona / #33" on two lines. Estimated value: $50. *Graettinger Collection.*

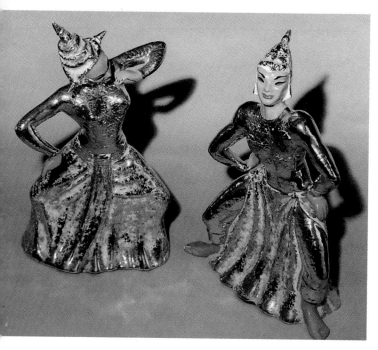

These are tall figurines, 13-1/2 inches on the right, 12 inches on the left. Both have closed bottoms, each is marked "Yona" in gold. Estimated value: $30 each. *Oravitz Collection.*

Pretty perhaps, but not Yona. These are very heavy when compared to Yona pieces; they have open bottoms; they are not marked. Perhaps Gilner, perhaps another company. Heights are 11 and 12-1/2 inches. Estimated value: not determined. *Oravitz Collection.*

Another tall pair, 13-1/2 (left) and 12-7/8 (right) inches. Each is marked "Yona" under the glaze. Estimated value: left $30, right $25. *Oravitz Collection.*

Bibliography

Chipman, Jack, *Brayton Laguna 1948 Retail Catalog,* privately printed, Redondo Beach, California, 1986.

_____, *Brayton Laguna 1957 Wholesale Catalog,* privately printed, Redondo Beach, California, 1986.

_____, *Collector's Encyclopedia of California Pottery,* Collector Books, Paducah, Kentucky, 1992.

Dale, Jean, *Charlton Standard Catalog of Royal Doulton Animals, The* Charlton Press, Toronto, Ontario, Canada, 1994

Derwich, Jenny B., and Latos, Dr. Mary, *Dictionary Guide to United States Pottery & Porcelain (19th and 20th Century),* Jenstan, Franklin, Michigan, 1984.

Florence Ceramic Company catalogs, various years, Florence Ceramics Company, Pasadena, California.

Gift and Art Buyer, The, various advertisments, New York, June 1952.

Guntrup, Marian J., "The Coast," *China Glass & Tablewares,* October 1955.

Harris, Dee, and Whitaker, Jim and Kaye, *Josef Originals,* Schiffer, Atglen, Pennsylvania, 1994.

Kay Finch Ceramics catalogs, Kay Finch Ceramics, Corona Del Mar, California, 1946, 1950, 1958, 1961.

Lafferty, James R. Sr., *The Forties Revisited, Vol. II,* privately printed, 1969.

Lehner, Lois, *Lehner's Encyclopedia of U.S. Marks on Pottery, Porcelain & Clay,* Collector Books, Paducah, Kentucky, 1988.

Pina, Leslie, *Pottery Modern Wares 1920-1960,* Schiffer, Atglen, Pennsylvania, 1994.

Posgay, Mike, and Warner, Ian, *World of Head Vase Planters, The,* Antique Publications, Marietta, Ohio, 1992.

Roerig, Fred and Joyce Herndon, *Collector's Encyclopedia of Cookie Jars,* Collector Books, Paducah, Kentucky, 1991.

_____, *Collector's Encyclopedia of Cookie Jars Book II,* Collector Books, Paducah, Kentucky, 1994.

Roller, Gayle, and Rose, Kathleen, and Berkwitz, Joan, *Hagen-Renaker Handbook, The,* privately printed, 1989.

Schneider, Mike, *Animal Figures,* Schiffer, West Chester, Pennsylvania, 1990

_____, *Complete Cookie Jar Book, The,* Schiffer, West Chester, Pennsylvania, 1991

_____, *Complete Salt and Pepper Shaker Book, The,* Schiffer, Atglen, Pennsylvania, 1993.

Tumbusch, Tom, *Tomart's Illustrated Disneyana Catalog and Price Guide, Vol. IV,* Tomart Publications, Dayton, Ohio, 1987.

_____, *Tomart's Illustrated Disneyana Catalog and Price Guide, Vol. III,* Tomart Publications, Dayton, Ohio, 1985.

Wellman, BA, "Florence Ceramics-A Thing of Beauty is a Joy Forever," *Antique Trader Weekly,* Dubuque, Iowa, July 6, 1988.